MASTERS
OF
ENGLISH
LANDSCAPE

D1131451

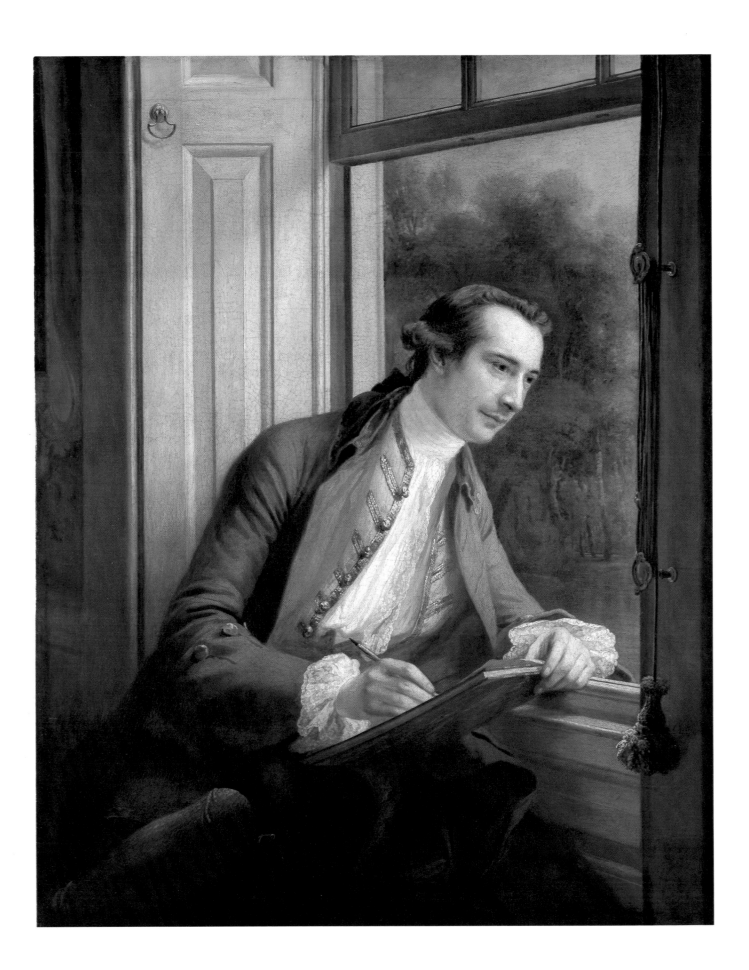

LAURE MEYER

MASTERS
OF
ENGLISH
LANDSCAPE

AMONG OTHERS

GAINSBOROUGH STUBBS TURNER
CONSTABLE WHISTLER KOKOSCHKA

TERRAIL

Cover illustration

J.M.W. Turner:
Landscape: Woman with Tambourine.
C.1840-1850. Oil on canvas.
88.5 x 118 cm.
Private Collection.

Previous page

Francis Cotes:
Portrait of Paul Sandby.
c.1760. Oil on canvas.
Tate Gallery, London.
Because he looked on nature as poetry,
and sought to express the nuances of
colour and atmosphere, Paul Sandby can,
perhaps, be regarded as the father of
English landscape painting.

Opposite

Sir Anthony Van Dyck:
A Country Lane.
Watercolour (detail).
British Museum, London.
The frequenter of the greatest courts of
Europe seems to have needed to go into
the countryside to enjoy its beauty and
freshness.

Editors: Jean-Claude Dubost and Jean-François Gonthier
English adaptation: Peyton Skipwith, with Eugène Clarence Braun-Munk
Art director: Christophe Merlin
Iconography: Claire Balladur
Composition & filmsetting: Compo Rive Gauche Paris
Lithography: Litho Service T. Zamboni, Verona

Worldcopyright: © FINEST S.A./ÉDITIONS PIERRE TERRAIL, PARIS 1992
A subsidiary of the Book Department
of ⊛ Bayard Presse S.A.
English edition: copyright © 1993, 1995
ISBN: 2-87939-037-0
Printed in Italy

All rights reserved. No part of this publication may be reproduced or transmitted
in any form or by any means, electronic or mechanical, including photocopying,
recording or by any information storage and retrieval system,
without permission in writing from the publishers.

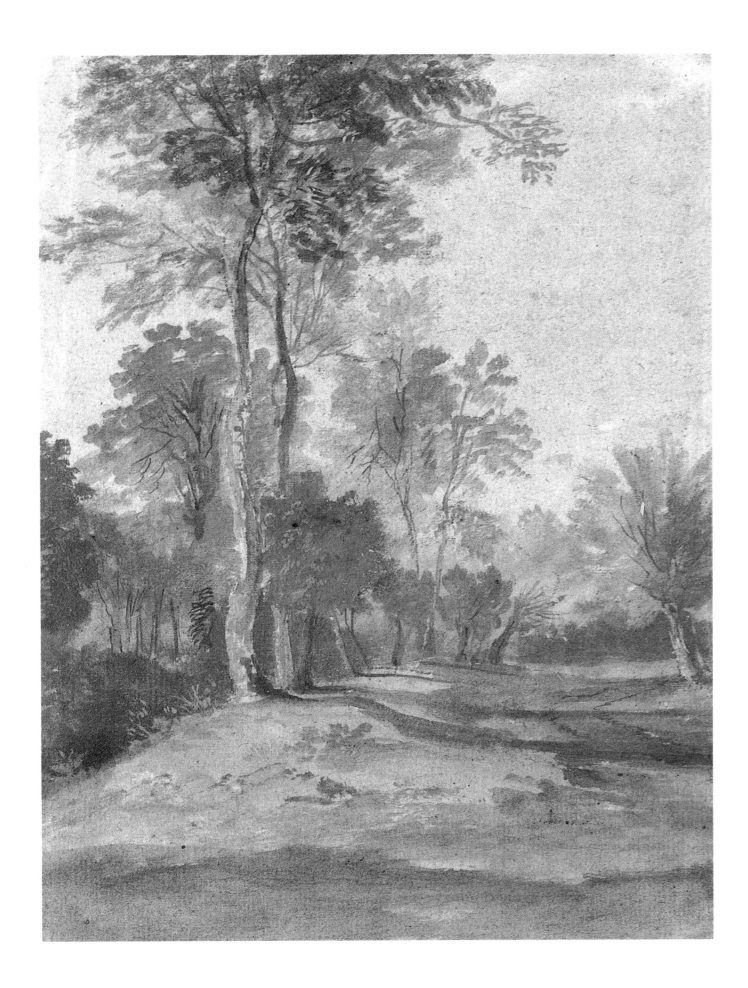

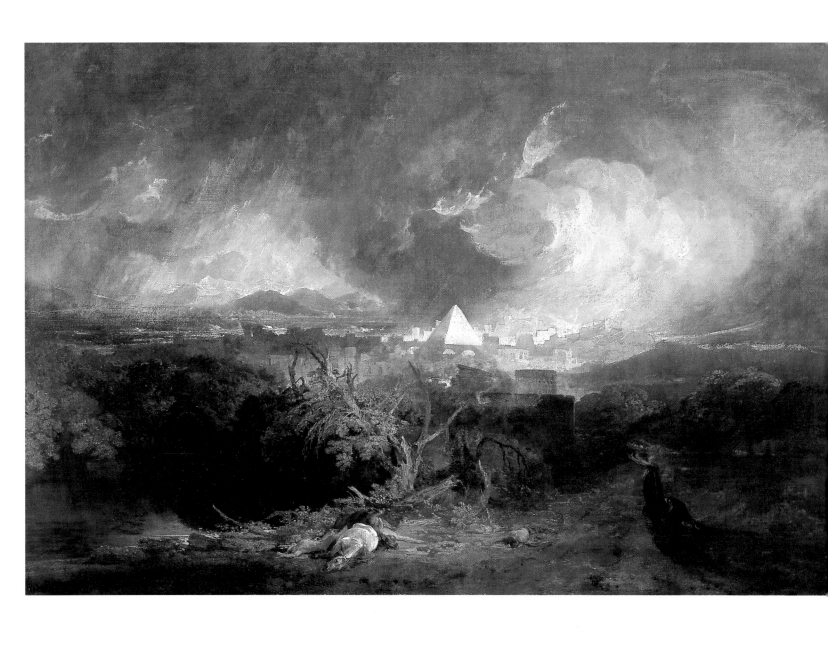

J.M.W. TURNER.
THE FIFTH PLAGUE OF EGYPT
1800. Oil 124 x 183 cm.
Indianapolis Museum of Art, Indianapolis.
The title of the painting is incorrect. The
scene depicted is not the fifth, but the
seventh plague. A perfect example of the
"sublime", which was in vogue at the end
of the 18th century.

TABLE OF CONTENTS

Introduction 8

Landscape and poetry during the Renaissance 15

Stimulation from Abroad 17

The topographical tradition and the search for beauty 25

Alexander Cozens and the triumph of the imagination 35

Hunting scenes and rural life 39

Wilson and Gainsborough disregarded in their day 51

Joseph Wright of Derby, commentator on the industrial revolution 67

The liberation of sensibility thanks to watercolour 73

Turner's amazing career 95

Long-range travellers 123

Crome and Constable, painters of the soil 135

The romantic vision 157

The Pre-raphaelites and victorian painting 171

Whistler and the impressionists 183

The beginning of the twentieth century 195

A glance backwards 211

Who were these painters? 212

Main places mentioned in the text 218

Index of names 220

INTRODUCTION

Great Britain witnessed a unique flowering of a school of native landscape painters. It developed spasmodically as artists reacted to the tastes of aristocratic collectors and to Continental influences alike.

It was only in the 19th century that landscape came to occupy a prime place in an art which had been dominated previously by portrait and history painting. This change of emphasis was important and evolved as individuals gradually relinquished their position as dominant subject matter in favour of nature. During the 17th and 18th centuries landscape existed chiefly in a supporting role as a backdrop to various human activities, or else to serve as the expression of the ideals of individual artists. It was not then regarded as an art form in its own right.

The beauty of specific sites, domesticated or wild, combined with the changing quality of light, heavy with mist or iridescent in hazy sunshine, the abundant vegetation and the presence of the sea, always close to hand and often angry, each of these elements favoured the development of an important school of landscape painters. The names of Turner and Constable immediately spring to mind, but one should not overlook their predecessors or those who followed after them. There were dozens of artists of great talent, painters of remarkable pictures, at whose work it is equally important to look. Just think of Gainsborough, Girtin and Whistler.

The transition which led to the pre-eminence of landscape was gradual, starting in the 17th century and then ripening in the 18th. This development was influenced by many different factors including the aesthetic dictates of the Royal Academy, ideas from the Continent, the tastes of rich collectors and amateurs alike and, above all, the skill and ability of individual artists.

LANDSCAPE AND THE ROYAL ACADEMY

The Royal Academy in London was slow to recognise the importance of landscape painting; although the Academy had been founded in 1768, it was only much later that it recognised landscape as a special subject and that was due to Turner's Will of 1833. Prior to its foundation other artistic bodies had existed but equally none of these had paid any attention to landscape in its own right.

The Royal Academy Schools admitted only thirty pupils a year and, in the 18th century, the practice of landscape painting was not taught there at all. A young man wishing to study in this field had to gain admittance, as

pupil or apprentice, to the studio of a practicing artist, and such mentors were not always of the highest calibre. In following this tradition Girtin was apprenticed to the watercolourist Edward Dayes, whilst Turner worked alongside Thomas Malton as a lowly collaborator.

The contempt in which landscape painting was held can be explained by the theories advocated by the Royal Academy at the end of the 18th century. Sir Joshua Reynolds, its first President, considered that the object of painting was not to copy or transcribe nature but to present an idealised vision of her. In this belief he was heir to a long tradition. He also believed in the hierarchy of subject matter, an artistic theory first developed by the French Academie des Beaux-Arts, but expounded with even greater rigour by its English counterpart.

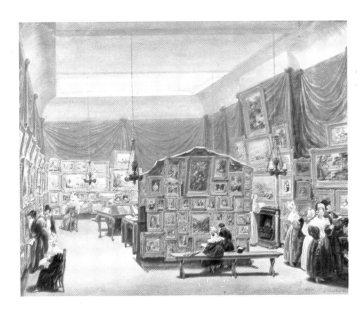

According to this principle history painting, inspired by biblical, historical or mythological incidents, was the highest branch of art because it conveyed a philosophical message, and its nobility was far removed from the mundane material world of everyday life. A special style, the 'grand style' or the 'grand manner', which was deemed to be both classical and noble, was evolved to enable artists to depict with suitable dignity such morally uplifting episodes.

Portrait painting, so long as it aspired to the ideal, held second place in this hierarchy, and was regarded as a laudable profession for an artist. It was at this level that Reynolds placed himself. Other categories of painting – narrative, portraiture (in the sense of transcribing a straightforward likeness), landscape and still life – were placed firmly at the bottom of the ladder.

However, one should not conclude from this that the Academy's role was a purely negative one. Founded by artists and enjoying complete independence, despite the privilege of its royal charter, it organised annual exhibitions, which enabled many artists to show their work and build their reputations. For many, especially the watercolourists, the hanging was not ideal. Pictures were hung in every available space, banked up one above another from floor to ceiling – conditions were no different at the Old Watercolour Society (now the Royal Society of Painters in Watercolour) – and watercolours were framed close up in heavy gold frames rather than isolated in wash-line mounts. Such conditions explain the need for artists to have created strong works of a considerable size which could be clearly seen from a distance. Finally, it was the existence of these crowded conditions, which meant that many works were skied, and others hung below the line, that led some artists, like Turner, to open their own galleries.

The auction houses, where works of art were offered to the public, have existed since 1744 (Sotheby's) and 1766 (Christie's). It was only in the middle of the 19th century that the idea of holding exhibitions in the newly founded provincial museums was developed, making important artistic centres of such cities as Leeds, Manchester and Liverpool. Also, at much the same time the new breed of entrepreneurial dealers started to open commercial galleries.

GEORGE SCHARF.
INTERIOR OF THE GALLERY OF THE
NEW SOCIETY OF PAINTERS IN WATER-
COLOURS IN OLD BOND STREET.
1834. Watercolour.
Victoria & Albert Museum, London.

Other Theories; the Sublime and the Picturesque

Happily the doctrines of the Royal Academy were not the only ones to dominate the English art world in the 18th century. The quest for knowledge highlighted two other aesthetic theories; the 'sublime' and the 'picturesque', which between them imbued the art of landscape with some of the dignity that the Academy denied it.

The notion of the *sublime* was developed by Edmund Burke in his *A Philosophical Enquiry into the Origin of our Ideas of the Sublime and Beautiful* (1756). Burke identified those moments when the 'sublime' character of a particular scene imbued it with a special quality of beauty, which was at the same time both admirable and awe inspiring, but also capable of imparting a frisson of fear. His notion of the sublime introduced a strong element of emotion and especially passion. Through comprehension of these emotions the viewer is enabled to enter a world of the imagination.

This theory limited the possibilities of landscape to a considerable extent, but it also inspired a number of great works such as Turner's *The Fifth Plague of Egypt**. Many of these canvases depicted major catastrophes, whilst others evoked nature in all her naked fury with terrifying scenes of great storms or precipitous alpine passes.

Less ambitious than Burke's theory of the 'sublime' was the notion of the "picturesque" made fashionable by Uvedale Price and Richard Payne Knight. Rather than investing nature with human emotions the artist concentrated on those details which he knew would delight the viewer. He was able to dwell lovingly on gnarled trees and irregular lines of old buildings in order to attract attention and lead the spectator's eye across the canvas. Painters of the picturesque often introduced ruined cottages or crumbling abbeys in the knowledge that such delightful and unexpected elements would surprise the viewer and hold his interest. Works of this character were very appealing as is witnessed by the large number of collections of lithographs of popular tourist sites. Samuel Prout's *Church of St Lo, Normandy**, is an excellent example of this genre.

The Demand for Landscape in the Eighteenth Century

The potential collectors of paintings were the aristocracy and the rich bourgeoisie, who were often self-centred and wishing to attract credit to themselves through their grand houses and castles as well as through their collections. This pre-occupation with taste extended also to their wives and mistresses, which meant that the great portraitists of the era, Gainsborough and Reynolds, had a secure clientele, which enabled them to live in considerable luxury.

Following the fashion of the period these aristocrats would condescend to purchase such things as Italian landscapes to adorn their walls. Salvator Rosa, Canaletto (active in England 1746-1755), Antonio Joli (in England 1744-1750) and Zuccarelli (in London 1752-1762), were the main beneficiaries of this patronage. At much the same time, however, there were

*Works marked with an * are reproduced in the book.*

excellent English landscape painters who were virtually ignored. Richard Wilson died in poverty, and when Gainsborough died a large number of sumptuous landscapes remained unsold hanging in the corridors of his London house. He earned his living solely through his portraits and these other works had been painted for his own pleasure.

The case, however, was not entirely hopeless for the landscape painter, because the nobility also liked to have records of their estates. They wanted exact topographical representations of their houses and parklands, as well as more extensive views of their larger domains, which often stretched for miles. An early work by Gainsborough, *Robert Andrews and his Wife*, Frances, (1748-9, p. 58) fits into this category.

For the aristocracy and the landed gentry the pleasures of the country, especially of the chase, were of the greatest importance, whilst the foundation of the Jockey Club led to a demand for records of great races as well as of the horses which won them. And, of course, no Englishman could neglect his dogs either, so they, too, had to be painted.

This desire for good topographical records naturally extended to the sea with a demand for scenes depicting hard won battles and naval engagements. As an island nation, the English had always been pre-occupied with the sea, and it furnished ideal subject material for a national school of marine painters.

Each of these three areas – topography, scenes of hunting and racing, and seascapes – led in their different ways to the development of a fine and independent school of landscape painters. The tradition evolved slowly, and not without many trials, but finally came into full bloom in the second half of the eighteenth century, producing a number of artists of the first rank.

THE PREVALENCE OF WATERCOLOUR

The works intended to decorate the reception rooms and great staircases of country houses were mostly in oil. However, parallel with this production, many artists were also painting fine and important watercolours. Due to the susceptibility to fading of these watercolours, collectors seldom hung them for long periods at a time; they were more often kept in portfolios, or even in albums like photographs or holiday souvenirs. This habit was given a great boost with the spread of the 'grand tour' with its visit to Italy, which became almost obligatory for any aspiring young gentleman wishing to display a knowledge of cosmopolitan culture.

From the middle of the 18th century the art of watercolour drawing became all the rage in England, and was practised by amateurs and professionals alike. This widespread enthusiasm meant that the results were equally varied, but at their best were of a quality that was quite remarkable. Making up for the lack of interest in landscape within the Royal Academy, numerous drawing masters, often permanently ensconced as tutors in the households of the aristocracy, guided and instructed their pupils. Nowhere else in Europe was the art of watercolour treated so seriously and with such passion as in England. However, despite this enthusiasm, it continued to be treated as a

SAMUEL PROUT.
THE CHURCH OF ST. LO, NORMANDY.
Pen, brown ink and watercolour. British Museum, London.
This watercolour is a perfect example of the "picturesque" style. Mediaeval ruins and old houses, with complex draughtsmanship emphasising the details; the foreground enlivened with agreeable groups of figures. The whole composition is unified to allow the eye to wander over the picture without being troubled by problems as to what was described in this particular view.

minor art form and was firmly relegated to the lesser rooms at the Royal Academy.

By the end of the 18th century everything was ready set for the flowering of a great school of landscape painting, which, thanks to the large number of talented artists in England, as in the rest of Europe and even further afield, seized upon the most colourful aspects of nature. These were often handled in a romantic way, which gave added psychological or philosophical meaning to the scene.

THE PRE-EMINENCE OF LANDSCAPE IN THE 19TH CENTURY

The extraordinary flourishing of landscape painting throughout Europe in the 19th century was encouraged by the increasing belief that nature in all her manifestations was good. Such pantheism gained considerable ground among painters and poets alike, whilst previously unquestioned religious faith began to decline. These new beliefs also corresponded with the romantic view, which had helped in the first place to guide the ideas and ideals of many thinking people towards an interest in nature.

Two major artists dominated landscape painting in England, Turner and Constable. Turner, the great visionary, pre-occupied with cosmic forces, was heir to the tradition of the "sublime", but through his researches into colour and his mastery of atmospheric effects, set the scene for the art of the 20th century. Constable, meanwhile, studied nature in his search for truth, and he too created a vision that was both fresh and new.

The middle years of the century, a period of crisis, were marked by the death of Turner in 1851. At the same time a further revolution in taste was heralded by the emergence of the Pre-raphaelite Brotherhood, whose adherents were not so concerned with landscape except as a background, being pre-occupied with the moral message of their pictures. At this time too the collectors were in a state of flux; no longer were they drawn primarily from the landed gentry and aristocracy, as in the first part of the century, but from the new breed of merchant princes, self-made men, who knew very little about art but wished to see scenes recorded in the minutest detail.

Happily, the development of impressionism in France sent ripples across the Channel, which added new elements to the British vision. The most important role in this cross-channel fertilization was taken by an artist who was not, strictly speaking, an impressionist, namely James McNeill Whistler. Whistler, although often associated with England, was an American, who lived mainly in London and Paris. In 1877, in a celebrated law-suit with the most influential critic of his day, John Ruskin, he expounded his poetic vision of a London steeped in fog, and set this in stark contrast to the public's wish for detailed, and often sentimental, scenes. Art for art's sake was his creed.

THE BEGINNING OF THE TWENTIETH CENTURY

At the turn of the century the prevalent artistic influences followed those from across the Channel quite closely, though a few years behind.

Cezanne, Van Gogh and Gauguin were enthusiastically admired by the younger artists, to the horror of their more established confreres. Post-impressionism was widely influential with each artist interpreting it in his own manner, making for a diverse and pleasing range of work. Several artists, including the Irish painter, Roderick O'Conor, who developed a daring palette based almost exclusively on the primary colours anticipating the fauves, even became a part of the Pont Aven school.

In 1913 Wyndham Lewis, wishing to challenge Marinetti's futurism, invented vorticism, taking its name from the 'vortex' to signify a whirlwind. Vorticist theory lauded violence, revelled in the depiction of high speed movement and worshipped the machine age. Partly due to the fact that it was primarily an intellectual movement, and partly due to the outbreak of war in 1914, it did not gain widespread popularity at the time.

After the war, in keeping with the mood of the times, individual artists, rather than schools or movements, began to dominate the scene. Among these individuals three great names emerge, Oscar Kokoschka, a Czechoslovakian who had become a naturalised British citizen, painted many beautiful landscapes based on his rare understanding of the science of colour. Graham Sutherland adopted a semi-mystical and pantheistic attitude to landscape, which he transformed into a stylised but harmonious vision, whilst Ben Nicholson, greatly influenced by Mondrian, painted works that were frequently totally non-figurative and established an important link with the art of the second half of the century.

At the same time certain artists, seeking a different form of expression, looked inwards rather than outwards, and without turning their backs completely on nature, tried to depict the landscape of the mind in preference to the world around them.

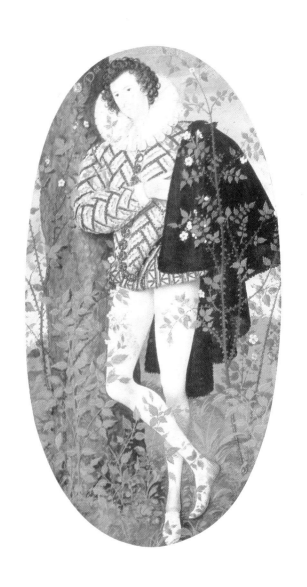

NICHOLAS HILLIARD.
AN UNKNOWN YOUTH LEANING AGAINST
A TREE, AMONG ROSES.
c. 1590. Vellum laid on a playing card.
13.7 x 6 cm. Victoria & Albert Museum,
London.
Through the medium of love poetry,
ardent verses which played an important
role at the Court of Queen Elizabeth, the
first aesthetic link was established
between man and nature.

Landscape and Poetry
during the Renaissance

At first sight it is easy to think that during the 16th century, under Henry VIII and Elizabeth I, artists were solely concerned with depicting the human image. The period is dominated by the great portraits of Holbein, whilst, on a more intimate level, the art of the miniature achieved a perfection that has never been surpassed.

In certain of these miniatures landscape is most beautifully delineated, although it is only there to serve as background. Nicholas Hilliard's *Unknown Young Man amongst Roses* (c.1590)* marks a turning point in the genre; it represents the pivotal moment when artists began to place their models within a naturalistic setting. Who is this young man? We don't know, but it has been suggested that he could be either the recipient of Shakespeare's sonnets, or Queen Elizabeth's favourite, the Earl of Essex, whom she later had executed. The setting is not that of a neat and orderly Elizabethan garden, but rather the edge of some wild woodland bowered with eglantine, the wild rose so often evoked by poets of the period to symbolise the agony of love. Such works as this helped to educate and refine the tastes of those who read the poems, and gradually a new sensitivity to the beauty of nature began to emerge. Little by little it became possible to regard the natural world as a place that could be beautiful rather than hostile.

This new sensitivity to nature can be seen again in another miniature, *Portrait of an Unknown Man, said to be Phillip Sydney*, by Isaac Oliver (c.1595). Phillip Sydney (if indeed it is him) was the greatest English poet of the Renaissance, and amongst the first to declare that "all painting is poetry." Isaac Oliver, originally from Rouen, but who had travelled and studied in the Low Countries and in Italy, was well placed to convey this new and revolutionary vision. His sensitive depiction of the background, to which the medium is ideally suited, shows his willingness to achieve an unprecedented degree of realism. The miniature shows quite clearly that Oliver had a reasonable grasp of perspective, and also an awareness of the work of continental European painters since the Italian Renaissance.

Despite their evident beauty, these two miniatures did not presage the development of a school, and it was to be by different routes that a school of English landscape painters began to evolve during the second half of the 17th century.

ISAAC OLIVER.
PORTRAIT OF A YOUNG MAN, SAID TO
BE SIR PHILIP SIDNEY
*c.1595. Vellum laid on a playing card.
11.7 x 8.3 cm. Royal Collection, Windsor
Castle.*
In a quiet way this miniature marks the advent of Italian style representation in England. This new awareness manifests itself, perhaps, at the expense of poetry, though various authorities have identified the unknown sitter as Sir Philip Sidney, the greatest poet of his age.

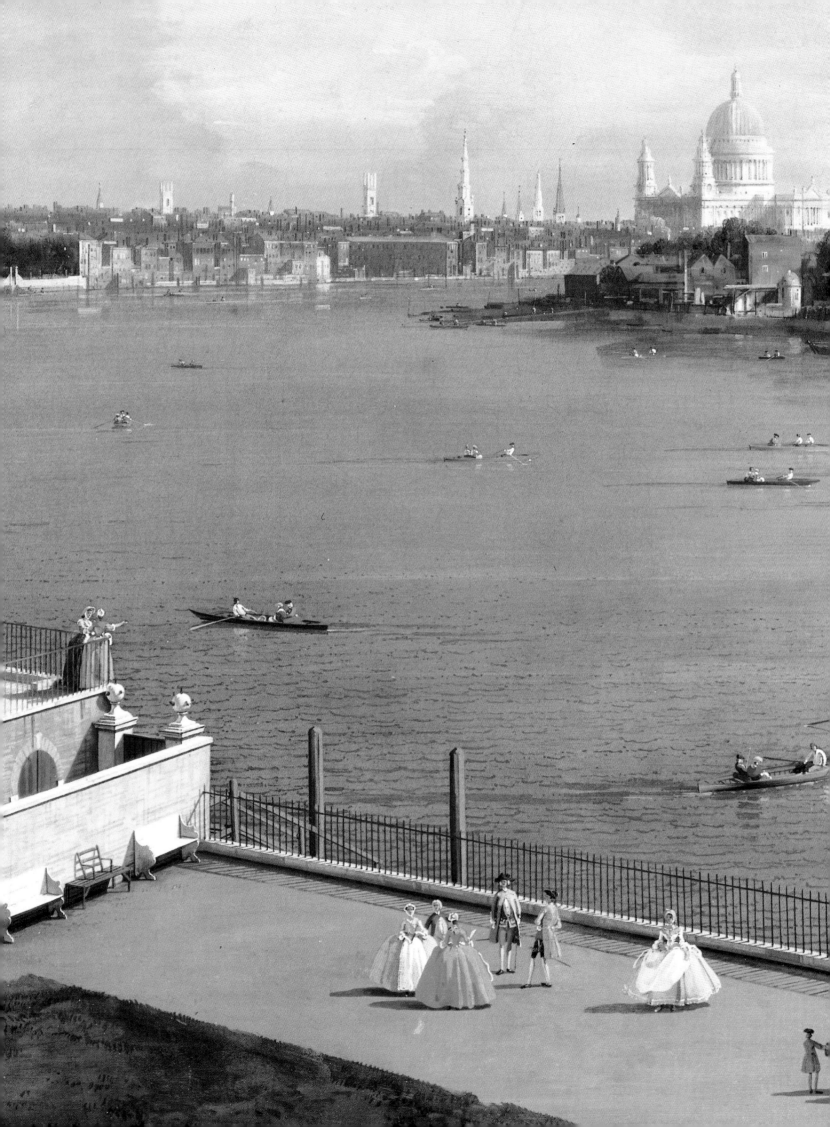

STIMULATION
FROM ABROAD

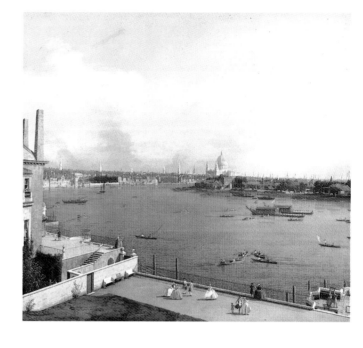

CANALETTO.
A VIEW OF LONDON FROM RICHMOND
HOUSE.
1747. Oil on canvas. 105.4 x 116.8 cm.
Goodwood House. Sussex.

In Britain the 17th century was punctuated with dramatic and often tragic episodes, most particularly the Civil War, which culminated in 1649 with the execution of King Charles I. Charles I, the last monarch to believe in the 'divine right of kings', was one of the greatest collectors that the world has seen, and assembled the most famous collection of paintings in Europe. The Commonwealth, which was established in the wake of the war, brought the Puritan leader, Oliver Cromwell, to power. He proceeded to wage an implacable vendetta against royalty, and much of the royal collection was dispersed at that time. Not surprisingly, during the Commonwealth, artists in general adopted a low profile, and the gentle art of landscape was barely practiced in England.

However, for much of Europe, the 17th century was a golden age and landscape painting and portraiture flourished, especially in the Low Countries. Prior to the Civil War, and again after the restoration of the monarchy, many Dutch and Flemish painters came to England, and, amongst other things introduced the word 'landscape', derived from the Dutch 'landschap' into the English language. The two most important visitors were Rubens and Van Dyck. Rubens was invited by Charles I and came to England in 1630; at this point in his career he was mainly painting portraits and allegorical scenes, and his major commission was the ceiling of the Banqueting House in Whitehall. His landscapes all date from the following decade after he had returned home.

Nevertheless he played an indirect role in the development of the English landscape school as an inspiration for later generations of painters, Gainsborough especially.

Sir Anthony Van Dyck lived in London from 1632 to 1641, with only a couple of interruptions. Having already attained the peak of his career he was welcomed like royalty and treated like an equal, even at court. Charles I, who enormously admired his talent, spared no effort in his attempt to retain him; he assigned him grand lodgings near the palace and appointed him "Principal Paynter to Their Majesties". Both the king and the queen were regular visitors to his studio, and during these years in London he painted many great portraits. Sadly, though, this was brought to an end when, one December day in 1641 Van Dyck fell gravely ill and died at the age of forty two. Although a portrait painter without equal he also made a small contribution to the development of landscape with several watercolour studies of woodland scenes, which show him to have been an innovator in the medium, capable of exploiting it fully. Spontaneity, freshness and transparency are the obvious hallmarks of these idyllic scenes.

Other, less well known, artists also came to London. The Czechoslovakian artist, Wenceslas Hollar, arrived in 1637, having previously worked in many of the great cities of Europe. His very precise drawings, showing something of the Dutch tradition, such as his *View of the Tower of London** are valuable documents recording the buildings which existed prior to the Great Fire of London in 1666. His detached way of recording the world around him is at the heart of the English topographical tradition.

The Flemish artist, Jan Siberechts, came to London about 1675. His grand and ambitious landscapes in the Dutch manner, mostly painted in oils, show an appreciation of light and colour that is both gentle and luminous. A quality previously unknown in England. His *Landscape with Rainbow. View of Henley-on-Thames* (c.1690)* is animated with figures and cattle, which gave him the opportunity to introduce accents of pink and grey in the foreground. This extra element enabled him to give a depth and substance to the landscape, which sets it apart from the linear drawings of Hollar and the other topographers. On the strength of this development, several historians have given Siberechts the credit of being the true father of the English landscape tradition.

BETWEEN SKY AND SEA — MARINE ARTISTS

William Van de Velde the Elder and his son, the younger William, scions of a dynasty of Dutch painters, specialised in depicting naval battles. The opportunities were numerous as Britain and the Netherlands were engaged in a bitter struggle for supremacy at sea, the key to commercial success.

During the war of 1652 the elder Van de Velde was the official Dutch painter recording the battles with the British navy, and to assist him in his work a special boat was put at his disposal. The precision of his drawings, often shaded in grey wash, is admirable. Amazingly, in 1673, in the middle of the third Anglo-Dutch war, he changed sides, and both father and son were appointed official painters to the English crown. By now the younger William

WENCESLAS HOLLAR.
THE TOWER OF LONDON.
Pen and brown ink with watercolour over black lead. 11.1 x 28.3. British Museum. London

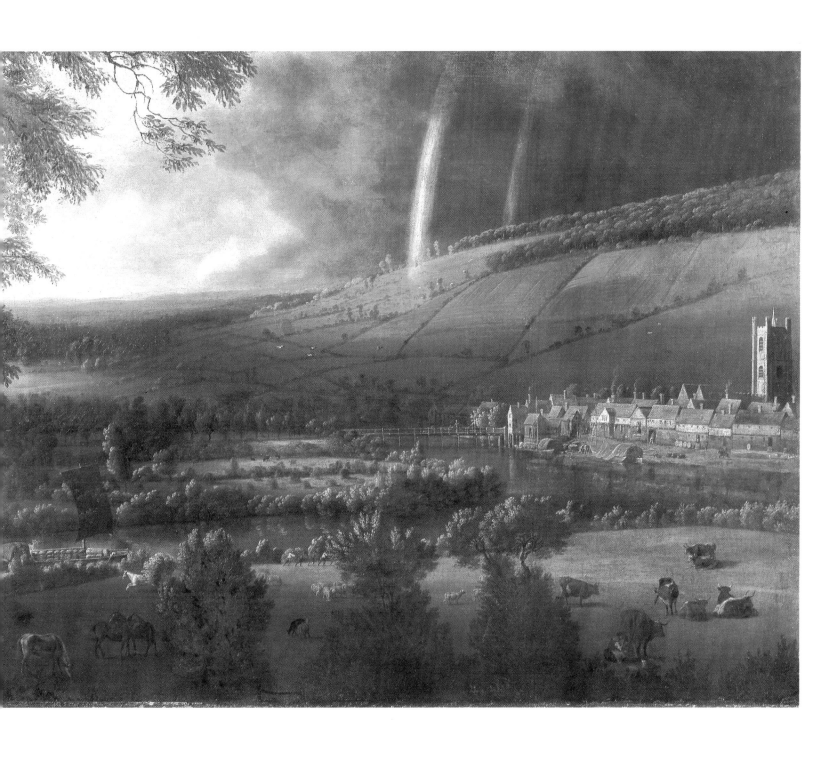

JAN SIBERECHTS.
LANDSCAPE WITH RAINBOW, HENLEY-
ON-THAMES.
c. 1690. Oil. Tate Gallery. London.

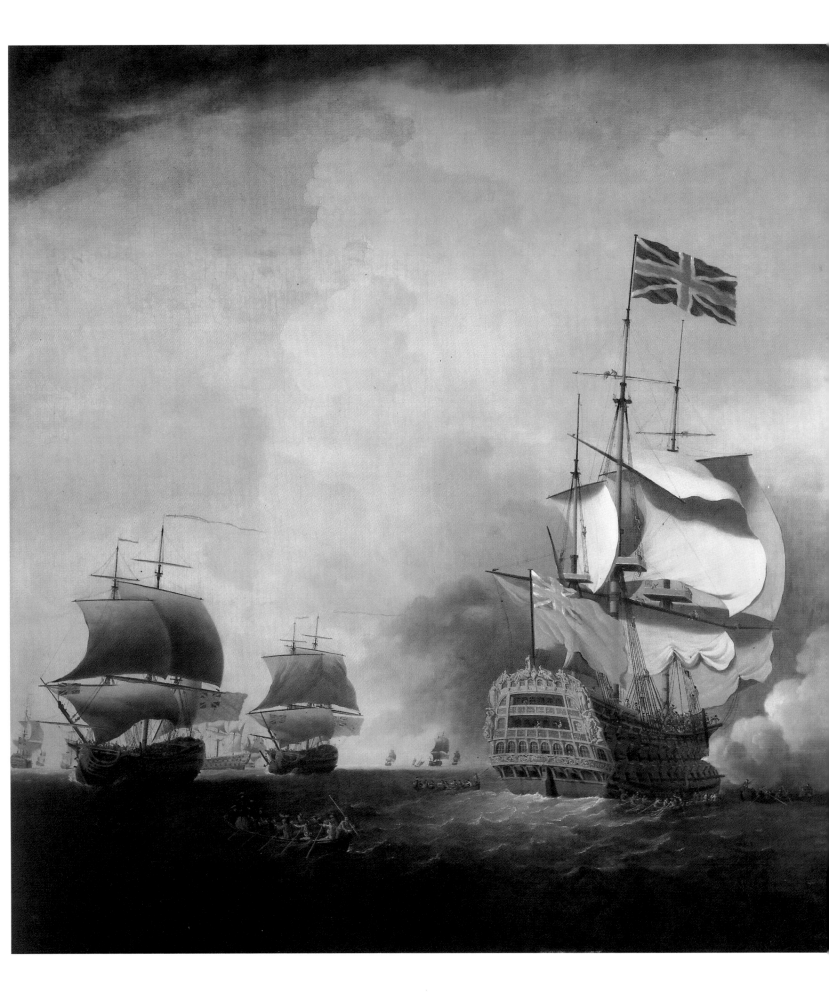

displayed such technical skill that he was able to give an immediacy to his pictures that makes them positively lifelike. In his work, the relationship of sky and sea take on new importance as he captures the play of light and shadow on the water, whilst canons belch forth fire and smoke in the heat of battle. By the subtlety of his composition he managed to transmit the feeling of these great sailing ships held hostage by the elements, whether in imminent danger from great storms or becalmed and unable to move.

The tradition of marine painting, introduced into England by the Van de Veldes, has never been interrupted. Amongst those who followed on one should particularly note Peter Monamy and Charles Brooking, but above all, Samuel Scott, who, during the early part of his career, painted some splendid shipping pictures such as *A First-rate Shortening Sail**.

ITALIAN CHARM

As heirs to a great tradition, Italian artists found a ready market for their works in England during the 18th century.

Since 1720, a steady stream of British aristocrats and wealthy young men had toured Europe, but most particularly Italy, as they made the 'Grand Tour'. The Grand Tour was the name given to a peripatetic journey of roughly a year's duration, during which these young men of the world visited the birthplaces of classical culture. It was the almost obligatory finale to every gentlemen's education. However, in 1740 the War of the Austrian Succession put a stop to this practice for the best part of a decade, which had the effect of making Italian landscapes even more desirable in the eyes of those deprived of the chance of visiting the country itself. In addition to this yearning for Italy, Italian landscapes had become the height of fashion and were seen as symbols both of status and culture, thus becoming the ideal decoration for the country houses of aspiring young aristocrats. At its peak this demand for everything Italian had an adverse effect on the livelihood of several good British artists, such as Richard Wilson, whose works were ignored because they themselves were not Italians.

Salvator Rosa, the most sought after Italian artist of his day, never actually came to England, but his landscapes became an important commodity in the commercial dealings between the two countries. His landscapes, painted well before the beginning of the Romantic Movement, thrilled their audience with their idealised and visionary interpretation of nature. Many other artists, however, did come to London.

Antonio Joli, who had made his reputation in Italy as a theatrical scene painter, worked in England from 1744 to 1750 both in the theatre and also decorating the new palladian villas being built around London by men of taste. Joli's landscapes are full of charm, though their generally hazy atmosphere is in the direct tradition of those pot-boiling Italian scenes churned out by the score.

Francesco Zuccarelli was introduced into English society by John Smith, the British consul at Venice. He made two prolonged visits to London, 1752-1762 and 1765-1771, during which he produced and sold a large

SAMUEL SCOTT.
A FIRST-RATE SHORTENING SAILS.
Oil on canvas, 228 x 219.7 cm.
National Maritime Museum, Greenwich.
The Union Jack, which flies from the masthead of the largest of the ships, indicates the presence of an admiral on board. Samuel Scott, working here in the Dutch tradition, succeeds through his use of light and atmosphere, in bringing an appropriate sense of foreboding to the scene.

BALTHAZAR NEBOT.
VIEW OF THE GARDENS AT HARTWELL
HOUSE, BUCKINGHAMSHIRE.
*1732-1738. Buckinghamshire County
Museum, Aylesbury.*

THE BOWLING GREEN AND OCTAGON
POND TO THE NORTH, WITH AYLES-
BURY CHURCH IN THE DISTANCE.
Oil on canvas, 80. 5 x 101 cm.

IN THE WILDERNESS, WITH VARIOUS
GIBBS TEMPLES IN THE DISTANCE.
Oil on canvas, 70.8 x 91.5 cm.

amount of work. Although his paintings were stylish, they tended to be much too sweet and his reputation was considerably over-inflated, which led to his paintings being chosen, usually unjustifiably, in preference to those of his English contemporaries.

John Smith was also the intermediary who introduced the work of Antonio Canal, known as Canaletto, to the English nobility, who supported him and purchased more than half of his entire life's output. Initially he painted typical tourist views of Venice, which he sold in great numbers to his English patrons. Fortunately, though, this extraordinary Italian topographical painter decided to come to London; he made two extended visits to the English capital between 1746 and 1755. His views of London are imbued with a luminosity and classical elegance reminiscent of his southern homeland. During his first visit the Duke of Richmond purchased two of Canaletto's greatest works: *View of Whitehall and the Gardens* (1746) and *A view of London from Richmond House* (1747)*. In this latter painting the scene swells out beneath a clear blue sky to embrace the whole expanse of the Thames, to which the artist imparts some of that indefinable beauty and atmosphere more readily associated with the Venetian lagoon.

Canaletto spent the best part of ten years altogether in London, and painted many landscapes, which he sold to eager patrons, but he never again quite achieved the magical quality of the Duke of Richmond's two masterpieces.

Whilst Canaletto brought to England an Italian elegance of vision, Balthasar Nebot, first mentioned as being in London in 1729-1730, owed his austerity and formal approach to landscape to his Spanish origins. In his paintings of *The Gardens of Hartwell House* (1732-1738)* he displayed his talent for animating rigidly geometrical perspectives with people and imparting to them a sense of ease and natural movement. His paintings reveal particularly the growing attraction which carefully landscaped parkland had for a public which was beginning to appreciate the beauty of nature.

SAMUEL SCOTT UNITES THE TWO TRADITIONS

As we have already seen, during the first half of his life Samuel Scott devoted himself to marine painting in the manner of the Van de Veldes, and his scenes of naval battles show him to be an artist of considerable talent. However, from 1746, the year of Canaletto's arrival in England, it is with the work of this artist rather than that of the Van de Veldes that his paintings must be compared. He brought to the cityscape the vision of a true Londoner, as can be seen in a series of paintings, destined to be bought by those same aristocratic collectors, whose tastes had been refined by contact with the works of the Italian master. Some of these paintings such as *The Entrance to the Fleet River** or the more formally classic *An Arch of Westminster Bridge* (Tate Gallery) reveal the hybrid character of their ancestry. In his life, as in his art, Scott was a living example of the two principal sources – the Dutch and the Italian – which together brought about the birth and inspired the development of the English landscape tradition.

SAMUEL SCOTT.
ENTRANCE TO THE FLEET RIVER.
c. 1750. Oil on canvas,
58.4 x 111.7 cm.
Guildhall Art Gallery, London.
A London view in the direct tradition of
Canaletto. The Fleet is now no longer
visible, being entirely underground.

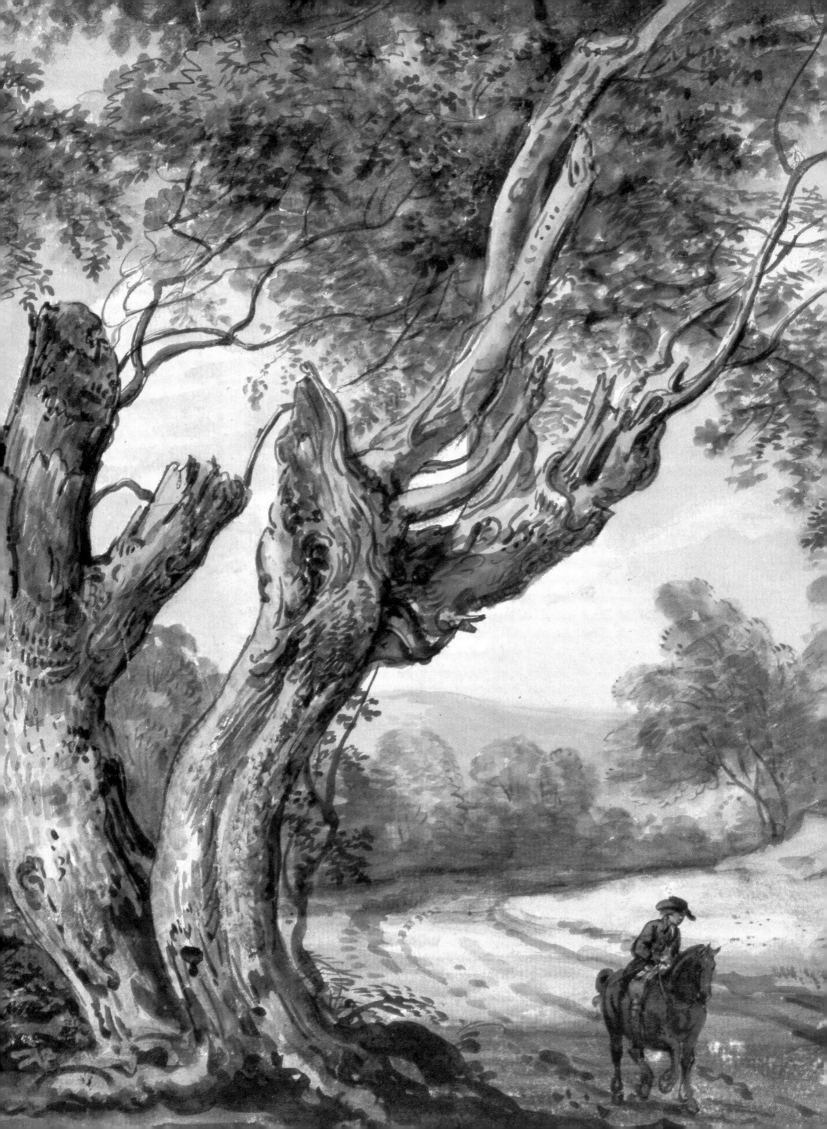

THE TOPOGRAPHICAL TRADITION
AND THE SEARCH FOR BEAUTY

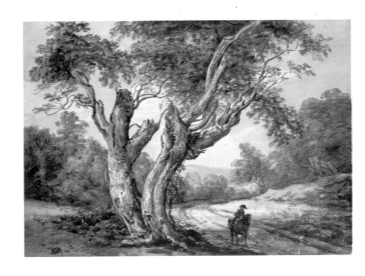

I n the middle of the 18th century English landscape painters were divided into two schools; on the one hand there were the large number of topographical artists, who had chosen the path of Hollar and his followers, whilst on the other there were those inspired by the idealised vision of Claude Lorrain. This division was already apparent at the time, and was commented on by Gainsborough in a letter of about 1762. Lord Hardwicke wished to commission a view of his country house; in declining the offer Gainsborough set out his ideas on topography thus: "With respect to real views from Nature in this country, I have never seen any place that affords a subject equal to the poorest imitations of Gaspard or Claude." (The paintings of Gaspard Dughet, brother-in-law of Nicholas Poussin, were greatly admired in England). Gainsborough, however, went on to suggest that Lord Hardwicke should approach Paul Sandby for the type of work he had in mind.

In those days, long before the invention of photography, topographical draughtsmen, whose work was detailed and true, were assured of a good living as their drawings were always in demand for publication. Through the medium of engraving their works were used to illustrate the numerous guidebooks and tourist albums, which catered for the tastes of a burgeoning bourgeoisie, hungry for an almost unending supply of cityscapes and studies of ancient buildings, monuments and rural scenes. During the later part of

PAUL SANDBY.
ROADWAY THROUGH WINDSOR
FOREST.
c.1790-1800.
Watercolour and ink on white paper.
37.5 x 55.2 cm.
Victoria & Albert Museum. London.

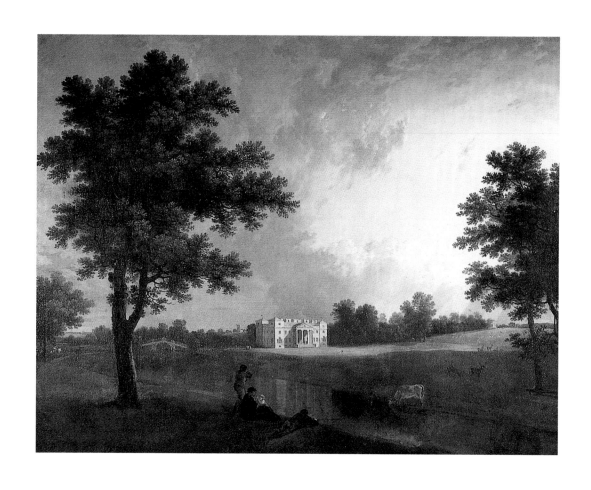

RICHARD WILSON.
CROOME COURT, WORCESTERSHIRE.
1758-1759. Oil on canvas, 129.5 x 165 cm. Birmingham City Art Gallery.
A fine example of the way in which Wilson handled the topographical views, which he had to paint after 1758 in order to earn a living.

the 18th century this market was exploited by a large number of topographical artists, and, even into the 19th century, major artists such as Turner did not despise the genre. For many members of the aristocracy, like Lord Hardwicke, who wished for views of their country seats to show to their metropolitan friends, watercolours were relatively inexpensive. However, the richer landowners preferred to have oil paintings by well known artists. Richard Wilson adopted this role in order to earn a living, and even Constable, when he was commissioned to paint *Wivenhoe Park* (1816, National Gallery, Washington) grumbled heartily at the number of finicky details that he was expected to include.

TOPOGRAPHY RAISED TO THE LEVEL OF ART

Gainsborough was right, Paul Sandby was by far the best topographical artist of his time. Paul Sandby, sometime partner of his brother Thomas, the architect, who left such remarkable projects as *The Bridge of Magnifence* (Collection of H.M. Queen Elizabeth II), which were full of light and life. Their contemporaries were fully aware of the capabilities of the Sandby brothers, both of whom were amongst the founding members of the Royal Academy in 1768.

The remarkable rise, both socially and professionally, of the two brothers was entirely due to their own talents. Their origins were modest. Born in Nottingham, they came to London about 1742, and found employment as military draughtsmen attached to the general staff at the Tower of London. Thomas later accompanied the Commander-in-Chief, the Duke of Cumberland, on some of his campaigns. Topographical drawing, which had to be accurate rather than beautiful, was essential for planning military campaigns, and developed as the purest form of this tradition.

Thomas Sandby was appointed Deputy Ranger of Windsor Great Park in 1765, and his brother, who was still living in London, visited him there frequently. Paul Sandby enjoyed these visits and looked at the countryside with a fresh and original eye, and it was at Windsor, with its great forest and ancient trees, that he found his profoundest source of inspiration. Receptive to the beauty and to the extraordinary diversity in appearance of these trees, he exploited the gnarled and twisted forms of their trunks and branches to produce fashionably picturesque watercolours such as *Road through Windsor Forest* (1790-1800)*. In 1770-1771 he travelled more widely, especially in Wales, in search of other picturesque localities, and he was amongst the first to exploit the new technique of aquatint when he produced the twelve plates for his *Views of Wales*. Superb draughtsman that he was, his watercolours are always alive with delightful and animated details. *Dragoons Galloping on Vanbrugh Fields, Greenwich* (1794, Victoria & Albert Museum) is an example of an otherwise uninteresting view brought to life by the rhythmic beauty of the scene.

However, even more important than his familiarity with nature and his mastery of the picturesque, it was his ability to capture the changing quality of light, which set him apart from his fellow topographers. As early as 1760 he

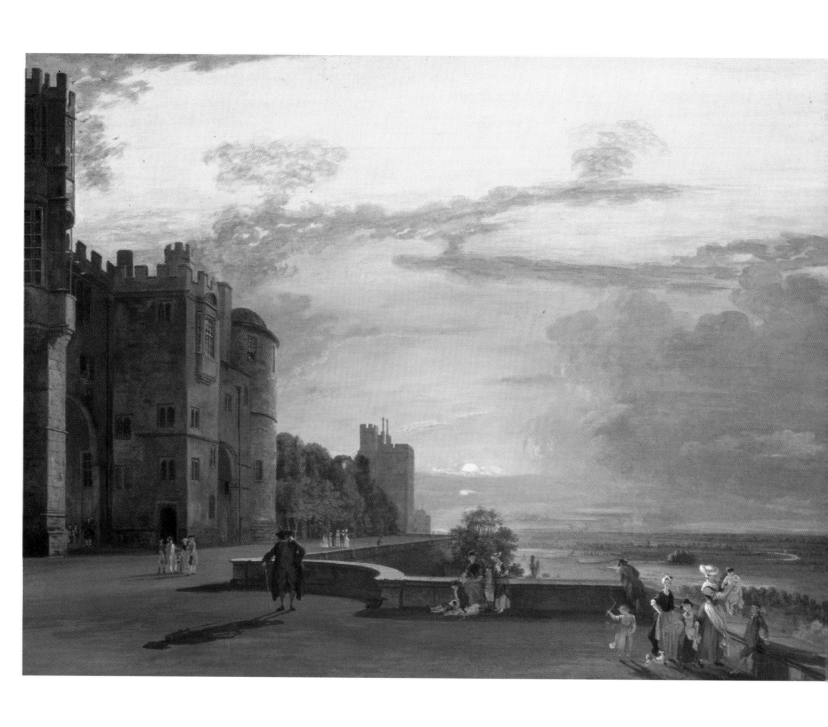

PAUL SANDBY.
WINDSOR CASTLE: THE NORTH TERRACE
LOOKING WEST AT SUNSET.
1770. Gouache on Mahogany Panel,
46.4 x 61.5 cm.
Victoria & Albert Museum, London.

was the first to use the term "watercolours" to describe his landscapes, rather than the more generally used terms of "tinted drawings" or "watercolour drawings". *Windsor Castle, the North Terrace looking West, at Sunset* (1770)* shows him at once more concerned with capturing the luminosity of the vast expanse of sky and the vivid colouring of the evening clouds than the architectural detail of the castle. This was an enormous step. At one bound he had moved the art of landscape painting from the preserve of the topographer to the point at which it could begin to address nature in all her guises. The eye, already attuned to the romantic vision, was now ready to respond to an even wider range of sensations.

SANDBY' CONTEMPORARIES

Some of the numerous 18th century topographical artists are still unduly neglected. It is worth looking at works such as Jonathan Skelton's sensitive view of *The Medway Near Sheerness* (1757)* and at William James's views of London, inspired by Canaletto. It is also well worth looking at Edward Dayes's watercolours. Dayes had been a pupil of Sandby's and, although less gifted as a colourist than his master, he was a virtuoso draughtsman.

Francis Nicholson tried to unite the topographical tradition with the picturesque, and is therefore slightly apart. However, when he was commissioned to paint the landscaped parkland at Stourhead with its carefully planted clumps of trees, its lakes and classical temples, he adopted a

JONATHAN SKELTON.
THE MEDWAY NEAR SHEERNESS.
1757. Watercolour over pencil.
25.7 x 57 cm. British Museum, London.
A landscape drawn by Skelton near
Rochester in Kent. The artist was on the
Archbishop of Canterbury's staff.

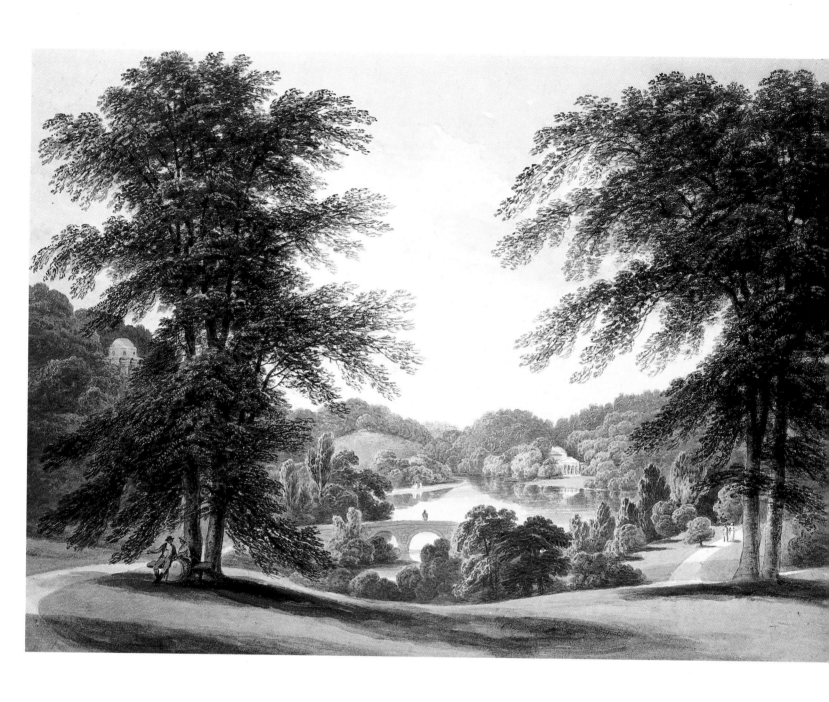

Francis Nicholson.
A View at Stourhead.
Watercolour over ink wash.
40.6 x 55.5 cm.
British Museum, London.
The landscaped park at Stourhead was
renowned for its classical temples and
grottoes sited around a lake.

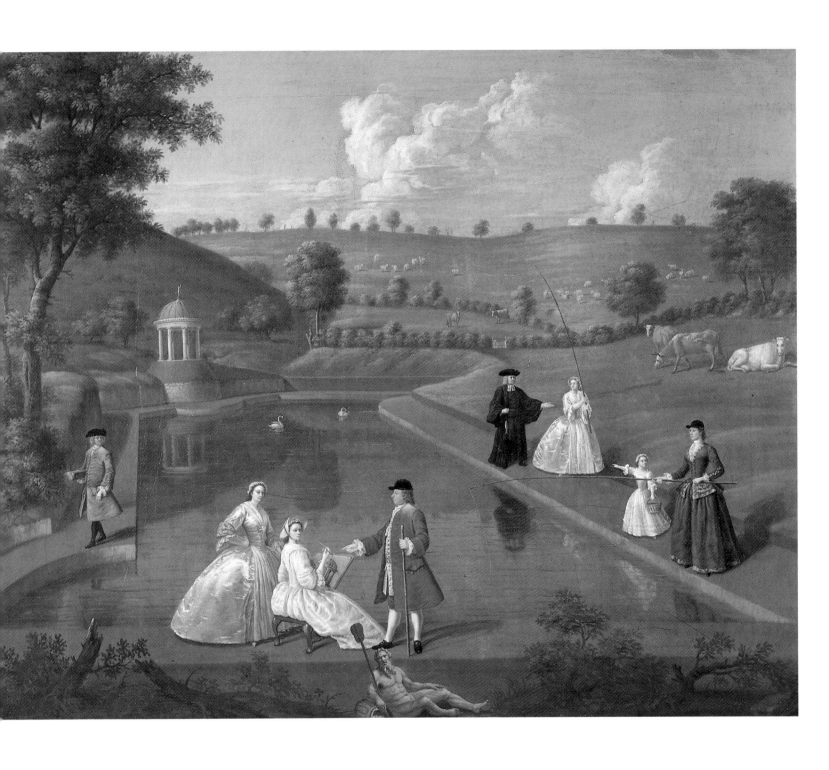

EDWARD HAYTLEY.
VIEW OF THE TEMPLE POND AT
BEACHBOROUGH MANOR.
1744-1746. Oil on canvas. 52.7 x 65 cm.
(one of a pair). National Gallery of
Victoria. Melbourne.

straightforward topographic approach, though even here his penchant for the picturesque is clearly evident as is born out by his *View at Stourhead**.

To facilitate their work, the topographical artists generally adopted a technique based on grey washes. This involved putting a thin initial wash right across the paper, which served as the ground, and then on top the artist would add in further washes of varying strength to define the shadows; or, conversely, he would lift some of the pigment to emphasise the highlights. It was only at this fairly advanced stage that he would then add touches of palish colour in the lighter areas. Edward Dayes in his *Instructions for Drawing and Colouring Landscapes* advocated the use of a Prussian blue wash for the sky and a brown one for the earth, both very diluted and meeting towards the middle of the paper. It was left to Thomas Girtin in about 1796-1800 to show his fellow artists how to use coloured pigments straight off without laying in the initial washes. This daring step constituted an enormous technical advance.

Alongside these topographical watercolourists one should also look at those artists who worked in oils. At the time it was considered considerably more ambitious to work in oils but some of these artists disappeared into almost total oblivion, and are only now beginning to be appreciated again. Joseph Nicholls, for instance, managed to combine an appreciation of the Dutch landscape tradition with the vision of a theatrical scene painter in his delightful scene of *The Fountain of the Middle Temple, London* (1738, Society of the Middle Temple), in which his remarkably naturalistic figures are clearly taken from life. One should also look more closely at the paintings of Edward Haytley, who, between 1740 and 1760, painted a number of conversation pieces, close in style to those of the better known Arthur Devis. In these works landscape was not an end in itself, but served as a topographical and slightly naive background to the people, who are the principal performers. Time seems to have stopped, and the figures are frozen in various attitudes, as in a snapshot, and it is this quality of innocence which adds considerable charm to paintings like Haytley's *View of the Temple Pond at Beachborough Manor* (1744-1746)*.

MARINE PAINTING

In Britain, marine painting has always been a speciality on its own, very traditional and inward looking. It has evolved gradually guided by its own peculiar rhythm. The precision of the topographers, and the use of grey washes, were both ideally suited to this kind of subject matter, with the result that this technique carried on being used by marine artists long after their land-bound counterparts had adopted more advanced methods. Robert Cleveley's *An English Man of War taking possession of a Captured Ship* (1783)* displays an effective marriage of the Dutch heritage of the Van de Veldes with the topographical traditions of the English, but it also shows a careful study of atmosphere, which is agreeably innovative.

Henceforth, the objective for the best painters would no longer be pedantic detail but the quest for beauty, which could be achieved through the atmospheric use of light and colour. Paintings were no longer documents, they were conscious works of art.

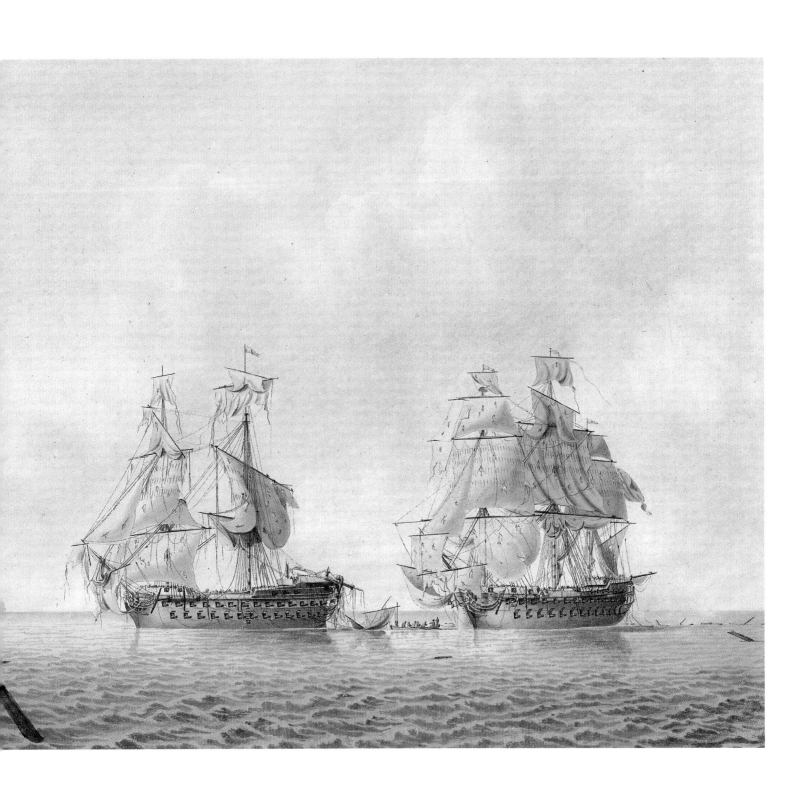

ROBERT CLEVELEY.
AN ENGLISH MAN-OF-WAR TAKING
POSSESSION OF A CAPTURED SHIP.
*1783. Watercolour and wash with pen
outlines. 34.3 x 50.5 cm.
Yale Center for British Art.*

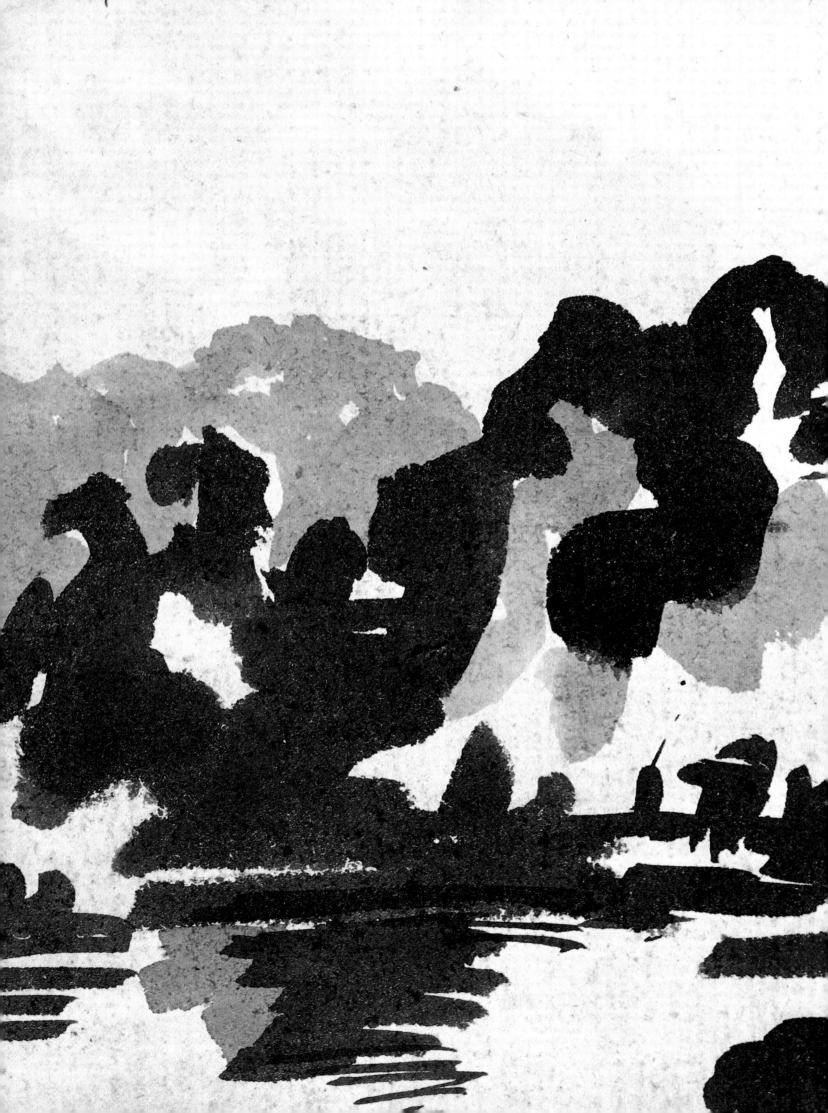

ALEXANDER COZENS
AND THE TRIUMPH
OF THE IMAGINATION

The character of Alexander Cozens is surprising and difficult to pin down. He was more a theoretician than a practitioner, and it was primarily through his writings that he influenced his contemporaries. In his bid to escape the limitations of detailed topography, the natural path for most draughtsmen of his day, he rejoiced in the supremacy of the imagination. "It is the power of art and invention which give pictorial beauty and strength of character to the works of a landscape artist. The composition and design of a landscape do not come from copying the specifics of nature; it is more than that," he wrote, and a little later he continued: "Too much time is spent in copying the works of others. And I do not hesitate to state also, that one risks spending too much time copying nature herself." He wrote this in 1785 when, shortly before his death, he set down in abridged form the beliefs that he had held since the 1750s. Through this credo, he was the first to imbue landscape with poetry and a sense of fantasy, and in this he prepared the way for the dawn of romanticism.

Some mystery has always shrouded his birth in St Petersburg in 1717, and it was rumoured that he was the natural son of Peter the Great. His real father was, however, employed there in building the Czar's navy. From his youth he had treasured some drawings by a Persian artist, Agamein, which have since been discovered in England; without this actual proof it would be difficult to judge precisely the importance of oriental art on his own work. He

ALEXANDER COZENS.
THE BANKS OF A LAKE.
Study in Indian ink, pages of a sketch-book. 14.5 x 19 cm.
British Museum London.

ALEXANDER COZENS.

"NEW METHOD".

Examples of Compositions of skies.
1784-1785.

Engraving, 11.3 x 16 cm.

Alexander Cozens was one of the first artists to become interested in cloud formations, as much for their meteorological concerns as for art. Joseph Wright of Derby and Constable both studied and copied some of the drawings from his *New Method*.

came to England in 1746, and from then, until his death in 1786, he earned his living as a drawing master and included the sons of King George III, and the fabulously wealthy collector, William Beckford, amongst his pupils. In the meantime he pursued his own studies as a draughtsman and theoretician.

In his last treatise, *A New Method of assisting the Invention in drawing Original Compositions of Landscape,* he expounded the idea of forsaking naturalism for invention, and advocated his belief that a sensitive mind could be applied to random impressions. His favourite working method was to drop blots of Indian ink haphazardly onto a sheet of paper, and then to create pictures by interpreting them. These random marks could be transformed into landscapes in fulfilment of the images which they evoked in the artist's imagination.

Cozens felt that the landscape artists of his day were shackled by the necessity to be faithful to nature, as, indeed, was the case with the topographers, and in order to liberate their full emotional and imaginative powers he offered them this key. Namely, the blot. Having successfully done this he established once and for all the superiority of the imagination over the commonplace; the power of artistic creativity over the mere recording of facts.

To illustrate his treatise Cozens engraved in aquatint *Sixteen Blots* of an indisputable beauty. The subtlety of his use of monochrome and their stylisation link them in our minds to the art of the Far East.

In the collection at the British Museum there is a touching little document: the exercise book in which Alexander Cozens traced the blots with the probable intention of teaching his son, John Robert, how to take advantage of this particular method of artistic creation. However, Alexander Cozens made it clear that these blots were not an end in themselves, but, as he had advocated in *A New Method,* merely a means of liberation, a stimulus designed to allow the imagination to take flight.

It is important at this stage to appreciate the direction in which Cozens's principles were leading, as he had opened up new possibilities for other artists. Following his instructions, it was no longer essential to concentrate on the careful delineation of the subject, a dry and restrictive discipline. The artist could now take advantage of the expanding blot of colour. Turner's colour beginnings were the logical conclusion of the path which Cozens had pioneered.

ALEXANDER COZENS.
WOODED LANDSCAPE.
Studies in Indian ink, pages of a sketch-
book. 14.5 x 19 cm.
British Museum, London.

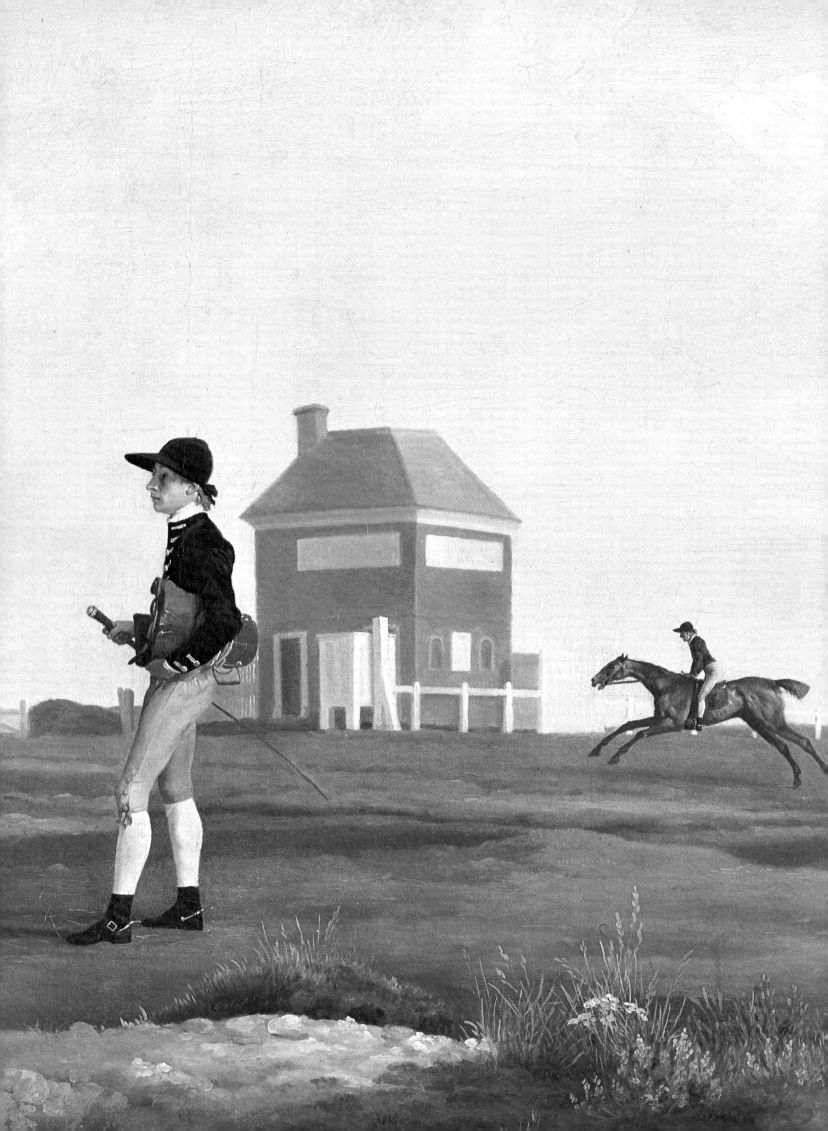

Hunting scenes
and rural life

Hunting as subject matter for English painting blossomed into its full glory during the 18th century, and part of the fascination which these scenes exert comes from the fact that they are set in beautiful countryside. The popularity of thoroughbred horses, whether at race meetings or in the hunting-field, was universal in Britain and reached a peak at this time, which it is difficult for us to appreciate. It has been pointed out that engravings after portraits of celebrated race horses circulated as widely as those of members of the royal family!

In England during the 18th century the grand families, on the whole, lived on their estates in the country, but kept a house in London for the season, and whilst in the capital liked to have portraits around them, not only of their families, but also of their horses. Scenes of horses exercising became popular, because they gave the patron not only the chance to boast of his favourite mares, but also to show off views of his estates. Right in the middle of the century, 1750, the famous Jockey Club was founded by a group of young bloods, with the result that some painters, who had previously found it difficult to make a living by portraits, discovered a new outlet for their skills. Newmarket, not far from Cambridge, became the main centre for training, and it was there that the earliest horse portraits and racing scenes were set.

GEORGE STUBBS.
GIMCRACK ON NEWMARKET HEATH,
WITH A TRAINER, JOCKEY AND A
STABLE-BOY.
c. 1765. Oil on canvas,
101.6 x 193.2 cm. Private Collection.
Gimcrack appears twice in this painting, once standing at rest with his trainer and again in the distance galloping with the other horses. The building on the left, which appears in several of Stubbs' paintings, is the rubbing-down house.

THE REFINEMENT OF JOHN WOOTTON

John Wootton was amongst the first artists active at Newmarket. Although his precise date of birth is not known, it is generally believed that one of the figures included in his painting, *The Warren Hill* (1715, Wimpole Hall), is a self-portrait. *The Warren Hill* is set at Newmarket on the day of one of the great races, and included in the foreground of the painting is the figure of a young artist sketching. Wootton, who always drew from life, would have been happy to benefit from this discrete publicity. However, he was considerably more than a mere painter of animals and set his more ambitious hunting scenes in idealised views of the English countryside.

He is reputed to have worked as a young man, between 1690 and 1700, in the studios of the great topographical artist, Jan Siberechts, and of Jan Wyck, the painter of battle scenes; both artists of Dutch origin, from whom he would have learned the traditions of the Low Countries. It would, probably, have been for the battle scenes that he started to study and paint horses.

Without doubt, Wootton's best paintings are those same hunting scenes, in which he was able to give full rein to his enjoyment of painting etherealised landscapes in the manner of Poussin and Claude Lorrain. This love of the ideal, which came naturally to him from the outset of his career, was re-inforced in the early 1720s, when he visited Rome and saw the works of the Italian masters at first hand, and, as Richard Wilson was to do a generation later, succumbed quickly and easily to their charms. Returning to England he was faced with the virtual impossibility of earning a living as a landscape painter, so he siezed upon field sports, especially hunting, as the perfect subject which enabled him to pursue his favourite genre, and at the same time asssured him a ready supply of patrons. Thus, twenty years before Wilson, Wootton became the first painter to classicize the English landscape. He taught George Lambert and was a direct influence on Gainsborough.

The Duke of Beaufort's Hunt (1744)* demonstrates clearly that he was capable of rising well above the simple horse portrait to successfully depict an animated scene set comfortably within the overall composition. In 1730 the poet, Alexander Pope, considered him the best landscape painter in England, but during the 19th century his reputation declined almost to vanishing point.

GEORGE STUBBS AND SCIENCE

For the next generation, hunting scenes and animal painting were dominated by the strong personality and extraordinary skill of George Stubbs. Unfairly, and certainly wrongly, Stubbs was classified merely as a "painter of horses", which designation failed totally to appreciate the thrust of his work and of his commitment. His love of nature and his passion for anatomy were at the root of this misunderstanding. From the beginning of his career, he divided his time between portraiture and anatomical dissection, which study he intended to use to illustrate a treatise on obstetrics. Whilst other artists

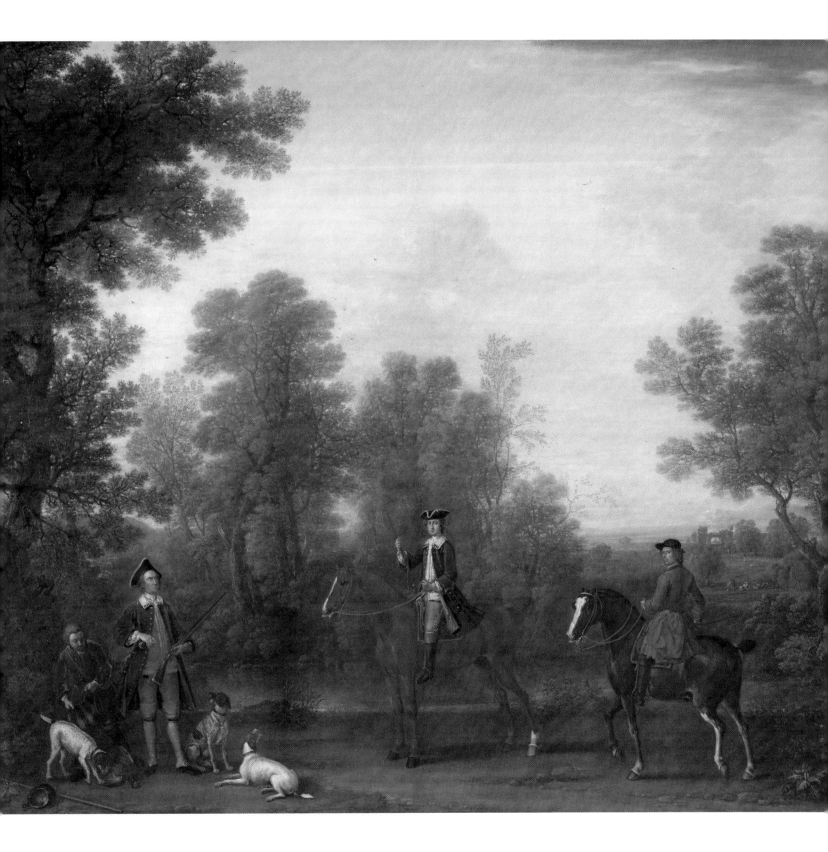

JOHN WOOTTON.
THE HUNT OF THE DUKE OF BEAUFORT.
1744. Oil on canvas.
Tate Gallery, London.

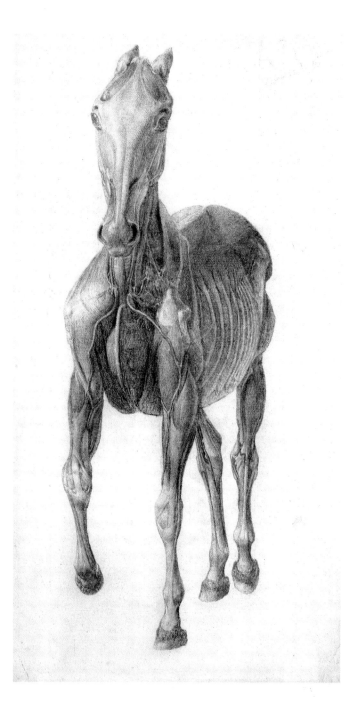

GEORGE STUBBS.
STUDY OF A HORSE DURING DISSEC-
TION: FINISHED STUDY FOR THE
SEVENTH ANATOMICAL TABLE.
Pencil on paper, 35.6 x 17.8 cm.
In these remarkably accurate drawings
Stubbs depicts the thickness of every
muscle.

learnt to draw from the plaster cast, he studied nature. He did, however, visit Italy in 1754, but he hurried home proclaiming that the experience "had convinced him that Nature was superior to art, be it even Greek or Roman." He decided therefore that nature in all her forms, including man, would be his chosen field of study and that he would examine her with the eye of a scientist. Soon after his return from Italy he embarked on his great treatise on *The Anatomy of the Horse*. He worked at it with frenetic energy for eighteen months during 1758 and 1759, shut away with his mistress on an isolated farm in Lincolnshire, in order to be able to carry out the necessary dissections without interruption and in his own time. Carcasses of horses were suspended in life-like attitudes in his studio. He removed layers of flesh and muscle until he reached the skeleton, drawing with exemplary precision the veins and tendons which he revealed, quite unmoved by the butchery which surrounded him or by the sight of the skeletons prancing about in some sort of *dance macabre*. Sometimes he worked for weeks on the same carcass in complete disregard of hygiene. As a tanner's son he had grown up with the stench of rotting flesh, and remained oblivious to it.

This treatise, for which he engraved thirty six plates, had an immediate success and made him a celebrity throughout Europe. However, he also became a prisoner of this success as, from now on, he became known as a "painter of horses", despite the fact that he had never worked at Newmarket. In response to the stream of commissions, which came his way as a result, he began to paint a number of horse portraits and hunting scenes. In 1760 he was the guest of the Duke of Richmond at Goodwood House, for whom he painted three great hunting pictures, and then, in 1762, he painted the celebrated picture of *Lord Grosvenor's Hunt*.

In these paintings he did not just depict aristocratic equestrians in idealised bosky settings, as Wootton had done: his landscapes derive their force from the exactness of his observations. This observation far exceeded mere, straightforward, visual transcription of the world around him, as Stubbs always wanted to bring out the plastic qualities of everything he painted by emphasising volume. In concentrating on the curves and contours he wanted to make an architectural statement and to enhance the monumentality of the composition. His colour, which, in general was rather low-keyed, sings out from the monochrome underpainting of his canvases more effectively than would the use of strident colours, strong contrasts or heady Venetian harmonies, and at the same time he was able to render the impression of movement. In order to capture the sense of the abrupt halt and bloody finale, following the headlong dash of horses and hounds, in *Lord Grosvenor's Hunt*, the participants are depicted as a surging mass grouped around the powerful form of the twisted tree which dominates the scene. The distance and middle ground appearing as a series of strong and majestic horizontals, very sculptural, act as a counterpoint to the swirling and undisciplined movement of men and beasts, thus containing them within a stable framework.

In the three canvases at Goodwood House, and especially in *The Third Duchess of Richmond and her sister-in-law, Lady Louisa Lennox, watching race-horses exercising on the South Downs* (1759-1760)*, the landscape is more

GEORGE STUBBS.
THE GROSVENOR HUNT.
1762. Oil on canvas, 149 x 241 cm.
Collection of the Duke of Westminster.

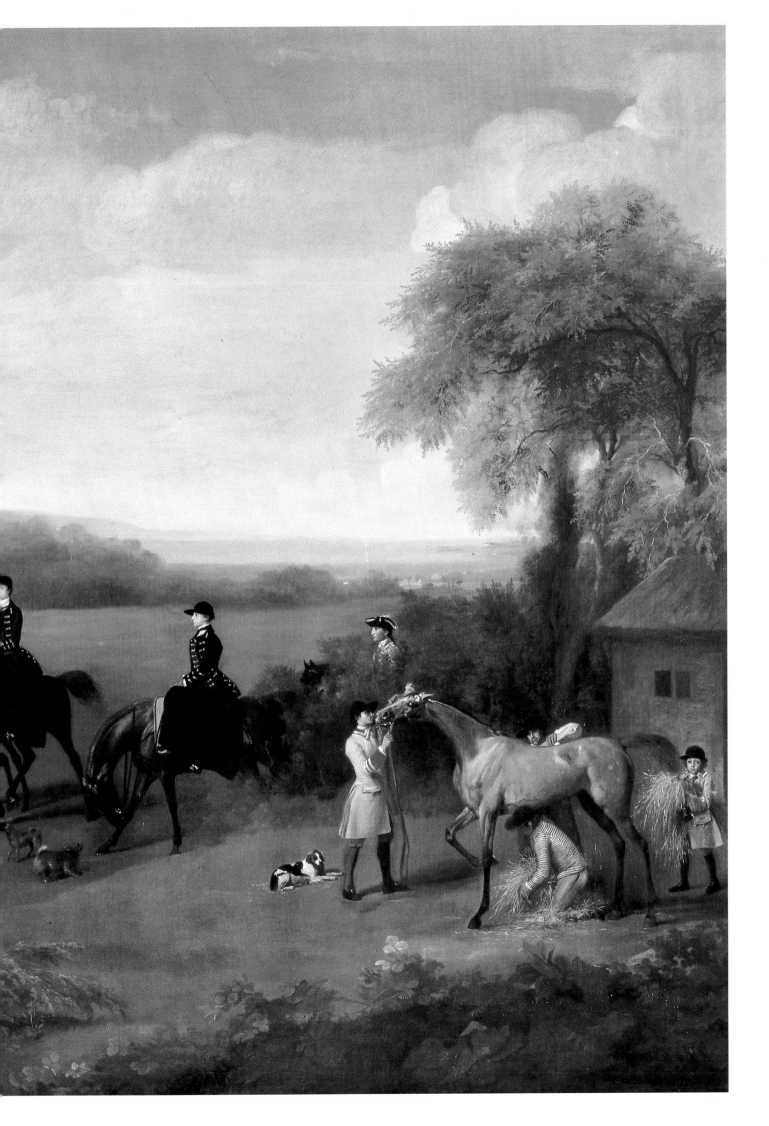

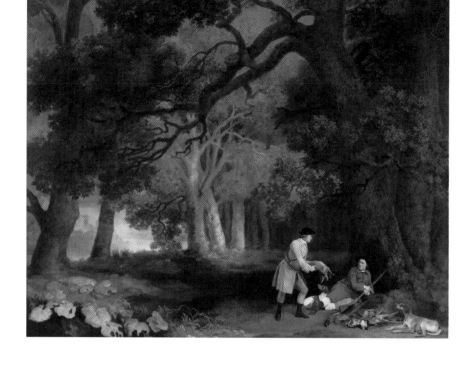

GEORGE STUBBS.
A REPOSE AFTER SHOOTING.
1770. Oil on canvas, 90 x 124.5 cm.
Yale Center for British Art.
In addition to depicting the feeling of
weariness at the end of the sportsmen's
day, and the dead game, Stubbs has
captured the air of mystery as night falls
within the forest.

Previous pages

GEORGE STUBBS.
THE THIRD DUCHESS OF RICHMOND
AND HER SISTER-IN-LAW, LADY LOUISA
LENNOX, WATCHING HORSES EXER-
CISING ON THE SOUTH DOWNS.
1759-1760. Oil on canvas,
127.6 x 205.1 cm.
Goodwood House, Sussex.
The horses that are beginning to gallop
carry the scarlet and gold racing colours
of the Duke of Richmond.

varied. Although it is scattered with luxuriant clumps of trees it opens out in the centre to reveal the beautiful cathedral town of Chichester, and to give a distant view of the Isle of Wight. Every detail of this rural scene is imbued with the limpid quality of a glorious spring morning; around the central group the rhythmic movement of galloping horses is balanced by the band of grooms lavishing attention on the horse to the right. Each of these three motifs, filling about a third of the canvas, could form a picture on its own, but the landscape and pervasive atmosphere act as connecting links, in that masterly way Stubbs had of using such effects to unify his compositions.

After the grand hunting scenes of the Duke of Richmond and Lord Grosvenor, Stubbs painted a set of four rather more prosaic paintings showing two English yeomen tramping the countryside, shotguns slung over their shoulders, in search of game. The last of these canvases, *Repose after Shooting* (1770)*, set in the gloom of the evening, recalls the earlier successes of the day. The two satisfied but weary sportsmen are illuminated by the last warm glow of sunshine, whilst behind them the woodland, deep in shadow, takes on an almost ritualistic role as it casts its pall over the dead game laid out upon the ground: evidence of the day's slaughter. In some ways this painting can be seen as a precursor of the canvases of wild animals that he was to paint in the following decade, and, despite his matter of fact acceptance of life and death, Stubbs begins to hint here at deeper feelings for the mysteries of nature.

At this time Stubbs also painted pictures of *Mares and Foals* and of *Wild Beasts*. Each work is notable for the way in which landscape serves not only as background, but also sets the tempo and reflects the mood of the

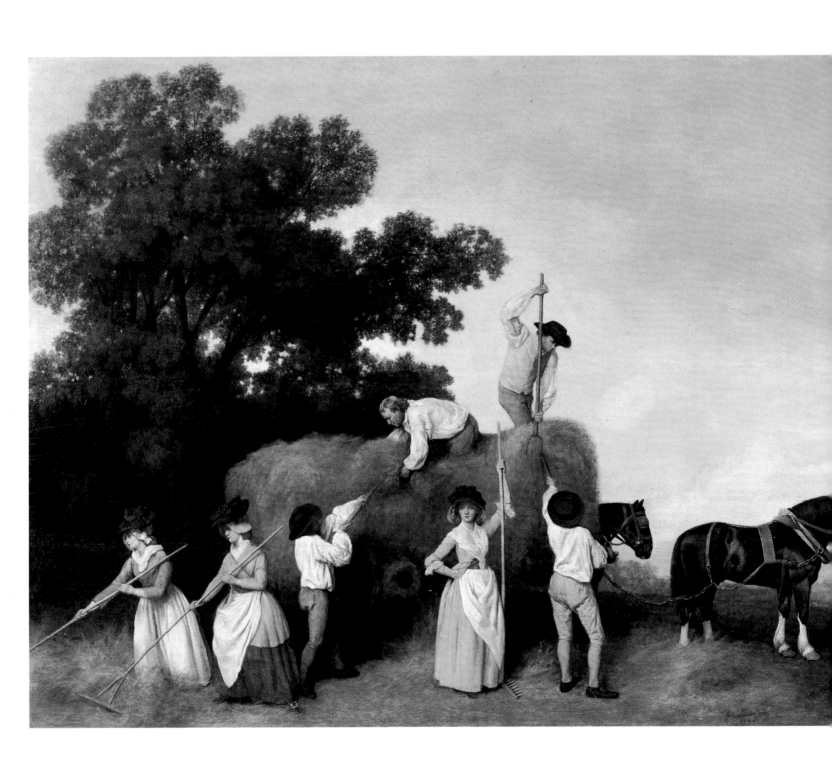

GEORGE STUBBS.
HAYMAKERS.
1785. Oil on wooden panel,
89.5 x 135.2 cm. Tate Gallery, London.
Stubbs was always anxious to show that
he could paint subjects other than the
"portraits" of racehorses, which the
public expected of him.

subject. For his paintings of wild animals, and the scenes in which lions attack horses, it is a feeling of terror, or at least of apprehension, which dominates. As one would expect, Stubbs depicted the animals with scientific precision, but the landscape settings gave his imagination full rein to invent and adapt. He created mysterious backdrops – rocky deserts or verdant forests bursting with luxuriant vegetation – deep and disturbing, with the disquieting overtones of nightmares, despite adhering firmly to his chosen path of describing everything factually, as in *Lion and Lioness* (Museum of Fine Arts, Boston). By contrast, in the paintings of mares and foals everything is suffused with sweetness and light, and the canvases become true celebrations of motherhood. Stubbs' compositions are carefully and cleverly thought out, and in these paintings he manages to combine the detached format of the sculptural frieze with the rhythm and continuity of links in a chain. In a tranquil landscape, such as we see in *Mares and Foals beneath Large Oak Trees* (1764-1768, Collection of the Princess Royal), the sun plays over the whole canvas, embracing the great tree trunks and the little houses in the distance, and uniting them into one glorious composition.

Stubbs never stood still, and virtually every decade found him tackling a fresh theme. Towards the end of his life, between 1785 and 1795, he concentrated on country people going about their work in time honoured fashion. For these works he summoned up all the resources of his art, the experiences of a lifetime, and invested these traditional country tasks with a sympathy and personal identification that was quite remarkable for the period. In terms of composition everything in these canvases is marked by a serenity and a grandeur, to which the setting and the people contribute in equal shares. The latter are harvesters or haymakers, who immediately identify the scene as taking place in the late summer, whilst the landscape, dominated by great trees, falls away in receding planes to a distant horizon. Subbs' debt to Dutch painting is unashamed and fits closely with his quest for realism. It is possible that he was directly inspired by the example of Albert Cuyp (1620-1691), whose paintings, having been neglected for years, were enjoying a considerable popular revival in England at this time. Despite the typically sculptural approach, which marked so much of Stubbs' work, one feels that in *The Haymakers* (1785)* he was making a conscious effort to achieve an effect of movement. This is especially noticeable in the pattern he created through the diverse angling of the women's rakes. No burst of colour interrupts the unity of the picture, the tonality of which is of that overall pastel hue, beloved by Stubbs towards the end of his life, and which helps to create a mood, if not exactly of eternity, at least of an enduring continuity. Despite the prosaic nature of the labour depicted in these seasonal country scenes, Stubbs treated them as though they were grand classical subjects, a point which was missed by most of his contemporaries, who scorned such work. Under-estimated during his life and quickly forgotten after his death in 1806, his paintings did not regain their full popularity until the second half of the 20th century, when they were once again hailed as being amongst the masterpieces of British art of the 18th century.

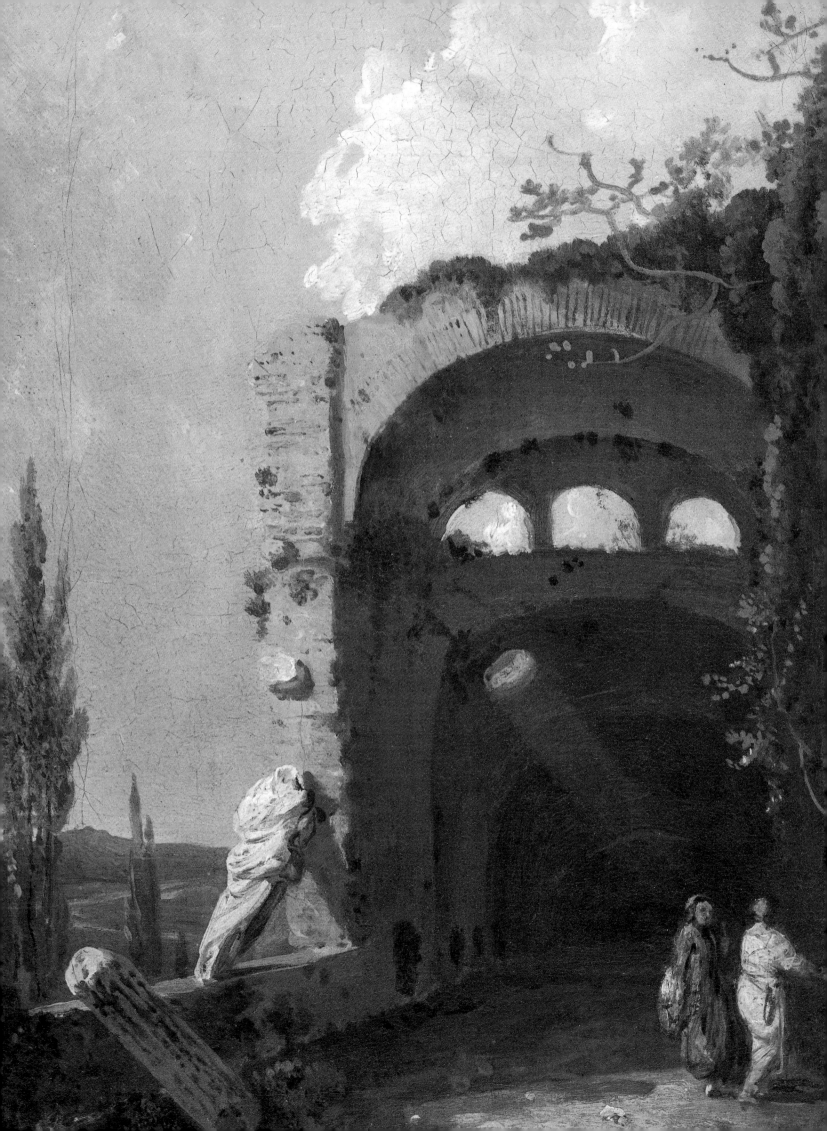

WILSON AND GAINSBOROUGH
DISREGARDED IN THEIR DAY

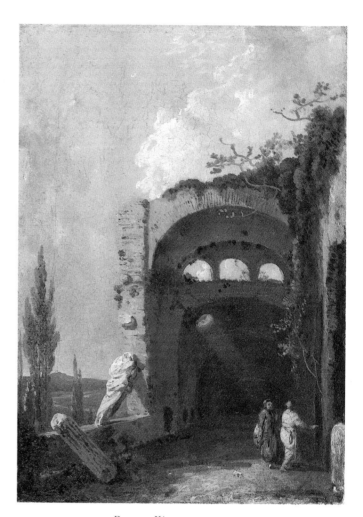

RICHARD WILSON.
MAECENAS' VILLA AT TIVOLI.
c. 1763-1765. Oil on canvas.
35.6 x 25 cm. Tate Gallery, London.
Within the framework of ruins it is the depiction of decaying grandeur that tells us that Maecenas was the greatest patron of the arts in Rome.

Almost total indifference and incomprehension were the general reactions against which the two greatest British landscape painters of the 18th century, Richard Wilson and Thomas Gainsborough, had to contend. Although Gainsborough was well known, and in great demand, as a portraitist, both he and Wilson were at a major disadvantage when it came to seeking patrons, or to selling their landscapes. They both bore unmistakably British names!

One English landscape painter, however, had managed to enjoy a modest success despite his name. This was Wootton's old pupil, George Lambert, who had practised as a scene painter in the theatre, and had produced a number of landscapes in the manner of Poussin and Gaspard Dughet. His views of English country houses rise well above straight topography due, principally, to the original way in which he depicted them.

WILSON AND THE CHARM OF ITALY

Richard Wilson was far more innovative than George Lambert, far more talented too. He achieved a degree of fame in the middle of the 18th century but found it very difficult to gain acceptance. However, with regard to the popular Italianate style, given his background, he was better placed than most of his contemporaries to benefit from it. As the son of a clergyman

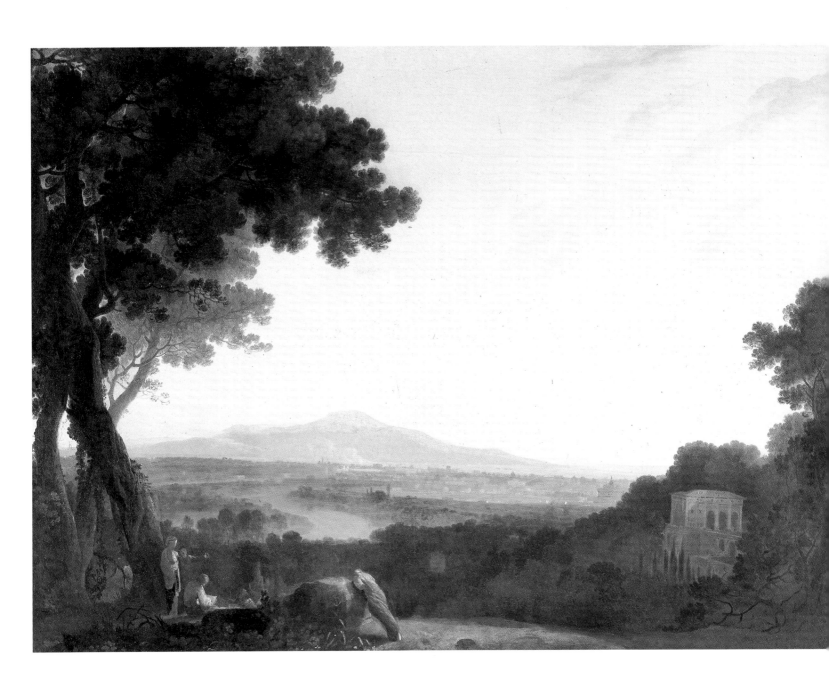

RICHARD WILSON.
ROME FROM THE VILLA MADAMA.
1753. Oil on canvas, 95.4 x 132.4 cm.
Yale Center for British Art.
There are many tributes to the work of
Claude Lorrain in this painting. The trees
to right and left, silhouetted against the
clear sky, restrict the delicately extend-
ing horizon, and provide a perfect frame
for the generous curve of the river.

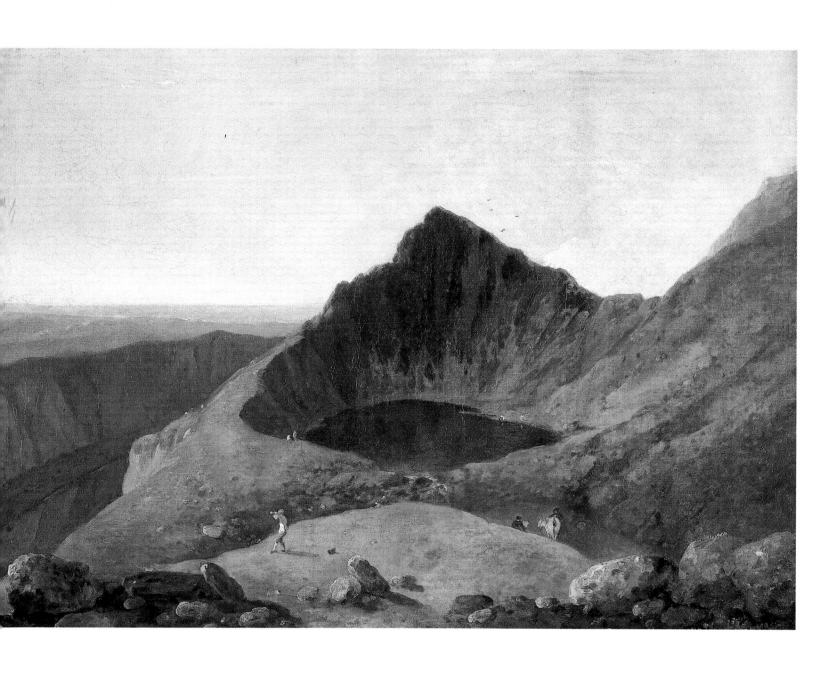

RICHARD WILSON.
CADER IDRIS, LLYN-Y-CAU.
c. 1765-1768. Oil on canvas. 50 x 72 cm.
Tate Gallery, London.
The rough landscape of Wales depicted
here by Wilson seduces us. He wanted to
paint a paradise of primitive simplicity, a
retreat far from the modern world.

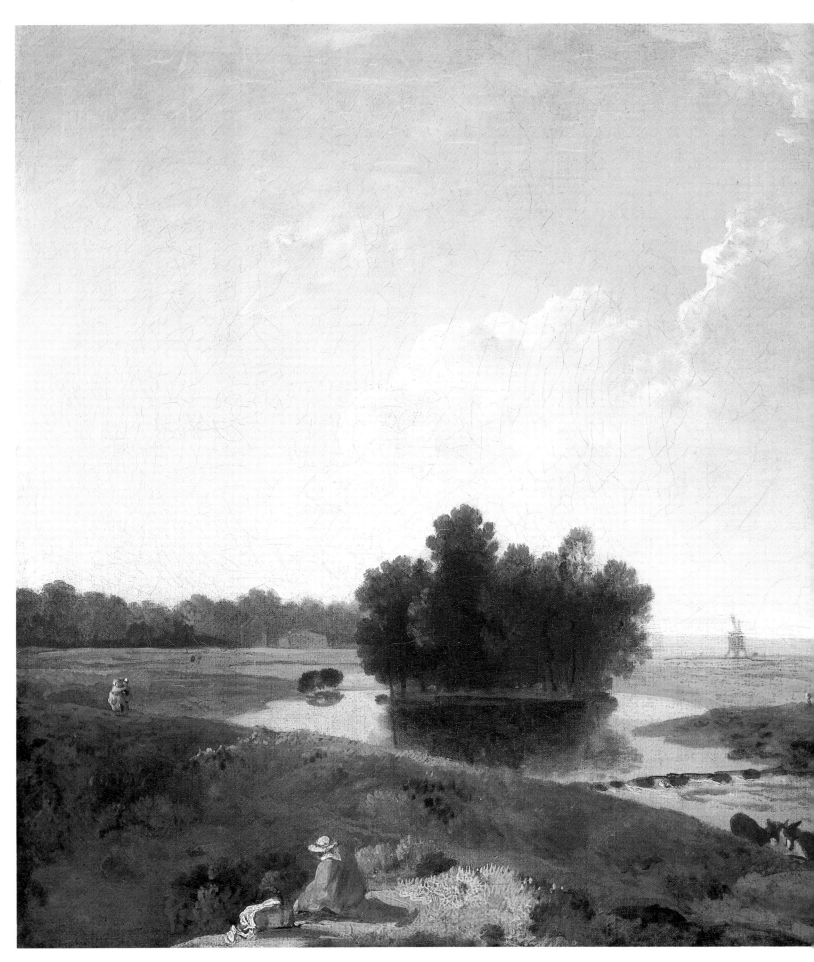

he had received an early grounding in the classics, which prepared him fully to appreciate the arts of the Italian peninsula, where he went to study at the age of thirty six in 1750. Up to that time he had only painted straightforward portraits. During the seven years he seems to have spent in Rome, he managed to earn a living by selling paintings to English aristocrats who flocked to the city as an essential part of their "grand tour". However, despite enjoying modest success, it was this stay in Rome which changed Wilson's life. Profoundly affected by the beauty of the Roman campagna, which he viewed through the eyes of Poussin and Claude Lorrain, he decided to devote his life exclusively to landscape. He was, perhaps, influenced in this by the French artist, Claude Joseph Vernet. Thus, he found his true vocation, but at the same time committed himself to a life of poverty, as, after his return to England, very few commissions came his way.

Whilst still in Italy, Wilson devoted himself to the painting of idealised landscapes in the manner of Claude Lorrain. *The View of Rome from the Villa Madama* (1753)*, with its idealised landscape, bathed in poetry, redolent with classical allusions and suffused with a hazy glow, dates from this period.

The spell which Italy cast on Wilson was so strong that it held him in thrall for the rest of his life, and after his return to London he continued to work in the same manner. However, it was not the picturesque Italy of Zuccarelli or Claude Joseph Vernet, for which he yearned, but the Italy of the Roman Empire from which he drew his inspiration, as can be seen in his view of the *Ruins of Maecenas' Villa at Tivoli* (about 1763-1765)*, and its pendant, *Hadrian's Villa*. However full of poetry these two paintings might be, the ruins remind one very forcefully that civilizations come and go, but the beauty of the landscape in these regions continued untouched. But above all, for Wilson as for other artists, it was the light which held him transfixed: light playing on trees and on the old stones, and particularly the light reflected in the sky. It was this that gave these Italian landscapes their special quality.

Wilson was never able to escape from the memory of the beauty of Italy. Back in London he chose to live in the north from where he could see the sunsets and the open heathland beyond Hampstead, and it is from this period that some of his most remarkable English landscapes date, such as *Hounslow Heath* (c.1765)*. These unpretentious landscapes, without any literary overtones, are transformed by the golden light that the artist tried to adapt from his memories of Italy.

Sometimes, however, the tougher side of his Welsh character asserted itself and drove him to tackle more demanding subjects, which he treated in an extraordinarily modern way, stripping out all superfluous detail and concentrating entirely on the principal sweep of the composition. Such a scene is *Cader Idris, Llyn-y-Cau* (1765-1768), distanced by the austerity of its treatment from the picturesque views, which were so popular at the end of the 18th century, and equally cut off from the classical traditions of Italy. Despite the fact that more than one version of this canvas found a buyer, Wilson was still reduced to poverty through the general lack of understanding of his work among potential patrons, including King George III. He found comfort, however, in the admiration of his fellow artists. In 1768 he was among the

RICHARD WILSON.
HARBOUR SCENE.
1753. Black chalk and stump, heightened
with white, 18.4 x 16.5 cm. National
Museum of Wales, Cardiff.
In this imaginary landscape Wilson
refers back as much to Claude Lorrain as
to Claude Joseph Vernet.

Previous page

RICHARD WILSON.
VIEW ON HOUNSLOW HEATH.
c. 1765. Oil on canvas, 42.5 x 52.5 cm.
Tate Gallery, London.

founder members of the Royal Academy, and in 1778 this august institution created the post of Librarian especially for him, in order to keep him from starvation. During the previous twenty years he had had to accept a number of commissions to paint country houses, though this type of journeyman topographical work was demeaning for an artist of his standing. In these paintings he rose far above straightforward representation, as can be seen in *Croome Court* (1758)*, imposing his memories of Italy upon the English countryside, as well as paying tribute to such Dutch masters as Albert Cuyp and Jacob Van Ruysdael.

GAINSBOROUGH

The demand for topography seems to have dogged the lives of most English landscape painters, and Thomas Gainsborough was no exception, being forced to start his career in this manner. For Gainsborough, as for Wilson, the people who commissioned him were, on the whole, matter of fact men, whom it was necessary to please in order to earn a living; but he was an artist of profound and poetic sensibility and never compromised or produced trivial work.

His childhood in Suffolk, before the industrial revolution, left him with a deep-rooted love of the soil and of the countryside. He was born in 1727, and it seems that he must have had some innate gift for painting, as well as an extraordinary sensitivity, as, given his family circumstances and the remoteness of rural Suffolk, the chances for him developing such talents were virtually non-existant. At the age of thirteen he moved to London and went to work in the studio of the French painter, Hubert Gravelot, a mediocre artist, who worked in the rococo manner.

For young painters with family connections or a small amount of money, such as Reynolds and Wilson, a spell in Italy was the culmination of their early training. Gainsborough had no such opportunity; what little money he could manage to earn went on supporting his family, and he was destined never to set foot outside his native country. This very insularity, however, had two advantages: he escaped the influence of classicism; whilst history painting which, as we have seen, was regarded at the time as the noblest branch of art, remained a closed book. Thus, unencumbered by the "grand style" in vogue at the Academy, he remained free; nothing obscured his creativity or the freshness of his vision, which drew its inspiration directly from nature. His technique was so vivid and spontaneous, and so perfectly matched to his subject matter, that, with hindsight, one can almost sense an early flowering of impressionism. His use of colour, which was always light and transparent, seemed to flow directly from the depths of his soul. Like many geniuses he worked erratically, sometimes stopping for weeks on end, and he did not hesitate to tell one admirer that "Genius and regularity are utter enemies, and must be to the end of time." During these spells of apparent idleness he would usually turn to music; the viola de gamba was his passion. Thus to talk of his colour in musical terms – harmonies, rhythms, etc – is not merely a figure of speech.

It would not be strictly accurate to assume that Gainsborough resisted all outside influences. At the time he arrived in London taste was turning strongly towards nature, and paintings by the masters of the Dutch landscape were in considerable demand. He was particularly attracted to the powerful and tragic works of Hobbema and Ruisdael, with their generous compositions and emphasis on mood, when he was asked to restore some of them. One wonders also, whether he saw the works of Watteau (died 1721) too. The delicacy of his touch, the refinement of his tones and the elegance of some of his scenes leads us to suspect this, but there is no proof.

In 1748, at the end of his stay in London, Gainsborough painted a remarkable picture, which clearly shows the gulf that already separated his work from that of the topographical painters of his day. This is *The Charterhouse* (1748)*, an unusual circular view of an identifiable building illuminated by contrasting bands of sunshine and shadow, and animated by a delightful vignette of two children absorbed in their game, crouching on the flagstones. The scene is transformed by the intensity of feeling which he manages to convey, through his ability to capture the heady atmosphere of a hot, lazy, summer's afternoon.

After eight years in London Gainsborough returned to his native Suffolk. The painting known as *Gainsborough's Forest* painted about this time shows too great an adherence to the precepts of the Dutch masters, at the expense of that spontaneity and sympathy, which were natural to him, and it would be interesting to know whether he was still in London at the time he painted this, or whether he was already back in Suffolk.

Happily this reverence for the work of other artists was soon subsumed and by 1748-1749 he had once again found his own true fount of inspiration, as is clear from the double portrait of *Robert Andrews and his Wife Frances** set in the Suffolk landscape. In the far distance are low hills, lovingly modelled in shades of mauve, which form an admirable counterpoint to the dominant golden hues of the corn sheaves. The young couple are shown confidently surrounded by their own land, with the figures and setting given equal emphasis. This double portrait is also a topographical view of their estate, but the treatment of the landscape, both naive and novel, achieves an effect that is totally charming.

During the 1750s Gainsborough painted imaginary scenes, in which he demonstrated that his Dutch inspired vision of earlier years had by now been totally transformed and had become the epitome of the English picturesque mood. These imaginary landscapes, often dominated by a venerable old tree or two, frequently serve as settings for little groups of figures – bucolic lovers dallying by the banks of a stream or on a twisty lane. The format of these works was often specially adapted, at the request of some patron, to fit a specific place in his house, such as the space above a door. Fulfilling these commissions was relatively congenial to Gainsborough, as they brought in money, but they reduced his status to that of a secondary artist.

In 1759 Gainsborough left Suffolk and established himself at Bath, a rich spa town that was to provide him with an important clientele for his portraits, his main source of income, and during this period his work reached its full maturity. It was almost as though his very considerable natural talent

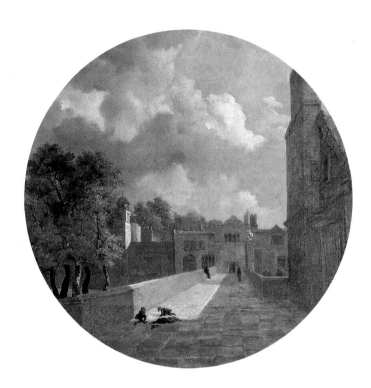

THOMAS GAINSBOROUGH.
THE CHARTERHOUSE.
1748. Oil on canvas, 55.9 cm (diameter).
Thomas Coram Foundation, London.

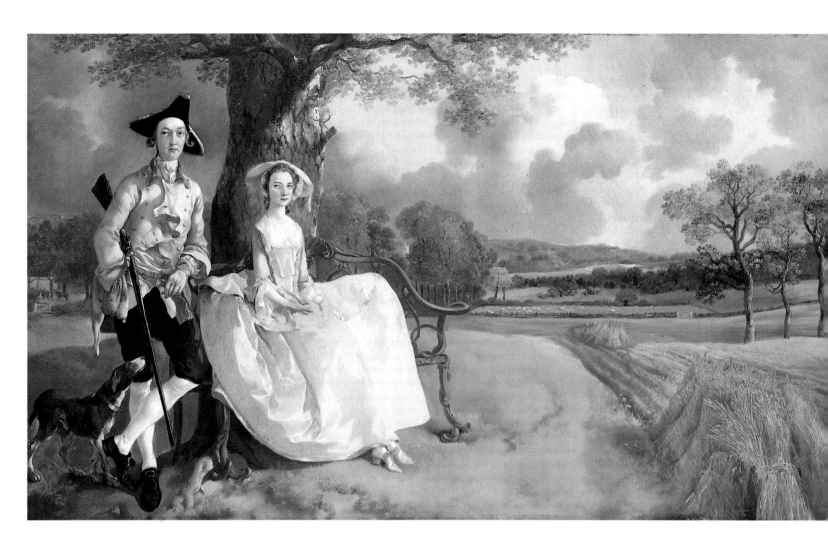

THOMAS GAINSBOROUGH.
ROBERT ANDREWS AND HIS WIFE,
FRANCES.
c. 1748-1749. Oil on canvas.
69.8 x 119.4 cm.
National Gallery, London.
on Mrs Andrews' lap, a small surface of
canvas was left blank. It was probably
intended to represent the game (a
pheasant) which her husband would bring
back from the shoot. The picture was
probably a marriage portrait, but for
some unknown reason it was never
completely finished – a misunderstanding
between the couple (Mrs Andrews does
not look very happy) or a premature
death perhaps?

was brought to final fruition through contact with the works of the European
masters, which he saw in the great houses, to which he was now invited. As
there were no public museums in England during the 18th century, access to
such masterpieces was not easy, however, he now discovered the magic of
those indefinably luminous distances of Claude Lorrain, which inspired him
to paint *Landscape with Amorous Peasants on a River Bank* (1763,
Philadelphia). Above all, he discovered the work of Rubens, and was
overwhelmed by the mastery with which that artist not only placed figures in
the open air, but incorporated them as key elements of his powerful compo-
sitions. From this point on Gainsborough's own paintings got more complex,
but also gained in balance and authority, especially in the manner in which he
handled the interplay of light and shadow. The pattern of reflected golds and
reds on foliage, touches of vermilion, the transparent airiness of the whole
composition, transmits a feeling of joy in the act of painting, as is born out by
Peasants Returning from Market through a Wood (1767-1768) and *Peasants
going to Market, Early Morning* (c.1773)*.

It seems that Gainsborough, who had been a devotee of nature since
childhood, had struck a lyrical vein that enabled him to express his intense

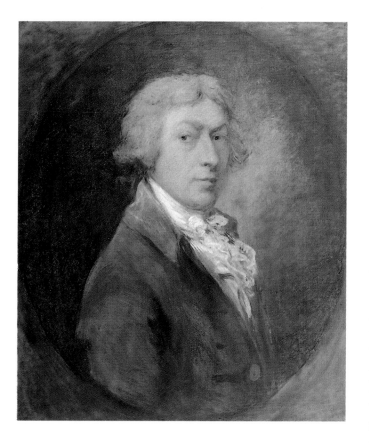

THOMAS GAINSBOROUGH.

SELF-PORTRAIT AT THE AGE OF 60.

c. 1787. Royal Academy of Art, London.

enjoyment in painting and a delight in the material of paint itself. At the same time he had mastered the ability to express his deepest emotions. His subject matter was never just an excuse for painting, it always related to his pleasure in the simple acts of country living – the return from market, animals being watered, harvesters in their laden waggons, or woodcutters bringing home faggots.

As a portrait painter at this period, Gainsborough's relationship with his sitters was often strained, as he indicated to a friend when he wrote in exasperation: "If these people, with their damnd faces could but let me alone a little!" He fled from the city during the summer months and immersed himself in the countryside around Bath, making long trecks on horseback through picturesque villages in which he would have liked to have lived, and refreshed his soul through contact with nature and the elements ; wind, rain, earth, woodland and the ripening harvest. The pantheism of the Romantics found its fullest expression around 1800, and the feelings that inspired Wordsworth's poetry were already in the air. At this period, immediately before the flowering of the romantic movement, Gainsborough was so deeply affected by nature that he communed with her, idealised her and re-created her. However, he did not wish to mirror precisely the actual landscapes through which he travelled. He made hundreds of drawings, but these were not intended, as was the case with Turner, to serve as a starting point, a stimulus, for the great, worked up, scenes that he painted entirely in the studio. Gainsborough's ambition was to capture the heady essence of the countryside and its intoxicating atmosphere, and it was this element that he tried to capture in these compositions, rather than actual details. He had totally rejected topographic realism. Like a great musician he created his own melodic style and eschewed daintiness. *Mountain Landscape with Bridge* (c.1783-1784)* is basically a study in rhythm and harmony. His aim was to create a grand decoration in which peasants and animals were absorbed in the overall harmony, as in *Mountain Landscape with Sheep* (c.1783)*, which probably evolved from one of the three dimensional models that he was in the habit of making. It would be interesting to know exactly how important to him these models were, which he made out of bits of twig, grass and mossy stones picked up during his walks and placed together with pieces of mirror, in triggering off in his mind's eye ideas for paintings. Did the act of playing about with these elements help him to visualise new juxtapositions of landscape, or give tangible form to the stuff of his dreams? Both probably, as Gainsborough was at heart a great poet.

Gainsborough finally settled in London in 1774, where he painted many portraits, without, however, giving up landscape painting, which represented the highest peak of his achievement. These landscapes, though, remained largely uncomprehended and unsold. Their subject matter remained much the same as before – wooded hillsides on which peasants and their animals move about – but the mountains in the distance grew higher and more dominating. Through literature and poetry, the public was becoming aware of the glory and sublime beauty of high mountain peaks. Gainsborough went to the Lake District in 1783 to admire them at first hand. Henceforth, he achieved his ultimate vision, the bonding of all the elements through the

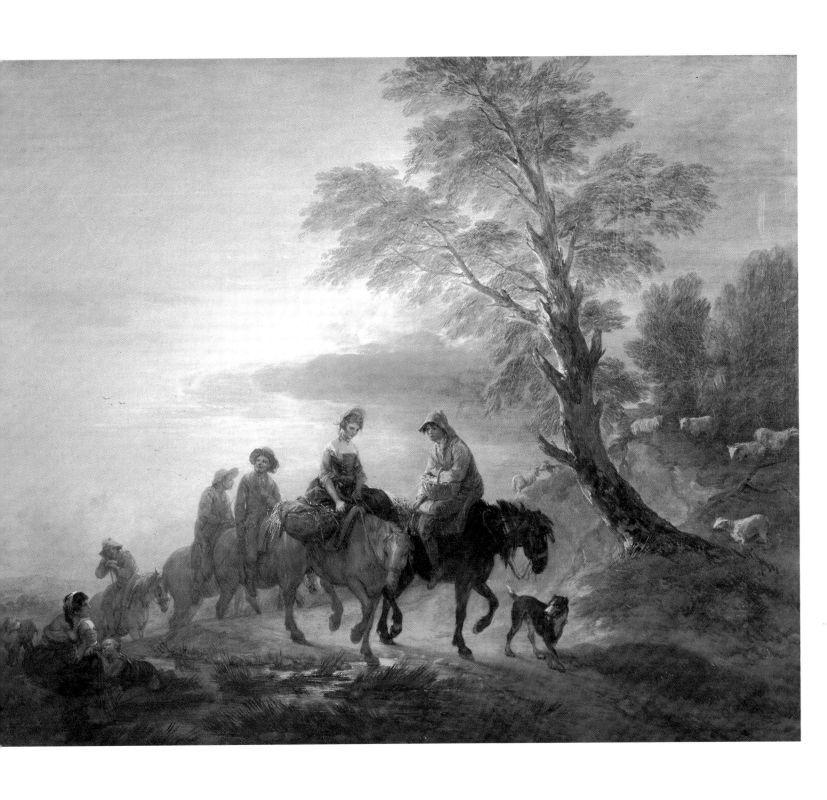

Thomas Gainsborough.
Peasants going to Market in the
early Morning.
c. 1773. oil on canvas. 121.9 x 147.3 cm.
Royal Holloway College, London Uni-
versity.

THOMAS GAINSBOROUGH.
MOUNTAIN LANDSCAPE WITH PEASANTS
CROSSING A BRIDGE.
c. 1783-1784. Oil on canvas (unfinished).
113 x 133 cm. National Gallery of Art,
Washington.

Thomas Gainsborough.
Romantic landscape with Sheep at
a Spring.
*c. 1783. Oil on canvas, 153.7 x 186.7 cm.
Royal Academy of Arts, London.*
The rocks which dominate this scene
were probably painted from the lumps of
charcoal, which Gainsborough used in
his models.

exploitation of atmosphere. His colours softened and became diluted, gradually melting into indefinable areas of mystery: trees built up in swelling masses of mellow and rhythmical foliage, which interconnect, giving great scope for dramatic chiaroscuro, whilst distances provided the excuse for brilliant arpegios of colour and subtle pastel shades.

The Market Cart (1786)* is the supreme example of this aspect of Gainsborough's work. The essential effect of monumentality is achieved through the way in which he painted the old trees, glorious in their golden autumn tints, in billowing masses like clouds piled one upon another. The scene is animated by the complicated rhythmical patterns contained within the composition, which, despite certain seemingly discordant notes, are carefully orchestrated to attain the final result. Figures and animals are treated like notations in a musical score making varied, but essentially vertical accents, which serve to emphasise the jolting forward movement of the cart. Gainsborough's brush-strokes flow with the cumbersome pull of the horse and the dog trotting lazily beside it, whilst the directional sweep of the track leads the eye backwards to the distant pool of light.

Finally, it is impossible to pass over in silence one of Gainsborough's last, and most extraordinary, artistic endeavours. This was an early precursor of the audio-visual system, a sort of son et lumiere, which he put together with his friend Philip de Loutherbourg, the artist and scene painter. They called this spectacle of light and sound the Eidophusikon. It was like a magic-lantern show with the lantern, lit by five candles, projecting his landscapes, which he had copied specially onto glass plates for the occasion. The whole of fashionable London flocked to see this show, which was performed to a musical accompaniment arranged by his friend Thomas Arne. Was this performance just a minor episode in the life of the great artist? The answer is almost cerainly in the negative, as this seems to be such an appropriate culmination to his life's work, and the logical objective of all the earlier phases. An enchanting spectacle, musical as well as visual, was the realisation of all his dreams, in which he was able to evoke the spirit of the most perfect landscapes that his fertile imagination could conjure up.

By the end of his life, Gainsborough enjoyed the respect of his fellow Academicians, and especially that of its President, Sir Joshua Reynolds, who had been his greatest rival. After he died Reynolds declared "If ever this nation should produce genius sufficient to acquire to us the honorable distinction of an English School, the name of Gainsborough will be transmitted to posterity, in the history of the art, among the very first of that rising name." Amidst general myopia, Reynolds' comments were clear and just.

THOMAS GAINSBOROUGH.
THE MARKET CART.

Winter 1786. Oil on canvas,
184.2 x 153 cm. Tate Gallery, London.
Only the blue distance recalls Claude Lorrain. The rest of the painting gives the impression of complete visual sponta-neity. In this masterpiece, painted two years before he died, Gainsborough achieved the highest point of his art.

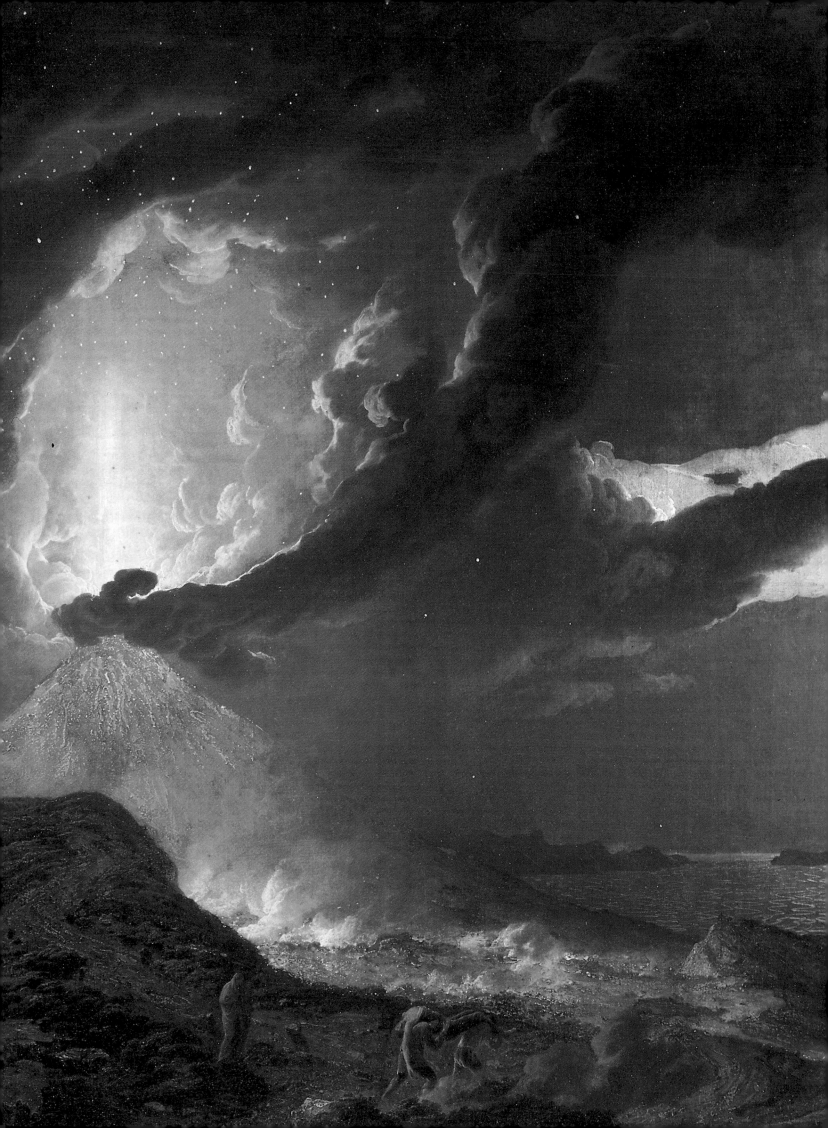

Joseph Wright of Derby,
Commentator on
the Industrial Revolution

Joseph Wright of Derby.
Vesuvius in Eruption, with a View over the Islands in the Bay of Naples.
c. 1776-1780. Oil on canvas.
Tate Gallery, London.

Fascinated by the enormous transformation that was sweeping across England towards the end of the 18th century, Joseph Wright, known as Wright of Derby, created a pictorial record that is at once great art and important visual documentation. He was, in fact, a sort of pictorial reporter, commenting on the new England that was emerging in the wake of the Industrial Revolution, which changed the face of the country for ever.

Wright spent most of his life in Derby at the very heart of industrialised England. But, far from being intellectually isolated, he kept in close contact with many of the best thinkers of his day, including men passionate about scientific matters, who were at the forefront of the practical application of these developments. Among the ranks of this intellectual elite he also managed to find sufficient patrons who wanted him to paint their portraits, and thus assured him of his livelihood. This ready supply of portrait commissions gave him the freedom, from 1776 onwards, to create works which, because of their disconcerting and innovatory character, would not necessarily find ready buyers. In each of these canvases, many of which were interior scenes, he depicted with extraordinary authority the reactions to various scientific experiments, which were quite revolutionary at the time.

About 1770, when he first dreamed of painting landscapes, Wright turned to Alexander Cozens' *A New Method of assisting the Invention in drawing Original Compositions of Landscape.* We know this because Wright's

JOSEPH WRIGHT OF DERBY.
LAKE NEMI AT SUNSET.
c. 1790-1792. Oil on canvas, 100 x 128 cm.
Musée du Louvre, Paris.
A non-idealised scene based on the care-
ful study of light-effects at the moment
the sun sets.

drawings are based on the illustrations that appear in an incomplete first edition of the text dating from 1759, long before publication of the 1785 version, which we have already described. This study on Wright's part shows his early desire to develop a personal style.

It was a sojourn in Italy from 1773-1775, which really inspired him to paint landscapes, though during the two years immediately prior to this he had produced several views of forges, which show the evidence of the earliest results of industrialisation, as well as depicting the change from manual labour to mechanisation. One of these, *A Forge viewed from Without*, is situated in a beautiful nocturnal landscape illuminated both by the silvery light of the moon and the incandescent glow from the furnace. It is a technical tour de force.

In order to paint works of this type, Wright had to develop for himself his own brand of realism, which owed absolutely nothing to his training in the London studio of the portrait painter, Thomas Hudson, or to the refined sensitivity of the contemporary school of watercolourists. One only has to compare Wright's *Lake Nemi at Sunset* of about 1790-1792* with John Robert Cozens' watercolour of the same scene (p.76) to be convinced of this. Wright's method was one of almost sculptural precision, with shapes firmly modelled, and clearly defined by the brilliant clarity of his light. More than any other painter of his time, Wright was the painter, par excellence, of light effects, and, for additional intensity and drama, often depicted the light sources against the background of a nocturnal landscape. He handled such scenes with consumate virtuosity, often uniting within the same painting a variety of light sources, both hot and cold, as well as exploiting the possibilities of reflected light. He painted fire and moonlight, lamps and rainbows and, on one occasion, he even depicted the gleam of phosporus.

Vesuvius erupting, which he had witnessed in 1774, naturally attracted him. The intellectuals of the period were asking many questions about volcanoes, and among them was John Whitehurst, a man of science and close friend of Wright's, who had written *Researches concerning the original state and formation of the Earth*. After he returned to England, Wright painted several versions of Vesuvius (c.1776-1780)*, which are as fascinating on scientific grounds as they are for the manner in which he posed the problem of rendering the effects of light.

Amongst the great new industrialists, whom Wright painted, was Sir Richard Arkwright, inventor of the spinning jenny, which, in addition to making his fortune, had done more to change the face of England than any other single invention. *Arkwright's Cotton Mills by Night* furnished Wright with the subject matter of one of his most beautiful nocturnes dating from about 1782-1783. Beneath the cool light of the moon Arkwright's factory exuded a force which shocked Wright's contemporaries, not only because it continued to throb all through the night, but because the image of this great industrial palace, fully illuminated, was for them akin to a vision of hell. All the traditions of old England were turned upside down by such a building and the new rhythm of life which it presaged. Wright was not only one of the first to appreciate its importance, but was also far ahead of his time in presenting it as a thing of beauty.

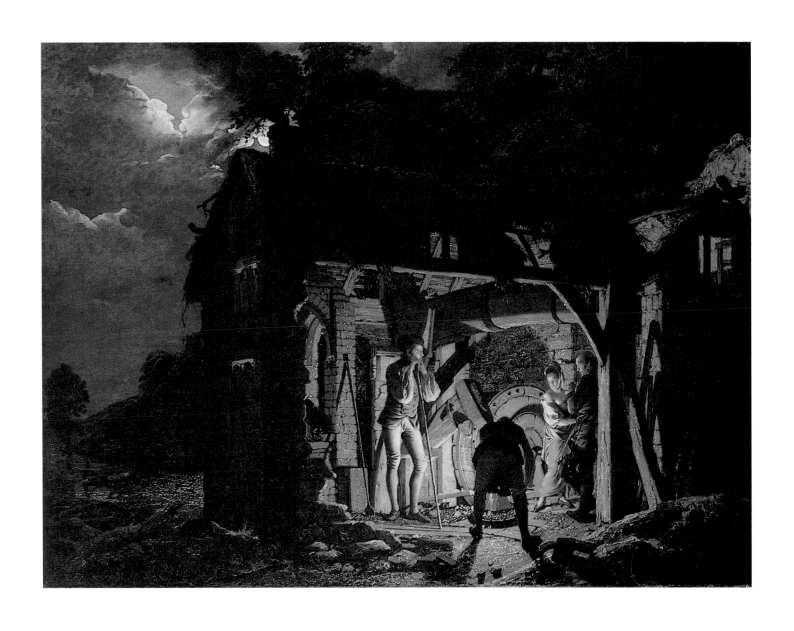

JOSEPH WRIGHT OF DERBY.
AN IRON FORGE VIEWED FROM
WITHOUT.

1773. Oil on canvas, 105 x 140 cm.
Hermitage Museum, St Petersburg.
This painting was bought by the Empress
of Russia, Catherine the Great. One can
quite clearly see the machinery which
replaced the traditional hammer in the
forge.

The liberation of sensibility
thanks to watercolour

John Sell Cotman.
The Dismasted Brig.
1807-1808. Watercolour. 20 x 30.9 cm.
British Museum, London.
The simple play of flat washes conjures
up a whole range of sensations.

Alexander Cozens' trumpet call for the unshackling of topography issued at the end of the 18th century, was responded to by a group of English landscape painters, most of whom were watercolourists. They found it difficult to be regarded as artists in their own right. As watercolours were relegated to the lesser rooms at the Royal Academy, the watercolourists decided to form their own society. Having thus, to some degree, escaped the restrictions of the Academy, they were in a more advantageous position to revive and enrich the art of landscape painting.

Due to the rapidity of execution and the fact that it was easy to carry around, watercolour enabled artists to work more frequently out of doors in front of the motif; these sketches made on the spot were often then worked up later in the studio. Such direct contact with nature and the elements gave artists an extra psychological insight into the mood and atmosphere of place, which they were then able to convey through their work. As a result of this ready access to nature they had no wish to idealise, nor to seek an imaginary world, as had Wilson and Gainsborough. These pioneers of the romantic spirit used painting, more or less consciously, as a means of expressing their feelings. Sometimes these feelings were tormented and depressive, but whatever the mood, watercolour, which was inexpensive, quick to apply and light and airy in effect, was the perfect medium to give expression to them and to preserve their frailty and elusiveness.

JOHN ROBERT COZENS.
INTERLAKEN.

1776. Brown and grey wash with pen and brown ink over pencil. Yale Center for British Art.

The comparison between this drawing and the finished watercolour, *View from the Road between Lake Thun and Unterseen*, allows us to see how J.R. Cozens used landscape to express his own innermost feelings.

Watercolour, with the possibility it provided for the exploitation of these new freedoms, was also a boon to those artists who, unable to spend several years studying in Italy on their own, were lucky enough, nonetheless, to be invited to accompany some wealthy aristocrat on his 'grand tour' to record the sites. The grandeur of the Alps, and the beauty of the Italian scenery, demanded an immediate response, which called for a new and vital means of depiction to be conjured out of the British landscape tradition. John Robert Cozens was one of these new talents.

THE LYRICISM OF JOHN ROBERT COZENS

The life and work of John Robert Cozens were dominated by his extreme, and often pathological, sensitivity, which culminated in a complete mental breakdown in 1794. Born in 1752 the younger Cozens had therefore only a short career, but it was long enough for him to bring a new sentiment to English landscape painting, a vein of lyricism and poetry that was previously unknown. His father's precepts had already freed his vision and liberated him from the desire for topographic accuracy. Alexander Cozens was, above all, a theorist and a devotee of monochrome, but the general drift of John Robert Cozens' work shows him to have struggled constantly to try and master subtle and refined colour, in order to express his own spiritual feelings, without ever falling into vulgarity. Two themes particularly inspired the art of this Englishman, who seldom depicted the landscape of his own country, the sublime grandeur of the Alps and the poetic beauty of Italy. He paid two visits to that country, the first in the company of Richard Payne Knight, chief expounder of the theory of the picturesque, and then with the Maecenas and dandy, William Beckford, who was a friend of his father's. Beckford was a free spirited dilletante, who was fascinated equally by the sublimely beautiful and the horrific.

Despite these contacts, and those of the numerous artists he met in Rome, nothing took Cozens out of himself, and he remained immersed in his inner world hearkening to his own melancholy muse. This enduring mood of deep melancholy superimposed over the actual landscapes an interior world, which found its expression through his discreet and complex use of colour. One of his watercolours, Interlaken, perhaps drawn from life, allows us to follow this development. The topographical point of departure is quite clear from the elgantly drawn ink outlines and the graduated washes, which show the influence of his father. However, it is the sensibility of John Robert that imbues the composition with a harmony that is uniquely his own. This sensibility comes through again in a worked up version of the same subject plunged in mist*, in which one senses, through its subtle colouring, some unspoken mystery close to the surface.

The inner world of the younger Cozens is steadily revealed in his watercolours; they are neither topographical nor picturesque. Gradually he stripped away the human elements, not only figures themselves but all signs of human activity including ruins, even in Rome. Colour became his principal pursuit, and his colour was never realistic or simply descriptive, never picturesque (as one gets later on with Bonnington), nor even decorative, it was the vehicle

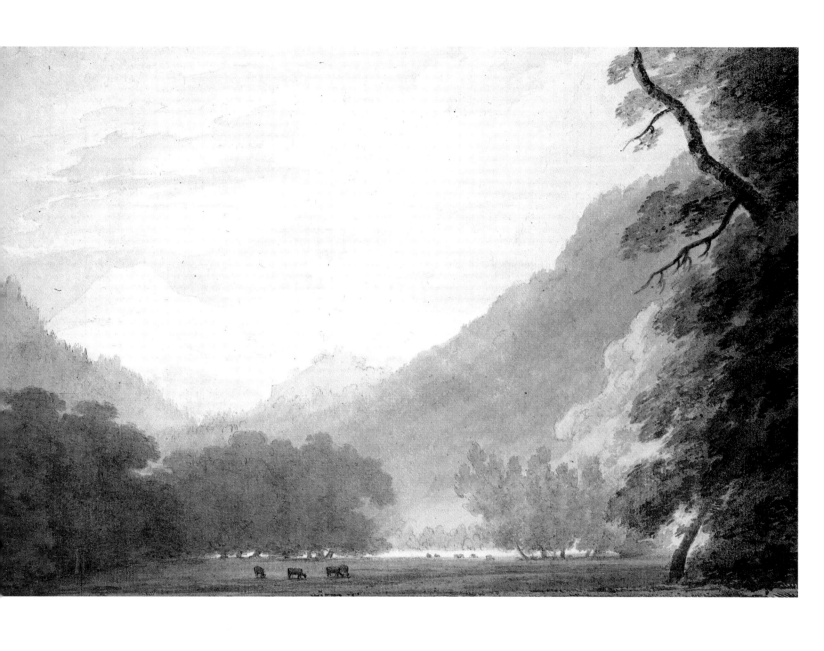

JOHN ROBERT COZENS.
VIEW FROM THE ROAD BETWEEN LAKE
THUN AND UNTERSEEN.
Between 1776 and 1779. Watercolour,
23.7 x 36.5 cm. British Museum, London.

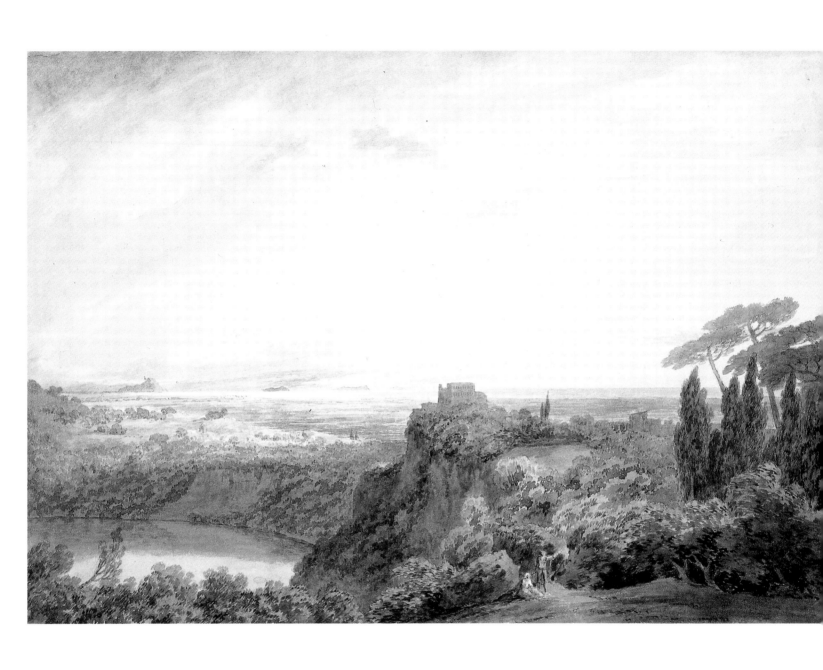

JOHN ROBERT COZENS.
LAKE NEMI, LOOKING TOWARDS
GENZANO.
c. 1785. Pencil and watercolour.
37 x 53.4 cm. British Museum, London.
The sky gave the artist the freedom to
experiment with non-figurative painting.

through which he strove to express his emotions. "Cozens is nothing but poetry", Constable said of him. His *Lake Nemi, View in the Direction of Genzano** of about 1785, shows us the point at which this inner mood takes over to dictate the colour harmonies and re-arrange the pictorial elements.

In many of his watercolours the subdued tones and wan reflections suggest a twilight world, as in *Lake Nemi*, and that moment that immediately precedes nightfall seems to be Cozens' favourite time of day. There exist, however, more "sunny" works, most notably a beautiful series of watercolours in pink and purple, dating from 1782-1783. For *The Temple of Maecenas at Tivoli* (National Gallery of Scotland, Edinburgh) he chose that crepuscular moment immediately following the setting of the sun, which, in Mediterranean countries, is suffused for a moment with a roseate glow.

During this period he spent a week of suffocating heat in Rome, evoked in his view of *St Peter's seen from the Villa Borghese, Rome* (Whitworth Art Gallery, Manchester) by his use of an orange tonality, which gives the impression of extreme and unbearable heat, despite the fact that the sun has clearly set.

Another extraordinary series is that of the *Grottoes* (1778)*. Usually Cozens preferred wide open spaces with distant horizons stretching far away. However, these cave watercolours are the reverse, and one is conscious of an overwhelming feeling of oppression and claustrophobia, which was another symptom of his psychiatric disorder with its ever present threat of mental collapse. An early indication of this condition appears in a rock-strewn landscape entitled *Satan Crossing the Gulf between Heaven and Hell.*

Cozens' free treatment of colour inevitably leads one to ask what influence his work had on Turner's. Indirect contact between the two was established when Cozens was an inmate of Dr Monro's asylum from 1794 to 1797, when he finally succumbed to his mental illness. The doctor was a well informed collector, and he bought or borrowed many works which he got the twenty year old Girtin and Turner to copy during the course of convivial evenings, at what has come to be known as Monro's Academy.

THE STARK ELEGANCE OF FRANCIS TOWNE

Francis Towne was a unique and solitary artist, whose work remained unknown for a century after his death. His watercolours and drawings are the very antithesis of popular taste of the period as he rejected facile topography, ignored the picturesque and was oblivious to the poetry that heralded the dawn of the romantic age. His was a linear art in which evenly coloured planes reduced the subject to a two-dimensional image. Every detail was carefully considered and subjected to a rigorous discipline that emphasised the harmony and elegance of the composition without detracting from its decorative value. His approach was methodical and precise and his compositions sit perfectly on the page. He organised his vision in tints of flat colour, discreetly overlapping and unencumbered by unnecessary detail, and defined the compositions by a neat and uninterrupted pen line.

This shy man was born in Exeter, a provincial cathedral city far removed from any artistic centre, and he spent the greater part of his life as drawing

JOHN ROBERT COZENS.
CAVERN IN THE CAMPAGNA.
1778. Pencil and watercolour. 38 x 51 cm.
Victoria & Albert Museum, London.
There are several versions of these *Caverns* by Cozens. This one, which is the most tragic, shows the fascination that this landscape held for the artist.

77

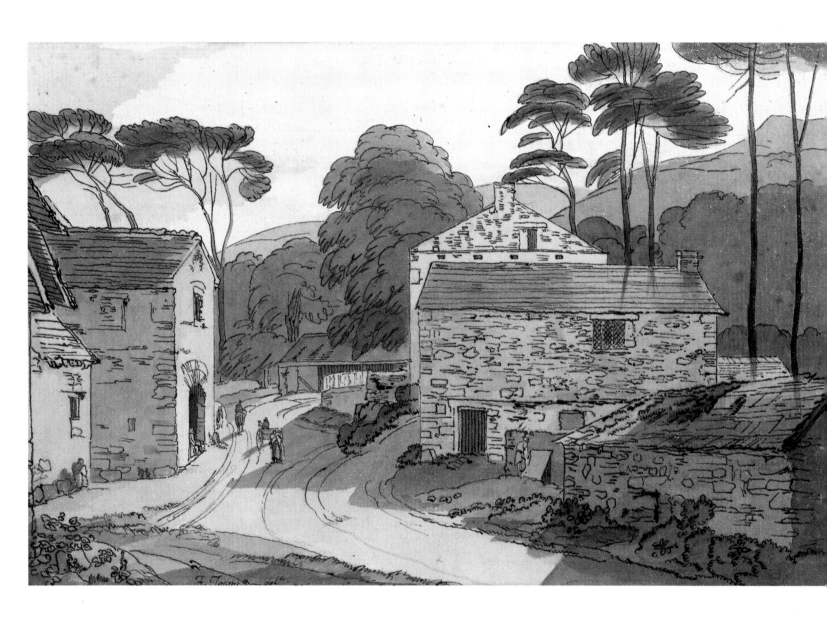

FRANCIS TOWNE.
AMBLESIDE.
1786. Watercolour, pen and ink and
pencil, 23.7 x 15.7 cm. Victoria & Albert
Museum, London.
For the background to this little town in
the Lake District, Towne, with his cus-
tomary elegance, drew mountains, which,
although they are not as high, still retain
some of the charctersistics of the Alps.

FRANCIS TOWNE.
THE SOURCE OF THE ARVEYRON.
1781. Watercolour over pen and ink,
42.5 x 31.1 cm. Victoria & Albert
Museum, London.

F. Tourne. de
1701

N.º 53

master to the well-to-do families of the district. At first he intended to paint landscapes in oils, and regarded his watercolours merely as sketches to show to potential clients, but he failed to get elected to the Academy and was unable to find a market for them.

It was during a trip to Wales in 1777 that his very personal style began to develop, but the great breakthrough in his work occured a few years later when in 1780-1781, he travelled through Italy and the Alps. Italy showed him how the harsh summer light could divide natural forms by emphasising the shadows, and thus enable him to flatten them out and translate them into decorative patterns. Nobody, previously, had worked in this vein, which was far in advance of its time. A comparison between *The Lake of Albano with Castel Gandolfo* (1781)* by Towne and Cozens' *Lake Nemi** demonstrates how far the crystalline quality of his vision had moved from the poetic lyricism of Cozens.

In the Alps he was forced to confront the strong verticality of the rock faces and, uniquely for his time, translated the menacing harshness of glaciers in *The Source of the Arveyron* (1781)* into a stylishly elegant motif.

After his return to England, and probably in search of new subjects, Towne toured the Lake District, and the works from this period, such as *Ambleside**(1786), show us, that he had not forgotten the lessons that he had learned in the Alps, especially in the way that he treated the mountain peaks.

Towne was a victim of his own modernity and remained largely unappreciated during his lifetime, with puchasers for his watercolours few and far between. He did not, however, underestimate his own worth, and bequeathed seventy five watercolours to the British Museum, where they lay undiscovered until 1911.

The austere grandeur of Thomas Girtin

Whilst visits to Italy opened the eyes of J.R. Cozens and Francis Towne, Girtin was less fortunate. Thomas Girtin was a Londoner from a very modest family and had no opportunity for foreign travel until the end of his short life when, already at the peak of his powers, he visited Paris. Despite this deprivation, by the time he died at the age of twenty seven his work was widely appreciated by connoisseurs and collectors alike, and, along with his friend Turner, he was regarded as one of the most promising landscape artists that England had produced.

His development had not been particularly favoured. He had been apprenticed to Edward Dayes in 1788 at the age of thirteen, but for reasons unknown had broken his contract. It is probable, however, that the cause had more to do with temperament than technique as, at this time, he was still using the wash ground that Dayes had advocated in his *Instructions for Drawing and Colouring Landscapes*. This was a trustworthy method, which gave a firm foundation to his work, and he continued to use it until about 1796.

From the time that he went to work in Dayes' studio he was forced to earn his own living, which he did by working as a topographical artist; in this capacity he accompanied James Moore, an amateur archaeologist, to Scotland,

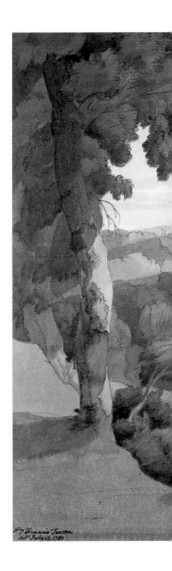

FRANCIS TOWNE.
LAKE ALBANO WITH CASTEL GANDOLFO.
Dated 12 July 1781. Watercolour with
pen and ink outline on two sheets of
paper joined together. 32.1 x 70.2 cm.
British Museum, London.
Towne achieved this vision of peace
through the elegant perfection of his
technique.

where he had to make precise records of various old ruins and sculptures. Unremitting and exacting topography indeed! Happily, though, the early stirrings of poetry in this still pre-romantic period began to relieve this gloom as, from 1794 to about 1798, he spent his evenings in the convivial company of Monro's Academy, where he and Turner were employed to copy watercolours by Dr Monro's by now deranged patient, John Robert Cozens. According to Joseph Farington, the chronicler of the Royal Academy, "Girtin copied the drawing and Turner added the colour." This experience was of immense importance to the two young men in heightening their artistic awareness. The tonal inflexions of Cozens' watercolours, reflecting every nuance of his mental state, were a useful addition to the rigorous training of Dayes, and considerably expanded Girtin's vocabulary.

About the same time Dr Monro also revealed the magic of Gainsborough's landscapes to Girtin, whilst another wealthy collector, Sir George Beaumont, introduced him to the works of Rubens and Canaletto. Inspired by the example of these masters, Girtin's skill as a draughtsman quickly developed. *The West Front of Peterborough Cathedral* (1794) shows quite clearly that by this time he was no

longer just a delineator of architectural detail, but was fully able to unite building and setting into a powerful composition, and to capture the very essence of the place and the strong upward surge of the building. This was a notable advance; topography had now been turned into drama. Drama emerges again in the quasi-Piranesiesque *Ruins of St Cuthbert, Holy Island* (1797, Yale Centre for British Art) in Northumberland.

From 1795 to 1798 Girtin took advantage of the summer months to travel through the popular tourist districts of Britain and to build up his portfolio of studies, which he could later use to advantage. It is difficult to be absolutely precise about dates and places, nevertheless, his journey through the North of England in 1796 appears as a turning point in his career. Coming from London, the vast empty tracts of Yorkshire were a shock to him, and having to come to grips with them helped him to find his true self. He instinctively grasped the power of wide open spaces and, rejecting the detailed approach of the topographer, threw himself wholeheartedly into trying to capture this vision of the infinite.

A small study of *Rievaulx Abbey* of 1796 shows that he was by this time starting to work directly with the brush without preparatory under drawing. From then on there was nothing to hinder him from applying colour freely, and this newly gained immediacy enabled him to respond directly to the sensations aroused by the scene in front of him, as is shown by *Landscape with Mountains and Clouds, Mynydd Mawr**.

During the following years he often chose to work on large sheets of coarse, buff paper, on which he laid the colour directly with brushes laden with water and pigment. Forms began to emerge almost immediately – contours of hills or the sparkle of calm water – from the long and uninterrupted strokes of his brush. Detail was sacrificed to overall effect, and even the trees now began to appear as great dense masses, as can be seen in *Kirkstall Abbey, Evening* (c.1800-1801)*. His brush moved freely and daringly over the paper, prompted by a combination of imagination and luck, which lead him to define the spaces and enabled him to exploit happy accidents. In these compositions he deliberately ignored what had until then been the generally accepted rules of the genre, that had been handed down unchallenged since the time of Claude Lorrain. Here the foreground, stripped bare of detail, is laid in with strong horizontal brushstrokes, so that one's eye is immediately drawn to the middle ground and distance. Traditional 'picturesque' devices, such as trees at the sides of the composition, have been swept away, and the lateral thrust of the landscape is allowed to bleed off each side into boundless space.

Due to his choice of a restricted palette the local tones dictate the overall values. He selected ochre and yellow, Prussian blue, crimson lake and a wide range of browns to translate his uncluttered and rather austere vision. Sometimes he invested his subjects with feelings of grandeur or tragedy, but, regardless of whether they were mountain scenes or cityscapes, he invariably handled them with great breadth.

Aware of the strength of personality that was emerging, one critic observed in 1799 that the young maestro already displayed "all the characteristcs indicative of genius."

Previous pages

THOMAS GIRTIN.
LANDSCAPE WITH HILLS AND CLOUDS,
MYNYDD MAWR.
Watercolour, 14.9 x 25.6 cm. British Museum, London.
Following on from his architectural drawings, Girtin discovered the dramatic landscapes of the north of England. These watercolours are marked by a sense of melancholy and solitude, which is emphasised by his austere pallet.

Thomas Girtin.
Estuary of the River Taw, Devon.
c. 1801. Watercolour over pencil.
26.2 x 45.1 cm.
Yale Center for British Art.
This landscape was perfectly adapted for
Girtin's vision with its extended horizon
and restricted colour range.

THOMAS GIRTIN.
WESTMINSTER FROM LAMBETH.
c. 1800. Watercolour, 27.9 x 52.7 cm.
British Museum, London.
This is one of the preparatory water-
colours for Girtin's panorama of London,
Eidometropolis, which was lost in
Russia.

Several views of the coast of Devon and Dorset, painted about 1801, gave rein to his extraordinary technical prowess and enabled him to produce some of his most beautiful watercolours. *The Estuary of the River Taw, Devon* (1801)* is an admirable example, which, without any particular geographical detail or shift of key to jar the mood, conveys the sensation of space unfolding endlessly towards eternity.

The obvious next step from this expanded vision was the panorama, an art form which was in great demand at the end of the 18th century. Panoramas are continuous paintings which depict, through a complete circle of 360 degrees, everything that the artist sees as he pivots around on a fixed point. About 1800, Girtin commenced to paint in oils a panorama of London, which, exhibited as the Eidometropolis, was a great popular success. Although it was his largest work, it has long since disappeared. Happily, however, the preparatory watercolours have survived, and *View of Westminster from Lambeth* (c.1800)* is one of them. In it Girtin manages to give not only an impression of the buildings, but also of the smoky atmosphere of this vast, teeming, metropolis.

It was probably with the object of making another panorama that Girtin went to Paris, where he worked in 1801-1802. He was suffering from tuberculosis, which was already at an advanced stage, but was still able to produce a series of *Views of Paris* (Yale Center for British Art); he engraved these himself shortly before he died. His sensitive and nervous line punctuates the masses of the buildings and gives a breadth and spaciousness to these scenes which gradually become all pervasive. They form a touching end to the career of this young artist, who Turner rated so highly that he is reputed to have said: "If poor Tom had lived, I would have starved."

THE COMPLEX ART OF JOHN SELL COTMAN

Despite his quite exceptional talent, John Sell Cotman remained virtually unknown throughout his life, and not one single obituary notice was published at the time of his death. However, not withstanding the fact that he followed immediately in the wake of Towne and Girtin, he, too, brought a new and refreshing vision to the practice of landscape painting in Britain. Like Towne's, his work was too innovative and revolutionary, and he chose to escape from the competitiveness of London to seek employment as a provincial drawing master.

It has often been asked what influences played a part in the development of Cotman's style, but such questions are largely vain, as he was an original, and an original he remained, throughout his otherwise humdrum life. His vision was developed and refined solely by his everyday experiences.

Cotman was a provincial. Born in Norwich in 1782, into a family of small traders, he never felt at home in London, where he went at the age of sixteen without any artistic training. He managed, nonetheless, to get employment with Ackermann, the engraver, and in 1799 was amongst those lucky enough to be invited to participate in the evening sessions at Monro's Academy, and there encountered the works of Girtin and Turner, who had both worked for Monro a few years previously.

It is possible that contact between the artists was made through a drawing club founded by Girtin, and for which Cotman took over responsibility on Girtin's death. The club met once a week in the homes of each of its members in turn; the host for the evening selected a suitable theme, which usually consisted of a historical or mythological subject taken from literature or poetry. The work having to be completed immediately during the time allotted. These convivial evenings, which Cotman participated in up till 1805 or 1806, were an important corrective to the strongly topographical tendencies of the period.

For the young Cotman the opening years of the century were notable for his participation in exhibitions, which was promising, and for his study trips in Wales and Yorkshire, both of which areas were renowned for their outstanding natural beauty. His watercolours from this period, worked over a grey wash, are topographical and picturesque views, often dominated by strong architectural features. But some studies of *Trees* (1803-1804) already show an extraordinary mastery and responsiveness to the dictates of a spirit sensitive to every aspect of nature. The indirect influence of Girtin is often apparent in these works of 1802-1804, but more in the palette with its carefully selected shades of blues and browns, than in the way he placed the composition upon the page.

The year 1805 witnessed a major change in Cotman's work. A third visit to Yorkshire took him to the Morritts' home, close to Greta Bridge. The watercolours from this period are difficult to date with total accuracy, as he made many sketches which he worked up during the following two or three years, however, *Greta Bridge* (1805-1807), one of his most renowned watercolours, is set apart from his earlier works by its startling clarity of line and serene balance. It seems almost as though some kind of spell has been cast upon the place; nothing moves and, despite the passing of time, it feels as though everything is frozen, and the whole scene takes on an air of enchantment.

Some of his other works from the same period show that by rejecting the temptation to produce picturesque renderings of nature he was able to paint a truer picture. His gaze penetrated the woodland around Greta, and almost lost itself in the effort to disentangle the profusion of foliage. In his attempt to put some sort of order into this riot of vegetation, he adopted a system by which he drew sparingly with the brush whilst spontaneously applying large areas of coloured washes. Like Girtin, Cotman also discovered the liberating effect of colour, and was thereby able to find an outlet for his innermost feelings. Gradually, through his very personal use of colour, he began to paint a landscape of the soul in addition to the scene before him. *In Rokeby Park* (1805-1806)* reflects this interior vision, whilst *The Scotchman's Stone on the Greta, Yorkshire* (1805-1806)* makes one imagine the artist fascinated by the swirling waters of the deep pool. Parallel with this exploration of nature and quite inexplicably, as there is no precedent in British painting, Cotman began to develop a semi-abstract vision of the world. In his watercolour *The Dropgate in Dunscombe Park* (1805) the entire motif is reduced to an interplay of lines against flat washes, which to our eyes suggest that he was more interested in the pictural effect than in reproducing the

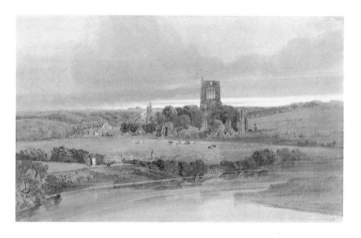

THOMAS GIRTIN.

KIRKSTALL ABBEY, EVENING.

c. 1800-1801. Watercolour, 31 x 51 cm.

Victoria & Albert Museum, London.

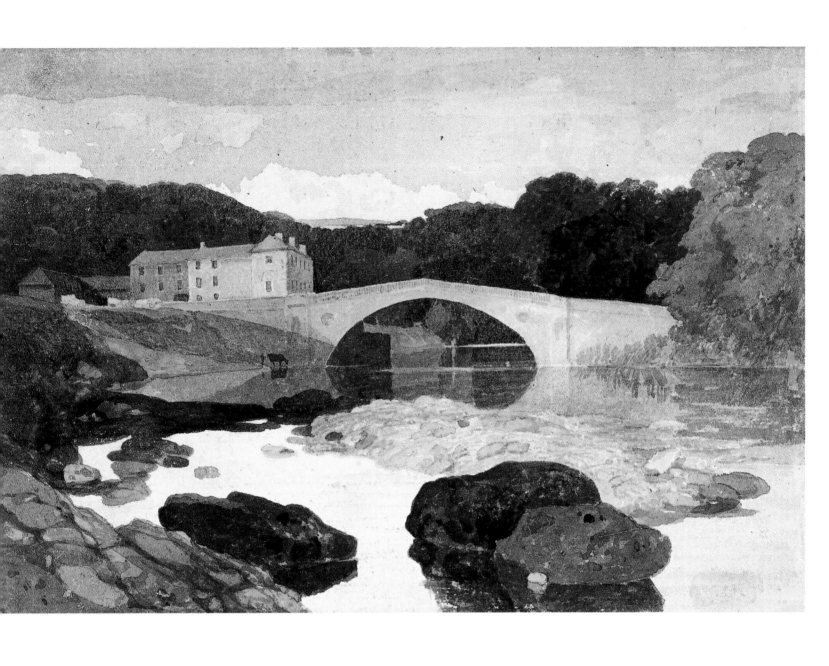

JOHN SELL COTMAN.
GRETA BRIDGE.
1805-1807. Watercolour, 22.9 x 33 cm.
British Museum, London.
Despite his depressive character,
Cotman produced in this watercolour an
image of perfect serenity.

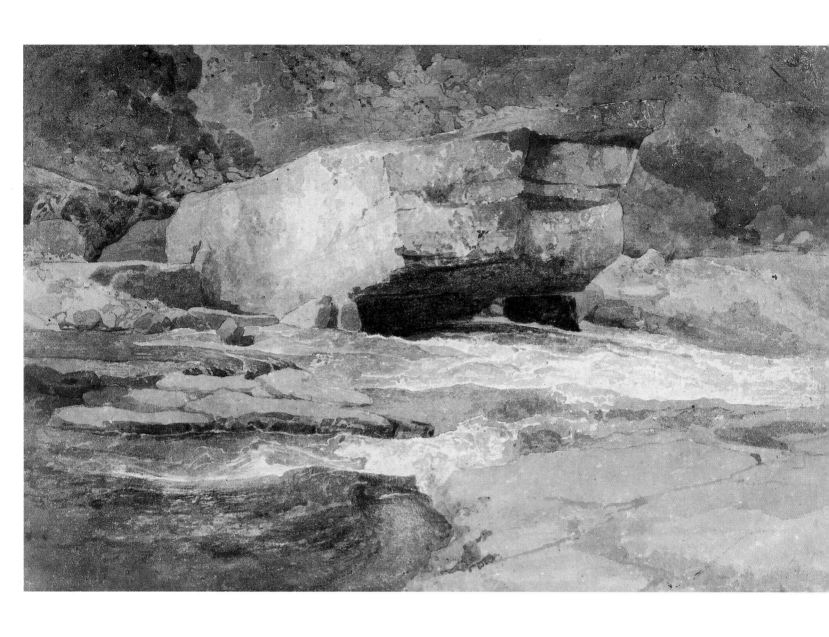

JOHN SELL COTMAN.
THE SCOTCHMAN'S STONE ON THE
GRETA, YORKSHIRE
1805-1808. Pencil and watercolour,
26.7 x 39.4 cm. British Museum, London.
The weight and solidity of the rocks
contrasts with the bubbling of the water.

JOHN SELL COTMAN.
THE DROPGATE, DUNCOMBE PARK.
1805. Watercolour, 33 x 23.1 cm.
British Museum, London.

reality of the scene. The same can be said of *Greta Bridge* in which the dominant mood of serenity is achieved through the fine balance of the composition.

Cotman's life at this time was not easy. Disappointed at not being elected to the Watercolour Society, he exhibited for the last time at the Royal Academy in 1806 and turned his back on London, returning once again to his native city. It is tempting to read into *The Dismasted Brig* (1807-1808) intimations of the mental illness which, as it became more insistent, increasingly threw him into fits of the deepest depression. For this powerful image of a sailing ship in dire distress he used a series of flat tints, just as he had done in his tranquil scenes on the banks of the Greta, but here the brush strokes are jagged and deeply disturbing.

In other works painted during the Norwich years from 1806 to 1812, one can see him steadily developing the type of abstract view of the world, which was already apparent in *The Dropgate*. He rigorously eliminated all superfluous detail, thereby reducing the scene to the bare essentials, which he was then able to transform through the grandeur of his vision into a powerful and haunting composition such as *Chirk Aqueduct* (1806-1807)*. This dramatic move away from both the topographical and the picturesque approach, which we see so graphically in *Chirk Aqueduct* was not, however, final. From 1812 to 1823 he devoted all his energies to drawing and engraving architectural views to illustrate the publications of his friend and patron, Dawson Turner, devoted to the mediaeval remains of Norfolk and also of Normandy, in connection with which he made three trips to France. However, he always felt frustrated by the pressing need to produce precise, topographical, records for his patron, which left him little scope to pursue his own unique and innovative vision. Tragically, after all the years of work, the publication of the two volumes of *The Architectural Antiquities of Normandy* in 1822 passed almost unnoticed, causing Cotman the deepest disappointment.

Every summer from this time until the end of his life he was prevented from working by severe fits of depression, but he still endeavoured to continue to teach drawing in Norwich and then at King's College, London. At this time he abandoned the use of transparent watercolour and started experimenting with opaque pigments, which he achieved by mixing size with the watercolour, drawing into the thick surface of the medium with the pointed end of the brush. These works had little success and he was never again able to rekindle the inspiration and creative vision which were the hallmark of the most fruitful and productive years of his life.

JOHN SELL COTMAN.
CHIRK AQUEDUCT.
1806-1807. Watercolour.
31.8 x 23.2 cm.
Victoria & Albert Museum, London.

JOHN SELL COTMAN.
IN ROKEBY PARK.
1805-1806. Pencil and watercolour.
32.9 x 22.9 cm.
Yale Center for British Art.

TURNER'S
AMAZING CAREER

J.M.W. TURNER.

SNOW STORM: STEAMBOAT OFF A
HARBOUR MOUTH MAKING SIGNALS IN
SHALLOW WATER AND GOING BY THE
LEAD.

1842. Oil on canvas, 146 x 237.5 cm.
Tate Gallery, London.

Despite the turbulent and apocalyptic
mood of this picture, Turner stated that
he was recalling a real incident by
adding to the title the words "The artist
was caught in this storm on the evening
that the Aeriel left Harwich." To those
critics whom he met, he said in
conversation "I have not painted this in
order to be understood, but I wanted to
show how this sort of scene looked. I
persuaded the sailors to tie me to the top
of the mast. I remained tied there for
four hours and I scarcely thought that I
would escape alive."

Joseph Mallord William Turner, like Girtin, was born
into a family of modest means in London, but unlike his less fortunate friend,
his good health and long life enabled him to pursue his artistic development to
a far greater degree. At the time of Girtin's death in 1802 at the age of twenty
seven, Turner, equally twenty seven, was the youngest member of the Royal
Academy, with a brilliant career ahead of him. Although his earliest water-
colours, dating from about 1792, are unexceptional exercises in the picturesque
tradition, those from the middle and later part of his life reveal him as the great
precursor of twentieth century artistic developments. Although he was often
misunderstood during his life he is now perceived as the outstanding genius,
who bridged the gulf between the English eighteenth century topographical
tradition and the art of the present day. He can be seen as having exploded the
concept of the picturesque in order to create a new vision which literally
pulsates with colour and atmosphere. It was a prodigious feat for any one man
to achieve this transition from topographer to universal visionary.

What sort of an individual was this great artist? In 1829 an English
traveller wrote to a friend: "I have fortunately met with a good-tempered, fun-
ny little, elderly gentleman, who will probably be my travelling companion
throughout the journey. He is continually popping his head out of the win-
dow to sketch whatever strikes his fancy, and became quite angry because the
conductor would not wait for him while he took a sunrise view of Macerata...

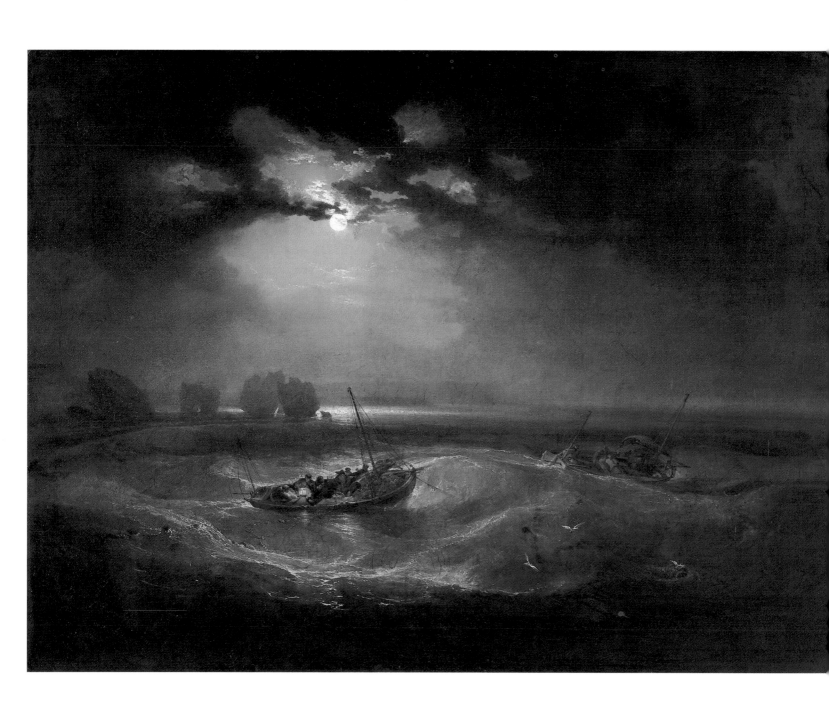

J.M.W. TURNER.
FISHERMEN AT SEA.
1796. Oil on canvas. 91.5 x 122.5 cm.
Tate Gallery, London.

J.M.W. TURNER.

DOLBADERN CASTLE, NORTH WALES.

1800. Oil on canvas, 119.5 x 90cm.

Royal Academy of Arts, London.

Turner was elected an Associate member of the Royal Academy at the earliest permissible age of 24. In February 1802 he was elected a full Academician and selected to give this work as his "Diploma Work."

He speaks but a few words of Italian, about as much of French, which two languages he jumbles together amusingly – His good temper, however, carries him through all his troubles... From his conversation, he is evidently near kin to, if not absolutely, an artist... The name on his trunk is J.M.W. Turner."

TURNER'S PROGRESS TO THE ACADEMY

Turner was then 54 years old and at the peak of a career started in childhood, with the encouragement and support of his father. His mother was difficult and eventually went mad, but father and son had always been close. The elder Turner was a hairdresser and it was in his modest little shop that his son sold his earliest drawings, for sums ranging from one to four shillings (between five and twenty pence in today's currency). It was also in this shop that the proud father announced, whilst cutting the hair of the painter Thomas Stothard: "My son is going to be a painter." That was in 1789.

The young Turner was already a pupil of Thomas Malton the younger, a good, but limited, topographical artist. He moved on from there to the studio of Edward Dayes. In the short biographical sketch of Turner which he wrote, Dayes insisted that the boy was "indebted principally to his own exertions for the abilities which he possesses as a painter. The way he acquired his professional powers was by borrowing, where he could, a drawing or picture to copy from; or by making a sketch of any one in the Exhibition early in the morning and finishing it at home." Copying in the Royal Academy was strictly forbidden, hence the need to be furtive. This training stood him in good stead later, when he visited the Louvre in 1802, as he was able to scribble sketches of and comment upon some of the great masterpieces of European painting.

Let us go back a little, though. To complete his education, Turner was admitted to the Royal Academy Schools in 1789, where, until 1793, he worked from the Antique. Still a long way from landscape! However, he got closer to nature during evening sessions at Monro's Academy, in which he took part from 1794 to about 1797. Along with his friend, Thomas Girtin, he was brought into contact with John Robert Cozens' extraordinarily sensitive watercolours, which he had to copy. In the process his eyes and mind were opened to a whole new world.

The greatest impetus to improve his work came, however, from the scenic tours he made every summer throughout his life. Each region of Britain was selected in turn during the ensuing years for a detailed tour. From 1792 to 1801 he travelled extensively through Wales, the North of England, Yorkshire and the Lake District. His picturesque topographical views of 1792 had by 1795 given way to far more sophisticated and well informed landscapes, notable as much for their light and colouring as for their basic conception and composition. The young artist's vision evolved gradually. Although he was always able to produce detailed architectural studies, he focused his attention much more now on capturing the play of light, atmosphere, the spirit of particular places and the grandeur of selected views. Quite simply, the sublime had superseded the picturesque.

The quest for melancholic grandeur had brought about a change of palette, which gradually became weighted to more sombre shades of blue,

similar to the tones favoured by Girtin. Turner made little differentiation between oils and watercolours; he also turned his hand to poetry. A number of his paintings depicting aspects of the sublime were accompanied by verses on the same theme, which he would then have printed, to conjure up a vision of some appropriate historical or mythological event with which he wanted them linked. His subject matter – mountain peaks, lakes and castles set against stormy skies – gave scope for dramatic light effects, and shows that Turner, sensitive to the nascent romanticism, was already seeking for an appropriate visual language. One painting in particular, *Dolbadern Castle* (1800)*, which he presented to the Royal Academy as his Diploma Work, sums up perfectly these different aspects of his character.

For Turner the 18th century ended in grand style with his election as an Associate member of the Royal Academy, to be followed two years later, in 1802, with his election as a full Academician, which crowned his early years of struggle and experiment. Although the watercolours that he had exhibited since 1790 had attracted praise from the critics, he was well aware that a mere watercolourist could never be regarded as being in the top flight, nor would he get elected to the Academy, so he had turned increasingly to painting in oils. His first exhibited oil painting, *Fishermen at Sea* (1796)*, proclaimed his mastery of the medium. In order to compel the admiration of the critics he had brought together every conceivable difficulty and resolved them triumphantly. He contrasted the moonlight with lamplight on the boat, and the playfulness of the waves carrying the barque with the broader swell of the sea, thus giving rise to complex reflections in the water in the immediate foreground. He handled all this with tremendous authority without for one moment loosing the human and poetic character of the scene, or diminishing its value as a great romantic work.

TURNER'S DEFIANCE OF CLAUDE

Two paintings by Claude Lorrain, with which Turner was confronted, made an indellible impression upon him. This incident took place in the house of William Beckford, the fabulously wealthy collector friend of Alexander and John Robert Cozens. Beckford had purchased the two Claudes from the collection of the Altieri Palace in Rome, and Joseph Farington, the chronicler of the Royal Academy, who was present at the time of Turner's visit, recorded that Turner said of *The Sacrifice to Apollo* "that he was both pleased and unhappy while he viewed it, as it seemed beyond the power of imitation."

Turner was already familiar with an anglicised version of Claude's work, through the paintings of Richard Wilson, but at Beckford's, faced with the real thing, everything was different and the young Turner conceived an ambition to rival these masterpieces, which he nurtured for a long time. And even today, not every visitor to the National Gallery in London appreciates why two paintings by Turner hang beside two paintings by Claude. Turner decreed in his Will that his *Dido Building Carthage* and *Sun Rising through Vapour* should always be exhibited in this way.

Dido Building Carthage or *The Expansion of the Carthaginian Empire* (1815)* was complemented two years later by a pendant picture *The Decline of*

J.M.W. TURNER.
DIDO BUILDING CARTHAGE, OR THE RISE OF THE CARTHAGINIAN EMPIRE.
1815. Oil on canvas, 155.6 x 231.7 cm. National Gallery, London.

Following pages

J.M.W. TURNER.
THOMSON'S AEOLIAN HARP.
1809. Oil on canvas, 166.7 x 306 cm. Manchester City Art Gallery.
This landscape (a view of the Thames from above Richmond) owes its title to the verses that accompanied it, which were taken from the *Seasons* by the poet Thomson. It is likely that the figures of the dancers represent the seasons.

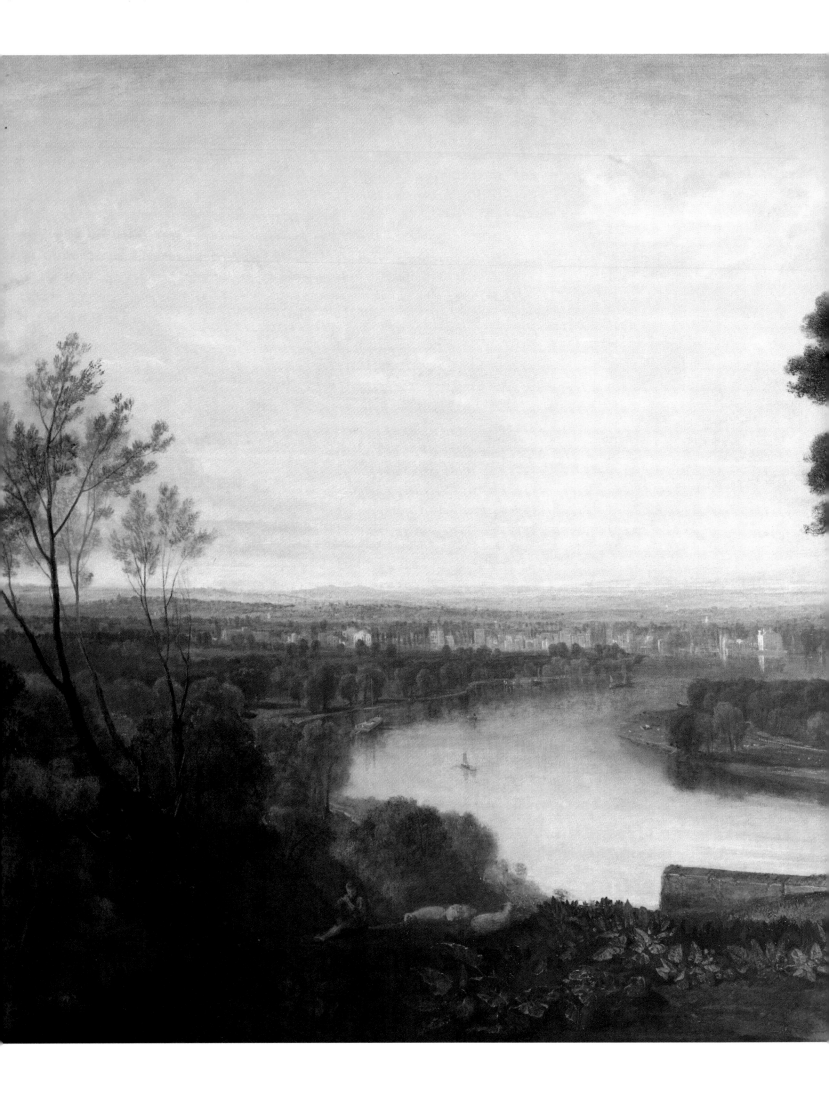

the *Carthaginian Empire* (Tate Gallery). It had taken Turner fifteen years to respond, point by point, to the original challenge of 1799. Nothing escaped him, neither the classical buildings nor the trees whose topmost branches form a tracery against the sky, nor the sunrise in the distance suffusing everything with touches of mellow light, nor even the golden reflections snaking across the water. His contemporaries were impressed, and Turner, himself, considered this to be his masterpiece, refusing to sell it, even for the staggering sum of five thousand guineas. He finally bequeathed it to the British nation on his death.

For present day taste many people prefer some of Turner's other paintings, in which he got closer to Claude in spirit, without trying to challenge him so obviously. His initial approach to Claude was tentative, as can be seen in *The Celebration of the Vendage at Macon*, reworked under the title of *Thomson's Aeolian Harp* (1809)*, in which the sweep of the river links with the elegant arabesques of the dancing maidens. *Crossing the Brook* (1815)*, on the other hand, is a truly English scene of the Tamar valley, on the borders of Devon and Cornwall, but here Turner equally chose a Claudian style, imbued with a silvery light and a gentle summer haze, which melts into the velvety sheen of the distant forests.

These two works are cited merely as milestones in Turner's extended series of landscapes, through which his devotion to the ideals of Claude run like a leitmotif. Each time he sought to find a new means of challenging and trying to equal, if not excel, the French master: he tried colour, he tried composition, he tried atmosphere and, finally, in paintings such as *The Bay of Baiae with Apollo and the Sybil* (1823) he resorted to mythological figures in an Italianate setting.

TURNER: PAINTER AND TRAVELLER

In 1802, having criss-crossed England recording the best known beauty-spots – a habit he had never broken – the continent was suddenly once again open to him, thanks to the Peace of Amiens. Turner was eager to explore France and he set off for Paris via Calais, before going on to the Alps and into Switzerland. On his return journey, a second stop in Paris gave him time to study at leisure the collections in the Louvre. In those days comfort was definitely not a characteristic of travel and *Calais Pier, with French Poissards preparing for Sea: An English Packet Arriving* (1803, National Gallery, London) recalls the confusion and risk of drowning that Turner encountered on arrival, but at the same time, despite this busy scene, he managed to convey the surge of the waves through the perfect quality of his painting.

For Turner the Alps were a shock and a revelation, with their powerful masses and perpetual snow, for which his visits to the Lake District had not prepared him. In his mind's eye he had envisaged them as being akin to the poetic visions in J.R. Cozens' watercolours. In reality he was deeply impressed by the gorges, defiles and precipices, which gave him a first-hand vision of the sublime. He captured this overpowering feeling of fear and suffocation in several superb paintings and watercolours like *The Pass of the St Gothard* (1803-1804)*. On reaching the summit he was equally impressed and in one of his sketch-books captured the icy and crystalline purity of *The Mer de Glace and Blair's Cabin*.

J.M.W. TURNER.

CROSSING THE BROOK.

1815. Oil on canvas, 193 x 165 cm.

Tate Gallery, London.

J.M.W. TURNER.
THE PASS OF THE ST GOTHARD.
c. 1803-1804. Oil on canvas,
80.6 x 64.2 cm.
Birmingham City Museum & Art Gallery.
A perfect example of the sublime as it was perceived at the beginning of the 19th century.

The continent, which had been cut off for a second time by the Napoleonic wars, was accessible once again after 1815, enabling Turner to visit the Low Countries. More importantly, though, in 1819, he made his first trip to Italy visiting Turin, Venice, Rome and Naples, before returning via the Mont-Cenis Pass. He was to visit Italy again in 1828, 1833 and 1840. What struck him most, though, on this first visit was the quality of light. More even than the memory of the antiquities and the great classic sites, it was this which remained with him. The light was of a quality of which he had never dreamed and for which nothing, not even his earlier visit to France in 1802, had prepared him. One may say, without fear of exageration, that it came as a revelation and precipitated a major change in his work. This visit to Italy in 1819 signalled the end of his first creative phase, during which he had concentrated on the depiction of sites from the standpoint of the sublime, and marked the opening of a new one devoted to experiments with light and colour.

He became obsessed with light. Light that was both soft and golden. A light that was often filtered through mist or haze (in Venice), and which cast a veil of indefinable colour over everything. The pursuit of such scintillating effects led Turner gradually towards the fragmented vision, which marks some of his later works.

During his travels in Italy, Turner made innumerable sketches – nearly fifteen hundred alone during a two month visit to Rome in 1819. These quick studies, combined with his phenomenal memory and fertile imagination, provided him with sufficient material to produce worked up watercolours when he got home, which he was able to sell, and also to paint the great pictures, which he exhibited at the Royal Academy. Two watercolours at least of Venice dating from this first visit, *Looking East from the Giudecca, Sunrise** and *San Giorgio Maggiore* (1819), must be adjudged masterpieces by any standards and, through their perfection, they give us some insight into the powerful visual and psychological inspiration that Italy was for Turner.

Italy was a treasure house for Turner and inspired the many oil paintings that poured from his brush during the next three decades. Venice became his particular love and he recorded the city on the water in every possible mood, sometimes with a precision worthy of Canaletto – *The Bridge of Sighs, Ducal Palace and the Dogano, Venice, with Canaletti Painting* (1833, Tate Gallery) – and sometimes reduced to sparkling and atmospheric light effects as in *The Dogana, San Giorgio, Citella, seen from the Steps of the Hotel Europa* (1842)*.

However, Europe for Turner did not consist solely of Italy. Visits to Swizerland and, from 1836, to the Rhineland, alternated with tours through the Italian peninsula. These inspired him with grander but more sombre visions charged with Germanic poetry, which he painted in cooler tones.

His 1841 visit to Switzerland led to the creation of some particularly remarkable watercolours. From among his numerous studies Turner selected fifteen subjects and immediately worked up four of them so that his agent, Griffith, could show them to potential clients in their finished state. Out of the original fifteen, which are amongst Turner's masterpieces and reveal his quasi-religious response to the grandeur of nature, only nine found buyers. Three views

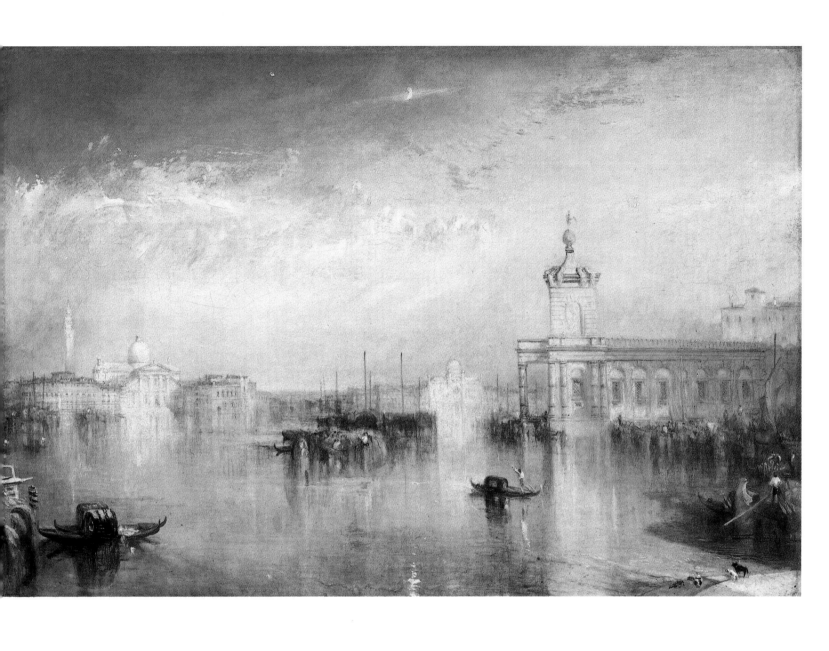

J.M.W. Turner.
The Dogana, San Giorgio, Citella
seen from the Steps of the (Hotel)
Europa, Venice.
1842. Oil on canvas, 62 x 92.5 cm.
Tate Gallery, London.

of the Rigi under different light effects, are at the very peak of achievement from this particular series (*The Red Rigi*, 1842)*, but his views of *Zurich* (1842)* are also remarkable for their dazzling effects of sunlight and mist.

Apart from his almost mystical communing with nature Turner travelled with a more immediately practical end in view; he wished to assemble a portfolio of scenes and records for publication in albums of engravings. There was a burgeoning market for such views, which is what kept the topographical artists employed, but Turner was able to raise this art form to a vastly superior level. This work ensured him a steady income and left him free to paint pictures which would not necessarily be easy to sell. After *The Rivers of England* and *Views in England and Wales*, he produced another folio, *The Rivers of France*, devoted to the Seine and the Loire. The original views of the Loire, painted on the spot in gouache on blue paper, beguile us by their simplicity, but according to the engravers they were not really suitable for the purposes of engraving. Many of his contemporaries described them as being pictures of nothing; they were really studies of the effects of light and colour reflected in the water below the hills and castles which lined the river. The views of the Seine, however, were more precise and less atmospheric, influenced a little, perhaps, by the work of Bonington, whose colourful style was already proving very popular. These souvenirs of *Wanderings by the Loire and the Seine* were intended to become part of a much wider project, *The Rivers of Europe*, which would include the Rhine, the Meuse and the Moselle. Its publication was announced in 1833, but the project was never fully completed.

THE FURY OF THE ELEMENTS

During the years immediately before and after his election to the Academy, Turner painted a number of works inspired by biblical or historical subjects. The treatment of these themes related directly to his notions of the "sublime", which transmitted sensations of terror as well as of beauty in the face of implacable natural forces. After *Dolbadern Castle*, which conjured memories of its political prisoner, he painted *The Fifth* and then *The Tenth Plague of Egypt*, as well as other compositions in the "grand style" so popular with the Academy.

It was not long, however, before Turner the landscapist dispensed with such historical pretexts for paintings, and went directly to nature to find suitably dramatic and sublime subjects. There was no shortage of natural disasters to evoke the sensations he sought and his selection ranged widely from mountain dramas and conflagrations to all the tragedies of the sea.

He had first glimpsed the overwhelming grandeur of mountains whilst in Wales, but these sensations were confirmed and augmented in the Alps in 1802, as we have already discussed. During the ensuing years, Turner exploited his Alpine memories using them as a suitable springboard for several of his most ambitious works. In *Avalanche in the Grisons* (1810)* the violence of this terrific natural force is transmitted through Turner's forceful use of the palette knife, which emphasises the diagonals, whilst the human dimensions of the disaster are vividly recalled by the roof of the chalet, which is virtually crushed by the largest of the displaced blocks.

J.M.W. Turner.
Looking East from the Giudecca.
Sunrise.
1819. Watercolour, 22.2 x 28.7 cm.
Tate Gallery, London.
Within the broad spread of this view the
shapes carefully relate to each other,
whilst above, the clouds are like the
notes that the artist made in his "colour
beginnings."

Natural disaster looms large again in 1812, but this time in historical guise as the force behind his great composition *Snow Storm: Hannibal and his Army Crossing the Alps* (1812)*. The composition expresses vividly the philosophical message of the painting, which is to underline the inequalities between man and nature. The irresistible force of the great storm that is threatening, not only makes the Roman soldiers look ridiculously puny, but threatens to annihilate every object on the face of the earth. The historical subject matter of this painting, augmented by the apocalyptic vision in the heavens, invests it with a tragic power, which makes it one of the most perfect of his renderings of the "sublime".

From avalanches, Turner moved on to volcanoes with his *Eruption of Souffriere* in 1812, and the watercolour of *Vesuvius Erupting* (1817), neither of which were painted from nature, but which bear witness to the intense interest that this theme held for Turner even before his first visit to Italy in 1819. Vesuvius did at least put on a performance with a minor eruption when he did in fact see it.

Fire was a very real threat, especially for Londoners, who were still very well aware of the destruction caused by the Great Fire of 1666. Turner witnessed a great conflagration at first hand during the night of 16th October 1834, when the Palace of Westminster burned to the ground. The scene was awe inspiring in the darkness, with the brilliance of the flames multiplied by their reflection in the Thames. In order not to miss any detail or sensation, Turner and several other artists, observed it from a boat. Nine watercolours (p.119) survive depicting a great fire, but they are too general in effect to allow us to be absolutely certain whether they actually represent the burning of the Houses of Parliament or another disaster two years later. The lack of detail, however, heightens rather than diminishes the extraordinary sense of the destructive force and violence, created by the dramatic contrast between the leaping flames and the surrounding darkness.

The Houses of Parliament in flames are the subject of two oil paintings dating from 1835. The one in Philadelphia (Philadelphia Museum of Art) encompasses every aspect of the scene and revels in the variety of detail. Turner portrayed not only the great conflagration itself, but the reflections of the flames in the water and in the sky, as well as the bizarre lighting on Westminster Bridge and the intensely curious London crowds who packed it, the river banks and every available craft. The seering and painful brightness of the fire made any detailing of the inferno quite impossible, and Turner rendered this with pure colour, reserving the detail for the periphery of the scene, where, in the foreground, everything is either silhouetted against the flames, or picked out in livid and unnatural hues. Nothing escaped Turner either in terms of incident or in the psychologically charged atmosphere of the scene. However, some people prefer his second version of the subject, which is in Cleveland. Seen from a greater distance, it is far less frenetic, and the conflagration assumes a menacing and almost apocalyptic dimension.

After Alpine peaks, volcanoes and fires the sea, with all its concomitant dangers, provided an inexhaustible source of sublime subject matter for Turner throughout his life. The number of these marine paintings is so large

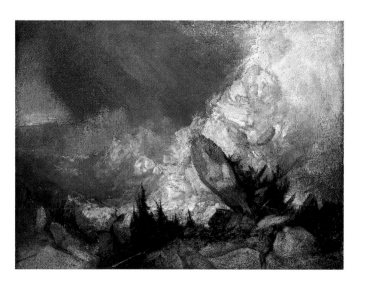

J.M.W. TURNER.

AN AVALANCHE IN THE GRISONS.

1810. Oil on canvas, 90 x 120 cm.

Tate Gallery, London.

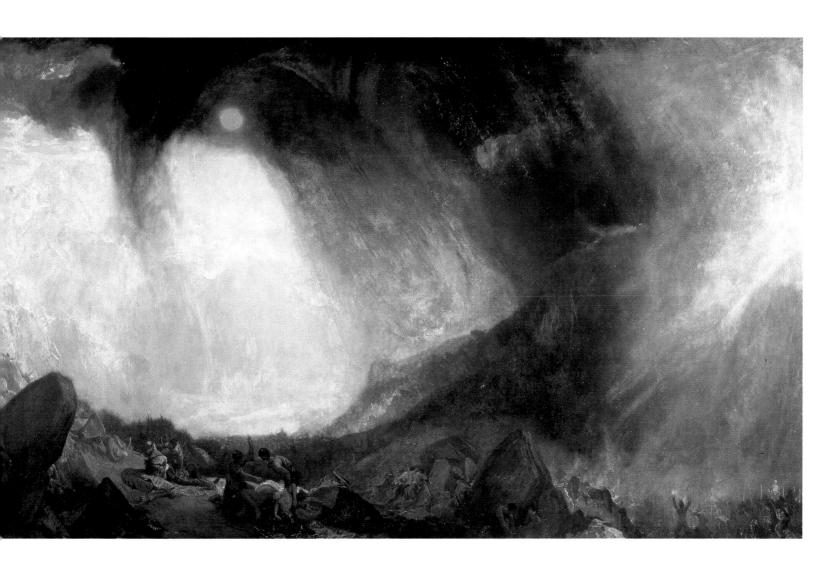

J.M.W. TURNER.
SNOW STORM: HANIBAL AND HIS ARMY
CROSSING THE ALPS.
1812. Oil on canvas, 91.5 x 122 cm.
Tate Gallery, London.
The date of 1812 is important. Behind
the usual title of this work it is also
possible to suggest an alternative:
"Napoleon and his Army during the
Retreat from Russia."

that one cannot endeavour to list them here. However, it is possible to get an idea of their evolution by juxtaposing the realism of *Calais Pier* (1802) with *Snow Storm. Steam Boat off a Harbour's Mouth making Signals in Shallow Water and going by the Lead* (1842)*. This long and detailed title was essential to explain the obscure subject matter of the picture, which was of a scene witnessed by Turner himself whilst lashed to the mast for safety. Painted at the height of the storm the shape of the ship is barely distinguishable, and with the subject matter thus dissolved – pulverized might be a better word – the painting is no longer representational but forcefully suggests the terrifying power of the elements, and the helplessness and blind fear of those poor mortals condemned to almost certain death in the embattled vessel.

Between these two extremes, Turner painted almost every aspect of life at sea. After the stylishly elegant *Ships Bearing up for Anchorage* (1802, Petworth House) in the manner of the Van de Veldes, he painted the tragic *Shipwreck* (1805, Tate Gallery) with its clusters of drowning passengers and crew caught in the foaming vortex.

Leaving aside such exceptions as the social scenes at *Cowes Regatta* (1828), Turner's marine paintings are usually variations on the theme of pounding waves and ships in difficulty, and regardless of whether these are factual scenes, which he had witnessed, or visions of the "sublime", he always handled them with a truly breathtaking skill. Sometimes, though, he chose to work in a purely romantic vein as in *Staffa, Fingal's Cave* (1832)*, based on the memory of a difficult trip around the north of Scotland by boat. The whole painting is a depiction of atmosphere, everything is wrapped in fog, including the fascinating and inaccessible island of Staffa. This is a fairy-tale vision and for once enchantment takes the place of shipwreck and disaster as Turner's inspirational theme.

Another seascape, even more subtle in its evocation is *Dawn after the Wreck* (c.1841, Courtauld Institute, London). In this painting the storm has already abated and only one incident bears witness to the drama and tragedy of the preceding night – the dog howling on the beach as if to recall its drowned master – everything else is calm and serene as a fresh dawn begins to illumine both sky and sea.

After so many catastrophes, natural, sublime and romantic, is it possible to detect a ray of hope in *Rain, Steam and Speed* (1844, Tate Gallery)? A victory for man over the elements for once? For Turner, who had drawn and painted several coaching accidents on pot-holed Alpine roads, the progression from horse-drawn vehicle to steam train is an obvious note of the benefits of civilisation. But at the cosmic level, he could not help but be aware that the elements could never be tamed.

The violence of natural disasters, despite their evident importance, were not the only inspiration for Turner's landscapes. They are matched by an equal number of calm and peaceful scenes of the English countryside, with its tranquil parkland and country houses. Some wealthy landowners welcomed Turner into their homes as a friend; he made long visits to Walter Fawkes at Farnley and to the Earl of Egremont at Petworth, where a special room was set aside as a studio for him.

It was for Lord Egremont that he painted *Chichester Canal** near Petworth.

Previous pages

J.M.W. TURNER.
THE BURNING OF THE HOUSE OF
LORDS AND THE HOUSE OF COMMONS,
16 OCTOBER, 1834.
1835. Oil on canvas. 92.5 x 123 cm.
Cleveland Museum of Art, Ohio.

J.M.W. Turner.
Staffa, Fingal's Cave.
1832. Oil on canvas, 91.5 x 122 cm.
Yale Center for British Art.

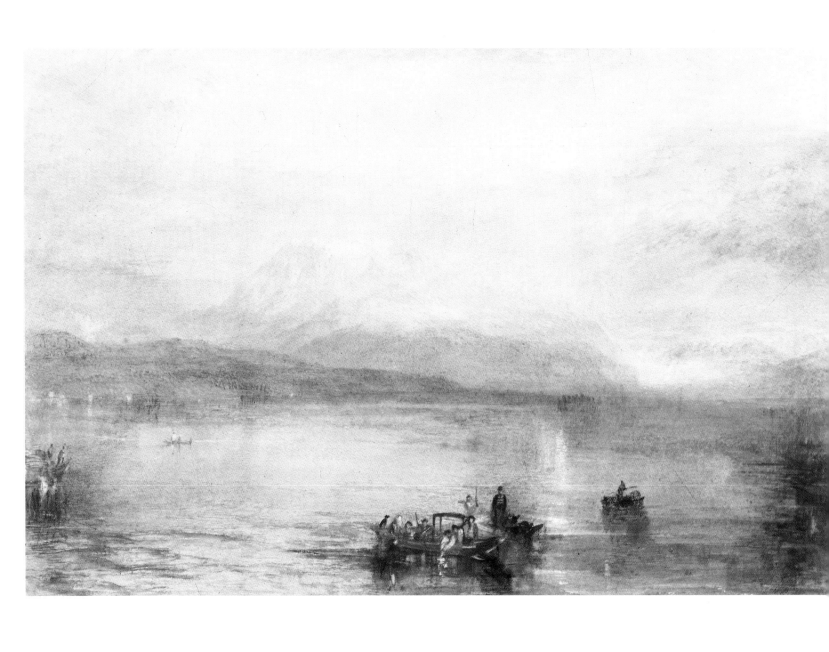

J.M.W. Turner.
The Red Righi.
1842. Watercolour, 30.5 x 45.8 cm.
National Gallery of Victoria, Melbourne.

J.M.W. Turner.
Zurich.
1842. Watercolour, 30 x 45.6 cm
British Museum, London.

An oil study for this painting (c.1828), which is in the Tate Gallery, expresses fully the serenity of the place and the delight that Turner had in working there. He managed to sum this all up in the one splendid image of twilight with the last rays of the setting sun reflected in the wide expanse of water.

CONSTRUCTOR AND DESTRUCTOR

Trained as he was in the most exacting discipline of the topographical tradition, Turner quickly mastered the difficulties of exact representation. This pursuit of formal representation reached a point of perfection with him in the drawings he made in 1807 following his nomination as Professor of Perspective at the Royal Academy. Between 1811 and 1828 he gave only six lectures, which were often inaudible and his text was, on the whole, incomprehensible. Having left school at the age of twelve, Turner always had the greatest difficulty in marshalling his arguments and expressing them clearly, but his audience were attracted, nonetheless, by the remarkable drawings which he created especially for the occasion. When confronted with the complexity of analysing the volume of a Doric frieze, or the reflections of light through a glass sphere full of water, he was quite capable of doing it, and even more extraordinary than the precision of these diagrams was their crystal clarity.

Parallel with his pursuit of precision, Turner was also developing an almost insidious campaign of deconstruction, which culminated in his extraordinary vision of *Snow Storm. Steam Boat* of 1842.

Because of its novelty this development was more noticeable to his contemporaries than it is to us today, accustomed as we are to looking at non-figurative work. In 1808 a critic, John Landseer noted: "...In the pictures of the present season, he has been peculiarly successful in seeming to mingle light itself with his colours." The essential point which Landseer was driving at was Turner's use of colour to achieve the effect of light. At first he achieved this through contrast, but gradually he eliminated shadow and sought to achieve the efect of light through colour alone. Sir George Beaumont, an implaccable enemy of Turner's charged him in 1812 with investing his oil paintings with the quality of watercolours. This was, to a large degree, true. In about 1795 Turner had decided to give extra body to his watercolours and to try and achieve in that medium something of the strength of oil paint. Twenty years later he was reversing this policy and was trying to imbue his paintings with the luminosity and clarity of watercolours, and in order to achieve this effect was working into a white priming. His imitators, and even Turner himself, came to be dubbed "the white painters". Sir George accused Turner of debasing the medium and doing a great disservice to the art of painting.

In 1816 the essayist, William Hazlitt stated the situation with clarity when he cited Turner in a note following the essay *On Imitation*. Having firmly defended him, Hazlitt continues: "We have alluded particularly to Turner, the ablest landscape-painter now living, whose pictures are however too much abstractions of aerial perspective, and representations not properly of the objects of nature as of the medium through which they were seen. They represent the triumph of knowledge [...] over lack of subject matter. They are pictures of the

J.M.W. Turner.
The Burning of the Houses of
Parliament.
1834. Watercolour. British Museum.
London.

Caricature: TURNER PAINTING ONE OF
HIS CANVASES. EXTRACT FROM *The
Almanack of the Month, June 1846.*
The evidence of such caricatures shows
Turner's contemporary fame. He is depict-
ed on varnishing day at the Royal
Academy. He would send in an incomplete
picture, which he would proceed to finish
in front of his astonished colleagues
during the three days permitted, in order
to gain their admiration for his skill. His
clothes are not a caricature, he was
always dressed in this manner. The word
"yellow" printed on the bucket is an allu-
sion to the artist's attachment to this par-
ticular colour. A newspaper referred
humourously in 1827 to "yellow fever" at
the Academy. Like Goethe, whose theories
he knew, Turner associated yellow with
the brightest form of light, as well as with
everything that was joyful and exciting.

elements of air, earth and water. The artist delights to go back to the first chaos
of the world, or to that state of things when the waters were separated from the
dry land, and light from darkness... All is without form and void. Someone said
of his landscapes that they were "pictures of nothing and very like."

Hazlitt, when he recalled and quoted the comments of the anonymous
critic, possibly had in mind *Hannibal Crossing the Alps*, although he didn't say
so specifically. He was remarkably perceptive, though, and it is quite possible
to say of Turner's later works that "everything is without form and empty",
and that they are "paintings of nothing and very like." With a century and a
half of hindsight this witticism is seen to be an observation of genius, a far
sighted value judgment.

We have noted that it was the experience of Italy and the revelation of
the light there that turned Turner towards trying to represent form by colour
rather than line. From that point on he constructed his paintings around
three complementary ingredients: form, colour and light, with the last two
increasingly taking the leading roles. He dissolved landscape in light but,
paradoxically, without light the landscape could not be seen to exist at all.

Through the existence of steam, snow storms, smoke or mist, light
plays and sparkles in the atmosphere and thus, for Turner, became a vehicle
for colour, which then enveloped form. In an interesting aside Constable said:
"Turner has surpassed himself. He appears to be painting with tinted mist,
evanescent and celestial." *The Burning of the Houses of Parliament*, like his
watercolour view of *Zurich* (1841, Tate Gallery), illustrates this perfectly.

On the other hand, Turner clearly appreciated that very intense light also
dissolves outline, and thereby literally destroys form. One particular landscape
of his demonstrates this clearly. It is *The Terrace at Mortlake on a Summer's
Evening* (1827, National Gallery, Washington). At the precise point at which
the rays of the setting sun strike the parapet, the upper part is broken, as though
shattered by the light, and its form is reduced to an irregular pattern of colour.

But this light, whilst it may be destructive of form, plays, at the same
time, a positive and psychologically important role in setting the atmosphere
of a place. In this same view of Mortlake it is difficult to accept the golden
tones at their face value as a factual record, but they have the power and the
ability to express the delightful tranquility of a summer's evening. Incapable of
appreciating this subtlety, many visitors to the Academy mocked Turner and
suggested he was suffering from "yellow fever."

The public would have been even more baffled if they could have seen the
works he kept hidden away, particularly the numerous "colour beginninings",
which were not discovered until after his death. These notes, which often consist
of little more than juxtaposed bands of watercolour, demonstrate that for Turner
the resolving of colour harmonies was possibly the most important part of his
work process. It is difficult to be precise but it is believed that the earliest of these
"beginnings" date from about 1815-1820. To our eyes they are generally
extremely beautiful, and it is fascinating that the artist was able to resolve so much
in these uninhibited studies, as he was the only one to witness the final results.

Turner was alone in his generation in the intensity with which he
responded to light and colour, and the only one to express this vision through

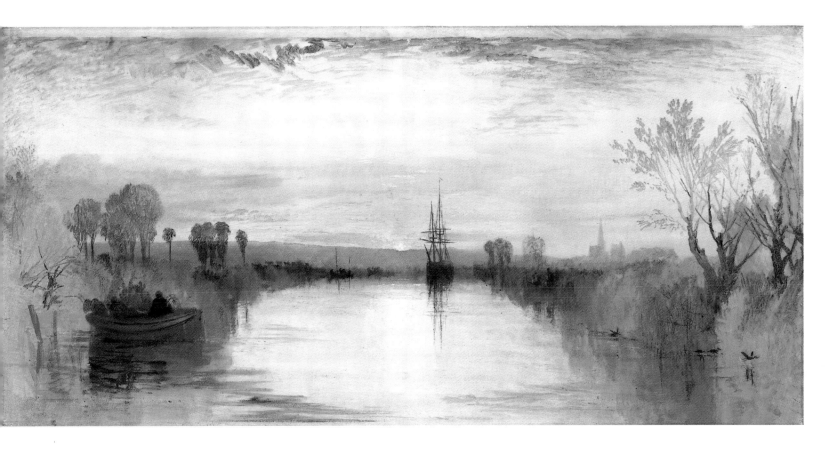

J.M.W. TURNER.
CHICHESTER CANAL.
c. 1828. Oil Sketch. 65.5 x 134.5 cm.
Tate Gallery, London.

purely pictorial means. He was far in advance of his time, and the gap which divided him from the public became more exaggerated as the years went by until, towards the very end of his life, they found his paintings almost totally incomprehensible. Although some of his more traditional landscapes had fetched fabulous prices during his lifetime, as several wealthy enthusiasts competed for them, many others were found unshown and unsold in his studio at the time of his death in 1851. The *Times* critic nonetheless commented freely on the fact that: "None of his brethren seems to have had any doubt concerning his decided excellence, and the best of them all have ever readily admitted his superiority in poetry, feeling, fancy and genius... Even those who could only sneer and smile at the erratic blaze of his colour... lingered minute after minute before the last incomprehensible "Turner" that gleamed on the walls of the Academy."

Because of being so much in advance of his time Turner did not immediately attract disciples and followers, but in 1870, when Pissarro and Monet were refugees in London they discovered his work and appreciated his genius, succumbing willingly to his influence. One can see a similarity beween Pissarro's *White Frost* (1873, Musée d'Orsay, Paris) and Turner's *Frosty Morning* (1813, Tate Gallery). Nevertheless, the profundity of Turner's art and his interpretation of atmosphere did not come to be appreciated fully until very much later. He alone remained the great visionary, who destroyed topographical form and heralded a non-figurative art.

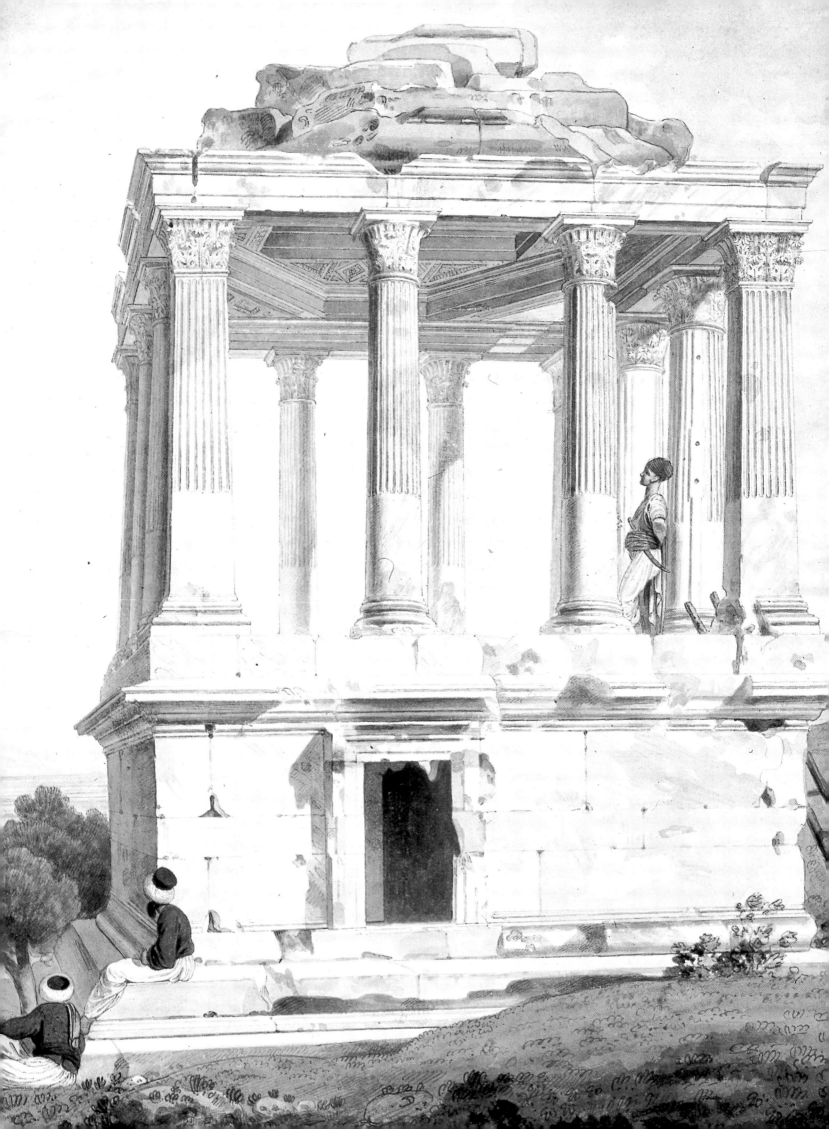

LONG-RANGE
TRAVELLERS

WILLIAM PARS.
A FUNERARY MONUMENT AT MYLASSA.
Watercolour, grey ink, gouache and gum
arabic. 28.5 x 47.1 cm. British Museum,
London.

Throughout Europe during the 19th century there was a great urge to travel, but in this field the British preceded their continental counterparts by several decades. The experience of the "grand tour", so sought after in the 18th century, had already become commonplace, except during the periods when the continent was cut off to tourists because of war.

When Turner scoured Europe in search of subjects, the journey from Paris to Lyon in a hired carriage took four days, and crossing the Alps in wintertime was a hazardous experience. However, for such an intrepid traveller nothing was impossible. Many other artists, especially water-colourists, were attracted to Italy: we have already looked at the work of John Robert Cozens and Francis Towne, but mentioned should be made also of Jonathan Skelton, Thomas Jones and John "Warwick" Smith.

Some artists were tempted to travel further afield to explore the Near and Middle East – Palestine, the Holy Land and Egypt – whilst others went to the Far East and even the Pacific Islands. In the latter cases an extraordinary amount of preparation and organisation was necessary. The person in charge of such an expedition would engage an artist with the express purpose of recording the places visited. On the expeditions return this material would be worked up for publication and probably also into more elaborate watercolours or oil paintings for exhibition and sale. These artist-travellers were often men of remarkable skill. When Lord Elgin prepared to leave for Greece, from

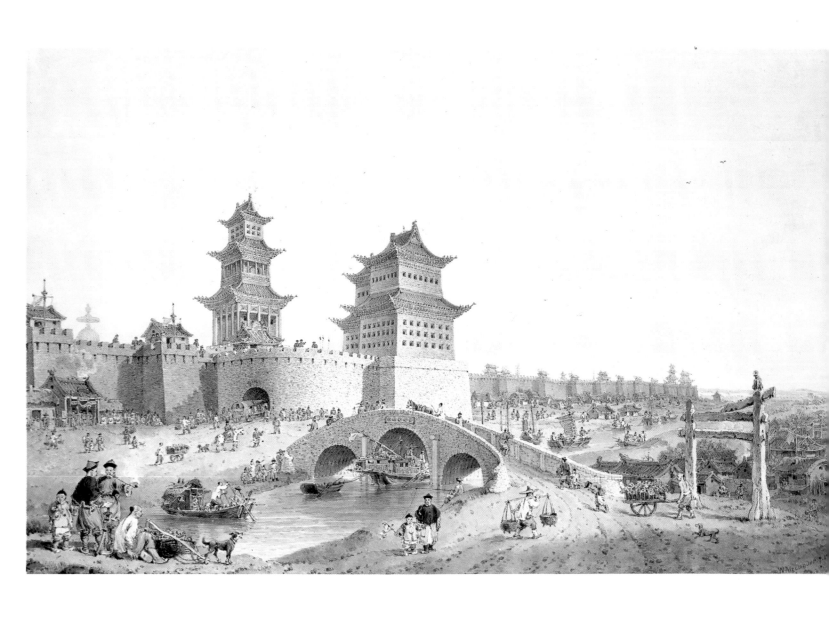

WILLIAM ALEXANDER.
PINGZE MEN, THE WESTERN GATE OF
BEIJING.
1799. Watercolour over pencil, with
touches of black ink. 28.4 x 44.8 cm.
British Museum, London.

whence he brought back the Parthenon marbles, he invited Turner to accompany him. Turner proudly refused as the salary offered was less than the noble earl paid his valet!

VOYAGES OF DISCOVERY AND DISTANT EMBASSIES

Captain Cook made three voyages around the world at the request of the British government. The second of these (1772-1775) was destined for Australia, and on the return leg Cook visited New Zealand and New Caledonia. Cook's two ships, *The Adventure* and *The Resolution* are familiar to us from William Hodges' drawings (1774)*. Hodges, who was the official artist attached to the expedition, also produced many watercolours of a topographical nature, such as the *View of the Island of Tahiti* (1773, British Museum, London), which are as accurate as any geographical survey. In this work the vegetation is detailed, though not to the point of pedantry, whilst the palm trees extend their fronds, making elegant silhouettes against the sky. Tempted again by travel and the Orient, Hodges made a long voyage to India (1780-1783), and on his return produced a considerable number of oil paintings in which he successfully managed to combine exotic subject matter with a traditionally classical format. Hodges had been a pupil of Wilson's and, even in these late works, still had a tendency to idealise his scenes.

For the third and last of his voyages (1776-1780) Cook took as his official draughtsman John Webber, who made a quantity of drawings of the jagged coastline of Vancouver Island, to the West of Canada. Webber's Swiss origins are apparent in his style, which recalls the work of the German engravers, however, it was perfectly suited to this bleak and ravaged landscape.

Important embassies were also accompanied by an official artist, and when Lord Macartney left for China in 1792 he took William Alexander, who was to become an important recorder of Chinese life and landscape. The choice of Alexander was a sensible one as he worked in a traditional manner akin to topography, and was able to transcribe accurately and without exaggeration exactly what he saw, leaving the drama to his exotic subject matter. The precision and documentary interest of *The West Gate of Beijing* (1799)* does not detract from its charm, and faithfully evokes both the architecture and the people. After his return Alexander worked up many of his sketches into finished watercolours, and a number were also made into engravings.

Archaeology, another favourite pastime of the British aristocracy, was the object of the Dilettanti Society, founded in 1753 by a group of noblemen to advance the understanding of ancient history. For the archaeological expedition to Asia Minor in 1764 the Dilettanti Society selected the twenty two year old artist, William Pars. Pars was a surprising choice as, until this time, he had been practising as a portrait painter and had little experience of landscape painting or topography. Nonetheless, he produced excellent watercolours. *The Funeral Monument of Mylassa** shows what he felt was due to an archaeological record in terms of detail, but at the same time happily evokes the atmosphere and the surrounding countryside. Later, Pars followed in the footsteps of J. R. Cozens and Francis Towne, when he travelled in the Alps

WILLIAM JAMES MULLER.
THE ROCKY STAIR AT TLOS.
1844. Pencil and watercolour on thin
board, 34.7 x 53.7 cm. Tate Gallery,
London.

WILLIAM HODGES.
THE RESOLUTION IN THE MARQUESAS.
1774. Ink and wash, 28.9 x 23.1.
National Maritime Museum, Greenwich.

with Lord Palmerston. Although his Alpine watercolours are to some degree scientific documents concerned with the formation of glaciers, they also rank as landscapes of considerable merit due to their clarity and breadth of vision.

THE INDEPENDENT TRAVELLERS

During the 19th century the prestige and expansion of the British Empire served to assure the safety of English travellers. Artists, like others, became free to travel on their own via Spain and the Eastern Mediterranean in search of new subjects with which to delight the public.

David Roberts and William James Muller travelled around the Near and Middle East without bothering about trying to meet. Roberts was able to boast of being the first British artist to ascend the Nile, ignoring the fact that Muller, the second, was there only a month later.

Roberts, having been born into a poor Scottish family, started life as a house painter, before moving to London and becoming a scene painter at the Drury Lane Theatre. The quest for inspiration for more great scenes and architectural detail took him to Spain (1832) and Morocco, and a few years later to Egypt (1838). Disdaining the slave markets full of beautiful women, and other exotic subject matter, he chose to concentrate on the antiquities, many of which were still partially buried. His watercolours of Philae and Karnak – particularly *The Temple of Amon at Karnak* (1838)* – Thebes and Abou Simbel, far excel mere topography, and convey something of his emotion when faced with these great monuments of ancient Egyptian culture. The following year, wishing to cross the Sinai Desert, he travelled to the Holy Land in a caravan, and painted an impressive view of *The Convent of Saint Catherine with Mount Horeb* (1839, Private Collection).

After his return to London and the publication, in lithographic form, of his watercolours, Roberts' artistic reputation was greatly enhanced, and to many of us today these watercolours, with their subdued tones, are far more beguiling than his oil paintings, which continued to be influenced by his experiences as a theatrical scene painter.

William James Muller was an enthusiastic and impassioned artist – "painting oozes from my fingers" he said – who travelled first in Europe and then, in 1838, decided to go on to Greece and Egypt. After his return to England his experiences and his drawings inspired him to produce grand paintings such as *The Carpet Bazaar, Cairo* (1843, Bristol City Art Gallery), pulsating with vibrant colour, and an extraordinary *tour de force* for a young man of only thirty one.

After a trip through France, during which he gathered material for a publication devoted to *The Age of Francois I of France,* he left England once again, in 1843, for Turkey, where he intended to join an archaeological expedition under the direction of C. Fellows, who was conducting a dig in Lycia. As it turned out, this was a mistake. Muller was barely tolerated and, being regarded as only peripheral to the expedition, had to work under considerable difficulties. However, he seized the opportunity of that journey to visit Turkey, Smyrna, Constantinople and Rhodes, before finally arriving in Lycia, where he

produced some very beautiful watercolours such as *The Rocky Stair of Tlos* (1844)*. This, howewver, did not inhibit him from depicting more populous scenes such as *The Great Harbour of Rhodes* (1844)*. The following year, after his return to England, Muller died of heart disease at the early age of thirty three. He had really only just begun to exploit his talents, which were still expanding all the time.

The public, however, preferred the work of John Frederick Lewis to that of Muller. Lewis, next to Turner, was the most celebrated artist in Britain; after travelling in Spain he spent ten years in Cairo. At that time, in response to the writings of John Ruskin, fashion demanded minute detail, which had the unfortunate result of breaking up a work of art into a number of vignettes, often emphasised by the use of violent colour. Such were the interiors and harem scenes which assured Lewis of success after 1850, but some of his exterior views, like *The Entrance to the Tomb of Sultan Bayezid at Constantinople**, were more subtle, and the beguiling quality of detail is forgotten in the quest for more general atmospheric effect.

In addition to these travellers who, having completed their travels, returned to England and settled down to exploit the material that they had collected, there was one artist of note whose entire life was spent travelling. This was Edward Lear, poet and writer of limericks, who was also the author of the *Book of Nonsense*. Despite frequent fits of epilepsy Lear travelled alone with his servant throughout the Levant. When he arrived in a place he would make numerous sketches of the scenery, which he would wash in later with watercolour; these studies could then be worked up either into finished watercolours, or translated into oils if a client or patron so wished. Although his colouring was hardly innovatory, his drawing was sensitive and of an extraordinary spontaneity, as can be seen in his *View of Jerusalem**.

Another peripatetic artist was Hercules Brabazon Brabazon, whose work is very different in feeling from Lear's. Brabazon was a rich and gifted amateur, who painted purely for pleasure, without ever dreaming of sales or even wishing to exhibit at the Academy. He was an enthusiastic admirer of Turner, as can be clearly seen in his own work, and fully appreciated the importance of freely applied colour regardless of form.

JOHN FREDERICK LEWIS.
ENTRANCE TO THE TOMB OF SULTAN BAYEZID, CONSTANTINOPLE.
Pencil and watercolour, 51.5 x 35.6 cm.
Victoria & Albert Museum, London.

Following pages

WILLIAM JAMES MULLER.
THE GREAT HARBOUR, RHODES.
1844. Watercolour. British Museum.

EDWARD LEAR.
VIEW OF JERUSALEM.
Pen and ink and watercolour. Tate Gallery. London.

CROME AND CONSTABLE,
PAINTERS OF THE SOIL

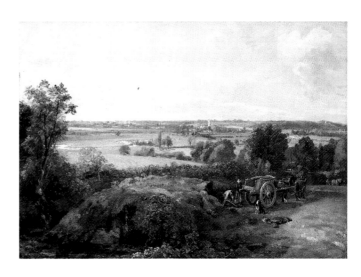

JOHN CONSTABLE,
VIEW OF DEDHAM. THE STOUR VALLEY
AND DEDHAM VILLAGE.
1814. Oil on canvas, 55.3 x 78.1 cm.
Museum of Fine Arts, Boston.

With *Cader Idris*, painted about 1765, Richard Wilson had taken an important step towards realism, especially in his choice of such an uncompromisingly dramatic site in Britain. This desire to paint at home was strengthened by the impossibility at the end of the 18th century for British travellers to visit the continent. It is not surprising therefore that a peculiarly English school of landscape painters should have developed around John Crome at Norwich, in Norfolk, a region to which Crome himself was deeply attached.

Crome came from a humble background and had no formal training as an artist, however, he fell under the spell of some of the Dutch painters, whose landscapes he saw, most particularly those of Hobbema, which he tried to emulate in his own work. In 1802 he visited the Lake District, which inspired a grander and more open vision, as can be seen in the *Slate Quarries* (1802-1805)*, in which the softening effect of the mist plays across the bare mountainside.

Despite many visits to London, extensive travels throughout England, and one visit to Paris, Crome remained loyal to his native county and preferred to use Norfolk as the inspiration for most of his paintings. It was there also that he founded the Society of Norwich Artists, a lively group of painters rooted in the area, who were eager for mutual improvement. One of the notable figures of the group was J. S. Cotman, who was elected President of the Society in 1811.

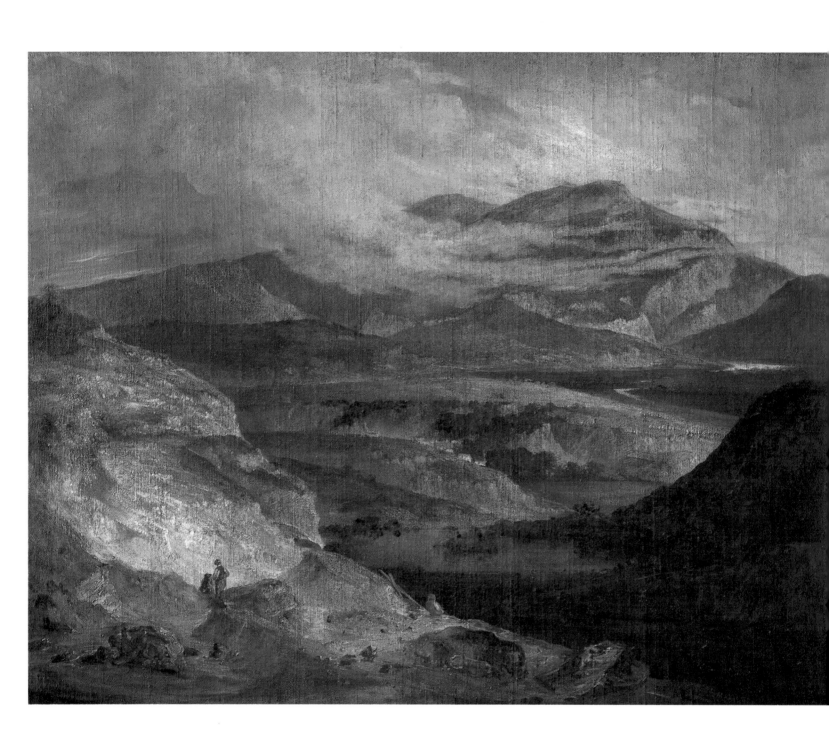

JOHN CROME.
SLATE QUARRIES.
c. 1802-1805. Oil on canvas.
Tate Gallery, London.

The Norwich School remained, in the strictest sense provincial, but nevertheless it provided an important forum for the development of landscape painting. It also established a link between many painters of consequence, as well as revering the memory of Gainsborough's art and appreciating the best of Constable's. Both Gainsborough and Constable had been born in East Anglia.

Constable's refreshing vision

Delacroix never hesitated to proclaim his admiration for Constable. He noted in his *Journal* for the 9th November 1823: "Today I saw a sketch by Constable, an admirable thing and quite astounding." The following year, having seen other works exhibited at the Paris Salon, he wrote: "Constable makes me feel good." From this we know that Delacroix was familiar with the two types of work which Constable produced: the sketch, which he had greatly admired, and the finished exhibition paintings which were shown at the Salon and included *The Haywain* (1821)* and a *View of Hampstead.*

From our point of view today, Constable's fully worked canvases, which he took to the high degree of finish beloved by the Selection Committee of the Royal Academy, have less appeal than his sketches and studies. He was a consummate master at producing quick, fresh and dashing sketches which exactly mirrored the intensity of his response to nature, from which he drew his inspiration. During the process of developing the sketch into a more finished study and finally into the exhibition painting, much of this quality of immediacy and spontaneity was lost, or completely overwhelmed.

Between the different stages there were many hurdles and Constable frequently found himself pulled in different directions. When one looks at his whole career, though, one appreciates that he had to overcome two particular problems. First of all he had to create his own pictorial vocabulary, which would allow him fully to express his feelings, and then he had to try and educate the public to come to terms with his vision. Constable's vision was revolutionary and the public had to accustom itself to seeing the world as it was, in all its naked realism, rather than through the imagination. For Constable to achieve such a degree of realism was to get to the very heart of the overwhelming beauty of the places he knew and loved.

Previously the English had had a preference for idealised landscapes in the manner of Claude Lorrain, and potential buyers at the beginning of the 19th century were not attracted to depictions of the real world. Constable was the direct opposite of this tradition; he was a man of the soil and deeply attached to the region of East Anglia where he was born. It was that countryside that he loved and wished to paint exactly as it was, without idealisation or added charms.

Reality changed in painting

John Constable spent his early life in the village of East Bergholt, where he was born, and where his father owned several mills – Flatford Mill, Dedham Mill and Stratford Mill – on the river Stour, and it was in this

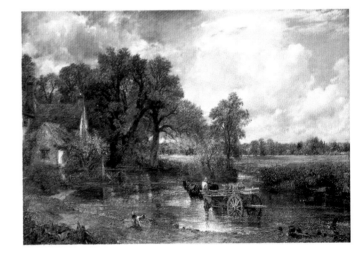

John Constable.
The Hay Wain.
1821. Oil on canvas, 130.5 x 185.5 cm.
National Gallery, London.

137

familiar countryside that he started to draw as a boy. Later, in 1814, he painted a remarkable scene, *The Valley of the Stour and the Village of Dedham* *, which captured all this early affection. It was there that he had his roots, and it was there that he returned every summer throughout his life to make sketches and studies, which he used during the winter months in London to create his more ambitious works. This annual renewal of contact with the area around Dedham was extremely important to him, so much so that one can almost regard it as an obsession. Has not the poet, Wordsworth, affirmed that: "The child is the father of the man."?

Contemporary psychological research suggests that the emotions of an artist explain his work better than his intelligence. They drive him to develop a language through which to express his feelings, and it is this same drive that adds power and emotion to his recollection of the past. Constable was fully aware of his motives and, in one of his letters, described the importance and strength of his own memories: "The sound of water escaping from mill-dams, the willows, old rotten planks, slimy posts and brickwork; I love such things... those scenes made me a painter."

Like Proust dedicating his life to exploring forgotten memories and past times, Constable felt compelled to immortalise the Stour valley as it had appeared at the beginning of the century, when it was a true centre of rural life. The river had been dug out like a canal, with numerous locks, to facilitate the movement of barges, with the result that the passing of men and horses on the towpath were a familiar scene. Such groups were to become incidents of colour and movement in the series of *Scenes of the Stour Valley*, which Constable painted between 1819 and 1826.

At a more profound level, though, it was the elements that truly fascinated him. The river in all its moods, sluggish and calmly reflecting the sky, or in full spate and rather frightening, or trapped between the lock gates brown and rippling with water weed. There were also the trees, which he loved, and with which he could identify so closely that he could almost feel how they felt as the sun played over them or the rain splashed down on their leaves.

It was in East Bergholt, too, that in 1809 Constable met Maria Bicknell, whom he married seven years later after a long engagement.

LONDON, HAMPSTEAD AND THE SEA

From 1799 onwards Constable spent a part of each year in London. After an initial reluctance, his parents had eventually come round to the idea of accepting his vocation, and in 1802 he was admitted as a pupil at the Royal Academy Schools, only returning to Suffolk during the summer holidays, when he rejoiced in the opportunity to paint out of doors once again. London life did not give him any great pleasure, and he seldom drew inspiration from the metropolis.

From 1819 he began to spend the summer months in Hampstead, where he finally settled, the cleaner air in this hill-top village to the north of London being better for his wife, who was tubercular. Saddly, Maria was never

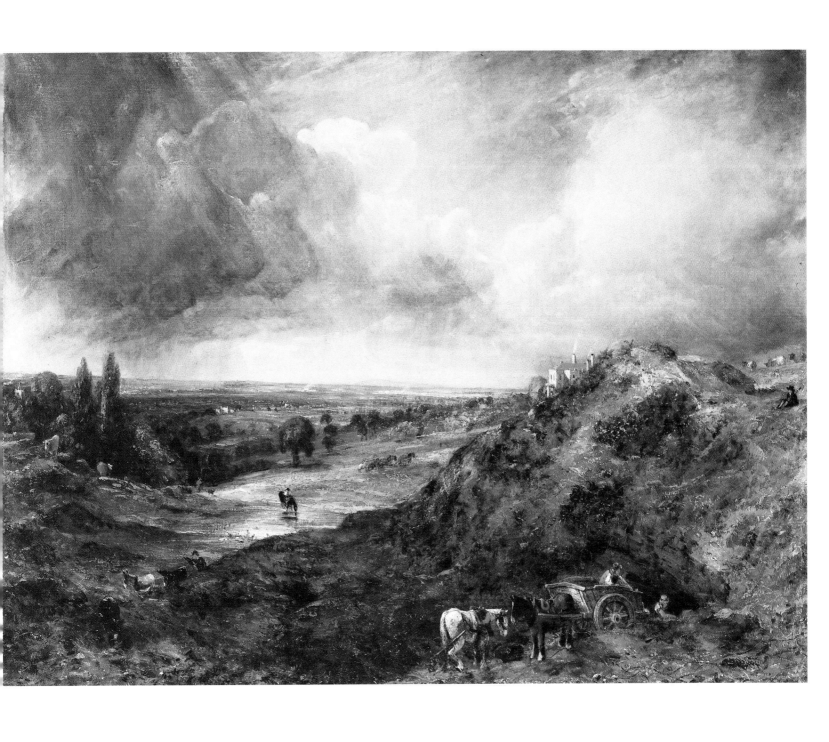

JOHN CONSTABLE.
BRANCH HILL POND, HAMPSTEAD.
1828. Oil on canvas, 60.6 x 78 cm.
Cleveland Museum of Art.

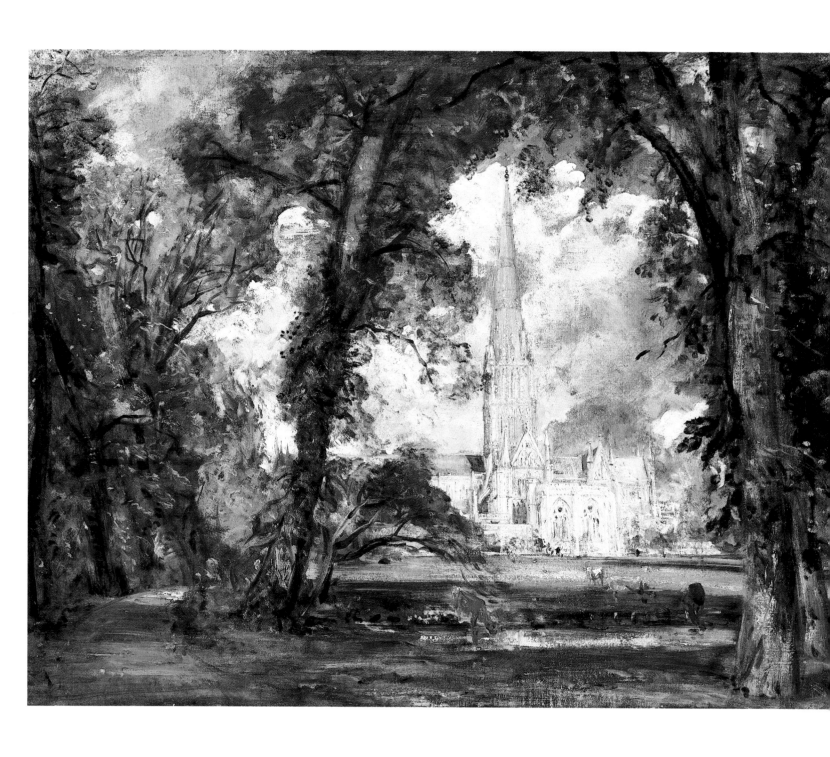

JOHN CONSTABLE.
SALISBURY CATHEDRAL FROM THE
BISHOP'S GROUNDS.
1820. Oil on canvas, 74.3 x 92.4 cm.
National Gallery of Canada.

cured, but her husband found many attractive subjects for his paintings. The view from their windows looking towards the capital was superb as he recorded in a watercolour *London seen from Hampstead* (1832, British Museum, London). Hampstead Heath itself, which was a wide wasteland that started at the very edge of the village, was a favourite place for walks as well as the inspiration for many sketches and paintings, of which some like *Branch Hill Pond on Hampstead Heath* (1828)* reflect the pessimism that plagued Constable towards the end of his life.

Salisbury, with its superb cathedral and beautiful water meadows, was another source of inspiration, and features in many forceful and highly charged works. The elegant spire of the cathedral can be seen soaring above the sombre trees in *Salisbury Cathedral seen from the Bishop's Grounds* (1820)*. Constable's best friend, John Fisher, lived close to the cathedral and he went to stay with him in 1828 following Maria's death.

Constable never felt the need to seek out fresh subject matter, preferring places with which he was familiar – Suffolk, Hampstead, Salisbury – and the sea provided the last of his favourite themes. In 1817 he and Maria spent part of their honeymoon at Osmington in Dorset, which gave him the opportunity to paint some very beautiful views of Osmington Bay and of Weymouth. Following this seaside idyll, and in the quest for his wife's health, they paid many visits to Brighton, despite the fact that he hated this busy and fashionable town, which he described as "Piccadilly on Sea". He was, however, captivated by the pounding of the waves on the wide pebble beaches and the play of the light on the sea, both of which he painted again and again in a series of strong and sensitive studies, which must be numbered among his most remarkable works. *Brighton Beach, 12 June 1824* is only one example from this extraordinary group of studies. These visits were always very moving for him, as they were closely connected to his wife's health, and it is perhaps significant that he only chose to work up one Brighton subject for exhibition at the Academy, *Marine Parade and the Chain Pier, Brighton* (1827)*.

How one becomes a "painter of nature"

Constable was already forty five years old when, in about 1820, he embarked on painting his most important series of canvases; they were the culmination of long years of research and experimentation. A group of drawings of *Cottages* (1796, Victoria & Albert Museum, London) show that by the age of twenty he was strongly attracted to the "picturesque" style, which was fashionable at the end of the 18th century. These sheets of studies are expressive and vibrant. Constable drew quickly and with great dexterity; his line dashes and coils across the paper, breaks sensitively and then contrives unexpected scrolls. His early sketches of trees are also airy and full of life as they evoke the mood of spring. Many aspects of his great *Scenes in the Stour Valley,* painted some twenty years later, seem to be presaged in these drawings. Somewhere, in a letter to his friend Fisher, Constable wrote about these landscapes seen in childhood: "Those scenes made me a painter... I had often thought of pictures of them before I ever touched a pencil." This was in fact the truth.

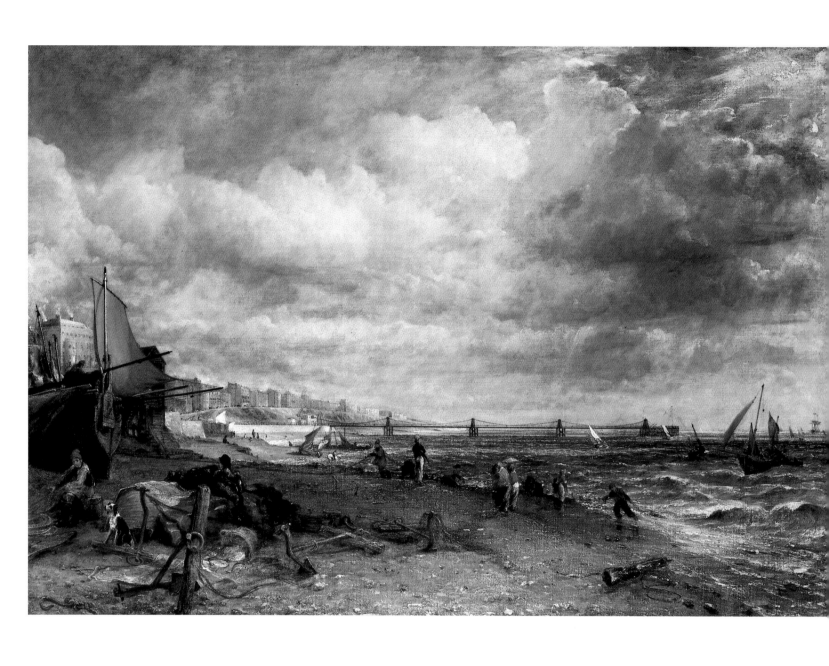

JOHN CONSTABLE.
MARINE PARADE AND THE CHAIN PIER,
BRIGHTON.
*1827. Oil on canvas, 127 x 183 cm. Tate
Gallery, London.*

JOHN CONSTABLE.

FISHING BOATS AT ANCHOR.

1822. Sepia, 18.5 x 22.4 cm. Victoria &
Albert Museum, London.

To realise this vision which he wished to translate into paint, Constable had long emulated the work of those landscape artists whom he admired, and it was Gainsborough, a native of Suffolk like himself, who moved him the most. "Tis a most delightful country for a landscape painter. I fancy I see Gainsborough in every hedge and hollow tree", he wrote whilst on a visit to Ipswich. A little canvas, *A Wood* (1803, Victoria & Albert Museum, London) shows clearly the influence of the 18th century master on the young artist.

Like Gainsborough in his early days, Constable came under the influence of the Dutch masters, especially Ruisdael. Like him he was also beguiled by touches of sunlight filtering through dense foliage.

His realist vision did not inhibit him in any way from admiring the works of Claude Lorrain and Rubens which the great collector, Sir George Beaumont, showed him, whilst the watercolours of John Robert Cozens and Girtin perhaps helped guide him towards his ability to capture the flicker of light playing on trees or water. However, Constable was quick to appreciate that too close a study of the work of other artists was injurious to his own vision, and that the only real truth lay within himself. On 29th May, 1802, he wrote to his friend Dunthorne: "For the last 2 years I have been running after pictures and seeking the truth at second hand. I have not endeavoured to represent nature with the same elevation of mind with which I set out, but have rather tried to make my performances look like the work of other men. I am come to a determination to make no idle visits this summer...I shall return to Bergholt where I shall endeavour to get a pure and unaffected manner of representing the scenes that may employ me... *There is room enough for a natural painter.*" He had found the correct description of himself as "a natural painter", and, at last, his true vocation had become clear. However, despite this, it still seems that he had some difficulty in disengaging himself from early influences.

A tour in the Lake District, which Constable undertook in 1806, shows how difficult it was to divorce his work from the Stour valley. He had undertaken the tour because he appreciated that familiarity with the Lake District was almost obligatory for any artist in pursuit of the picturesque. But Leslie, his first biographer, records: "I have heard him say the solitude of mountains oppressed his spirits... He could not feel satisfied with scenery, however grand in itself, that did not abound in human associations. He required villages, churches, farmhouses and cottages." Yet, despite his reluctance, the tour yielded a beautiful series of low-keyed watercolours such as *View in Borrowdale* (1806)*, charged with romantic melancholy, which we never find in his more expressionistic landscapes.

THE STUDIES: NATURE'S MIRROR

From 1810 onwards, the oil studies which Constable painted directly in front of the motif, like *Barges on the Stour at Flatford Lock* (1810-1812)*, reveal the intoxication he felt in the open air and, judged by the standards of the time, the total rejection of all discipline. This abandonment to the joy of painting is evident in the way that colour bursts out all over the place in long seductive brush-strokes, and in the manner in which the farthest distance is

almost forcibly gouged out, and yet he did not neglect the subtleties of light playing over the water in the foreground.

A number of other studies appear to be more controlled, though the texture of paint varies enormously in response to the motif: it could be laid on very sparingly or coarsely worked and highly wrought. The effects of light, which envelope the scene, come from the extraordinary nuances of tone which Constable was able to control in order to give impressions ranging from spring haze to the overcharged threat of late summer thunder.

In addition to this quest for naturalism, the studies made between 1810 and 1820, are notable for their enhanced sensibility, which manifests itself throughout. Constable did not just paint what he saw, he also painted what he felt, baring his soul through the texture and mood of these works. His temper shows through in the way he handles paint, sometimes harshly, even brutally, and at other times with a loving caress; he immersed himself in the heat as much as in the cold and wet, and gloomy shadow contrasts with bright sunshine. In this whirlpool of interior and perceived sensations, he had to work at speed to capture every fleeting effect, and in the process he took some surprising and daring short-cuts, as can be seen in *Willy Lott's Cottage* (1810-1815)*, a preliminary study for *The Hay Wain**. These studies, usually conceived as working sketches, were not intended to be offered to a public who, unlike Delacroix, were not sufficiently visually educated to appreciate them.

Sky plays an important role in these studies, and sometimes was their only subject. Constable was deeply interested in science and wished to establish the relationship between cloud formations, the seasons, the time and the prevailing meteorological conditions. Painter of nature he may have been, but he also wished to be a scientific painter, and he studiously noted such details on the back of his sketches, and in so doing he went considerably further than Alexander Cozens, his mentor whose precepts he followed so faithfully.

In some of his Hampstead studies he included the horizon at the bottom edge of the sheet, whilst in others he went still further virtually eliminating the landscape but leaving the sky anchored to the ground by the very tops of the trees. Then, again, in his famous series of cloud studies, the tangible world disappears altogether and it was the sky alone which held his complete attention as he wrestled with its secrets, trying to understand the shape, colour and density of different cloud formations. The sky, from where light permeates down upon the landscape, became a favourite theme and a chosen vehicle through which he could exteriorise his profoundest feelings, as in *Cloud Study, Hampstead* (1821)*. It became the canvas on which he was able to bare his own soul, and the scientific studies became mere pretexts. For Constable life consisted of a succession of sensations and by projecting his own inner sensations onto the changing aspects of the sky, he was able to surrender himself completely to the pure and simple joys of painting.

FROM STUDIES TO EXHIBITION WORKS

The deep personal pleasure in making these studies was not enough to satisfy Constable, and, although his brother, Golding Constable, who

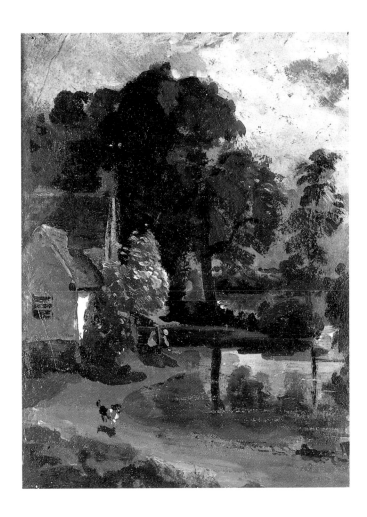

JOHN CONSTABLE.
WILLY LOTT'S COTTAGE.
1810-1815. Oil on paper, 24 x 18 cm.
Victoria & Albert Museum, London.
Between 1810 and 1816 Constable painted several studies of this cottage, of which he undoubtedly knew the occupant. He used these when he painted *The Hay Wain* in 1821. He seemed to have a strong attachment to this particular spot.

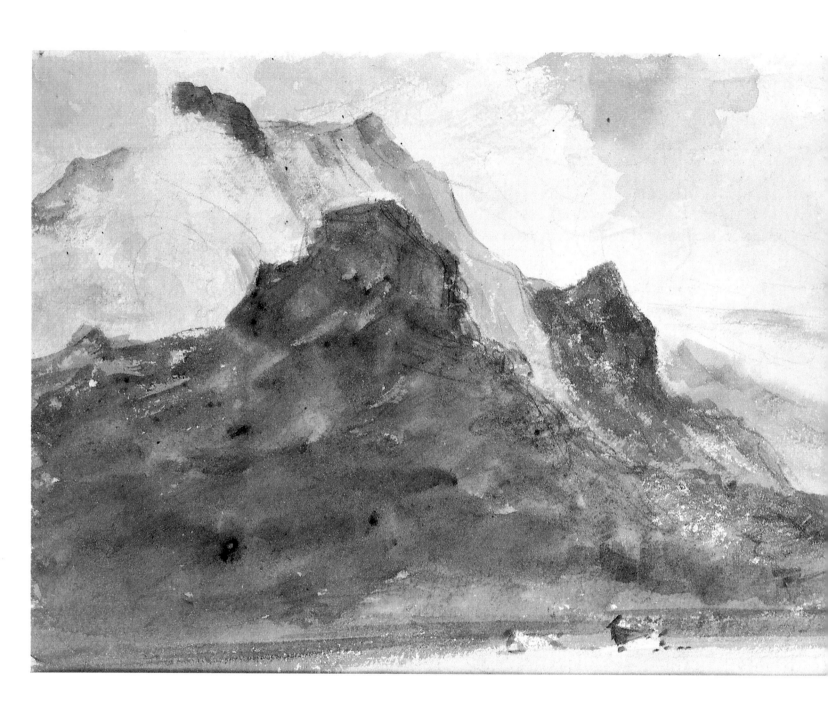

JOHN CONSTABLE,
VIEW OF BORROWDALE.
*Dated 4 October 1806. Pencil and
watercolour. 13.9 x 37.5 cm. Victoria &
Albert Museum, London.*

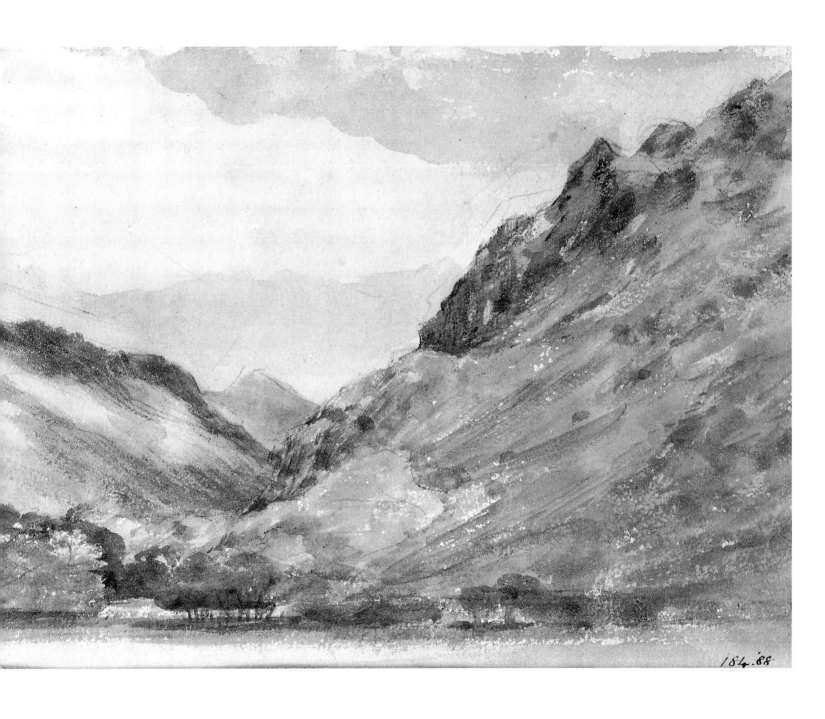

184.88

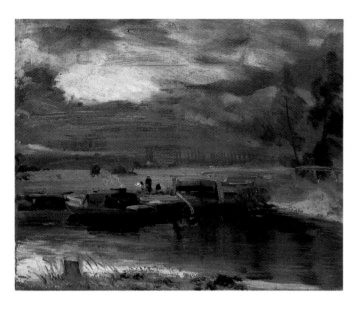

JOHN CONSTABLE.
BARGES ON THE STOUR AT FLATFORD
LOCK.
*1810-1812. Oil on paper, laid on canvas,
26 x 31 cm. Victoria & Albert Museum,
London.*
The studies of 1810-1812, are strong and
original, and show Constable's progress
towards the development of a personal
style. They are unique for the period.

managed the mills inherited from their father, shared the profits, this was not enough to support a family of eight children, so he still needed to earn a living. More urgently, though, he wished to make a name as a professional painter. He could not help looking at Turner, his exact contemporary, who had been a member of the Royal Academy since 1802. He, himself, was not elected an Associate until 1819 and only became a full Academician in 1829.

Once he had set his mind to becoming an Academician he exhibited there every year, and included, amongst his other works, a large canvas depicting some aspect of his youthful memories of the Stour valley. For these large and ambitious works, which were painted entirely in the studio, he used sketches and studies made on the spot. Not only did he use such small sketches, but it also became an essential part of his work process to paint a full scale study of exactly the same dimensions as the final canvas, that is to say, about six foot long. This study became an indispensable stage for him as it allowed him to pour out all his passion, and to fuse his feelings irrevocably with the subject.

In these full scale studies Constable was able to indulge in a form of spontaneous expressionism, and he painted his emotions just as surely as, in the *plein air* studies, he depicted nature, in a style that pre-figures impressionism. These large studies are almost totally introspective as Constable, alone with his memories, grappled with the process of turning illusion into art. These studies tend to be rather sombre and have an overall rather depressing grey-green tonality, from which the shapes emerge through the thickness of the pigment, like dream creatures, modelled with the palette knife. Every brush-stroke or slash of the knife is charged with emotion, and becomes a conduit through which Constable was able to express his subconscious.

Because these studies were never intended for exhibition, and thus because Constable knew that he was only painting for himself, he was able to achieve a freedom that was well in advance of his time. If they had not survived there would be little direct evidence to tell us at what precise point Constable's vision parted company with the more general ideas that dominated Victorian England. There would be nothing to reveal the deep inner torment that he experienced, when faced with the real nature of painting. This side of art, seering and terrible, agonising and triumphant at one and the same time, is revealed only to the greatest masters.

The "finished" paintings, which he exhibited at the Academy, are modified and based on a different vision, not absolutely academic, but far more traditional. Constable forced himself to give the public, in part at least, something of what it expected to find in a landscape - scenes which were easy to interpret. Hence the series of grand recollections of the Stour Valley: *The White Horse* (1819, Frick Collection, New York), *The Hay Wain* (1821, National Gallery, London), *The Leaping Horse* (1825)* and *The Lock* (1826, Royal Academy, London).

Some notes in Delacroix's *Journal* give us an insight into the difficulties that Constable must have grappled with in translating his sketches into

exhibition pictures. Delacroix, commenting on his own work wrote: "I am satisfied so far with this rough study, but how can I preserve this overall effect of simple massing whilst adding in the details?" There is no hard and fast rule for an artist that will tell him when to stop, and Constable was always exercised by this problem; he was liable to take back paintings and re-work them after they had been exhibited and, sometimes, even after they had been sold. The balance between the emotion he wished to express and the actual result was difficult to achieve. Turning to Delacroix once again (23 April, 1854): "The greatest difficulty, though, is to go back and erase details which are part of the composition, the very thread of the picture."

MULTIPLE DIFFICULTIES

In Delacroix's case the painter was faced with a relatively well informed public, his difficulties were with practical problems of painting, and were at the level of achieving the final work. For Constable the problems were more numerous and sprang from the social structure of the time. For a start he had to translate his vision of nature into paint, then he had to modify it in order to get it exhibited, and finally he had to sell it. The chief obstacles were presented by the Royal Academy and its traditions, the wealthy collectors who wished to be regarded as "connoisseurs", and the wider public who expected a landscape to be a sort of photographic image of the real world.

To a large extent artists were dependent on the Royal Academy. History painting, as we have already noted, was regarded as the highest aspiration and, to conform to this long established hierarchical view, Turner often gave his landscapes some historical or mythological twist, but it was impossible for Constable to resort to similar subterfuges. What he wished to paint was his beloved English countryside, lush and green under ever-changing skies, and peopled by the ordinary folk he met on his rambles through the Suffolk lanes.

One of the major problems facing Constable was how could an artist, at the beginning of the 19th century fight the power of the Royal Academy? After all, it was the Academy, through its influence on the public, that dictated what should and what should not be appreciated. Artists had little chance of getting their work known outside the annual exhibitions at the Academy. Also it was necessary to be accepted by the jury, which tended to be composed of men whose vision was already blinkered. Thus the emergence of a new style was extremely difficult.

Constable was to discover this by bitter experience. Finally, in 1830, the year after he was elected an Academician and when he was already fifty four, he could exhibit his work by right at the Royal Academy rather than having to submit it to the jury, of which he was now a member. During the selection someone "by mistake" (it could have been one of his close colleagues) put one of his landscapes among the works of the non-members. It was a small canvas briming over with freshness as water and sky mingled in a range of greens and silver; it was a simple and direct work entitled *Landscape, a Study. The Water Meadows near Salisbury* (c.1820)*. When it was shown to the jury the comments flowed furiously:

JOHN CONSTABLE.
STUDY FOR "THE LEAPING HORSE."
1824. Pencil and wash, 20.3 x 30.2 cm.
British Museum, London.

THE LEAPING HORSE

This is Constable's masterpiece. Amongst all his *Scenes of the Stour Valley, The leaping Horse* is the one whose origins are documented most thoroughly, and the different stages are known.

For a painting to have any chance of standing out the Royal Academy exhibitions it had to be large, as the pictures were hung in serried ranks one above the other. Some anecdotal detail was also required to attract attention. Constable selected a six foot canvas. For subject he selected a barge-horse lightly harnessed to enable it to jump the gates which were placed at intervals along the tow-path to prevent cattle straying from the fields. It is an enormous horse with powerful haunches, of a type with which he would have been familiar during his childhood forty years earlier.

For his big painting for the Summer Exhibition, the artist would have started work in his studio early the previous winter. He selected first of all from his portfolio of drawings a sketch of a pollarded willow, which he later modified, he then made two different sketches, in what order we do not know.

one of these is static and descriptive, whilst the other is expressionistic.

Then he steadily developed the theme and vision which he archieved in the full size oil study, one of his greatest works. Here, working for himself without having to worry about public reaction, he gave full reign to his feelings as he recalled memories of his childhood. The turmoil of his emotions is captured in a style that presages expressionism, and the grey-green tonality of his palette accords perfectly with the dreamlike quality of the scene.

The final canvas destined for public exhibition, which is of exactly the same dimensions as the study, is easier to interpret, more traditional and also more brightly coloured. To compare the two is to appreciate that one is primarily concerned with emotion – "sensibility" – and the other about subject matter. One emerges from the shadowy depths of poetry into the accessible clarity of beautiful prose.

Despite these concessions the painting failed to sell until 1838, after the artist's death, changed hands several times and was finally offered to the Royal Academy in 1889.

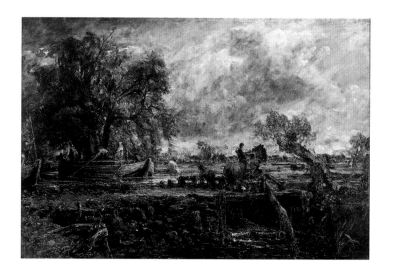

JOHN CONSTABLE.
FULL SIZE STUDY FOR "THE LEAPING HORSE."
1824-1825. Oil on canvas,
129.4 x 188 cm.
Victoria & Albert Museum, London.

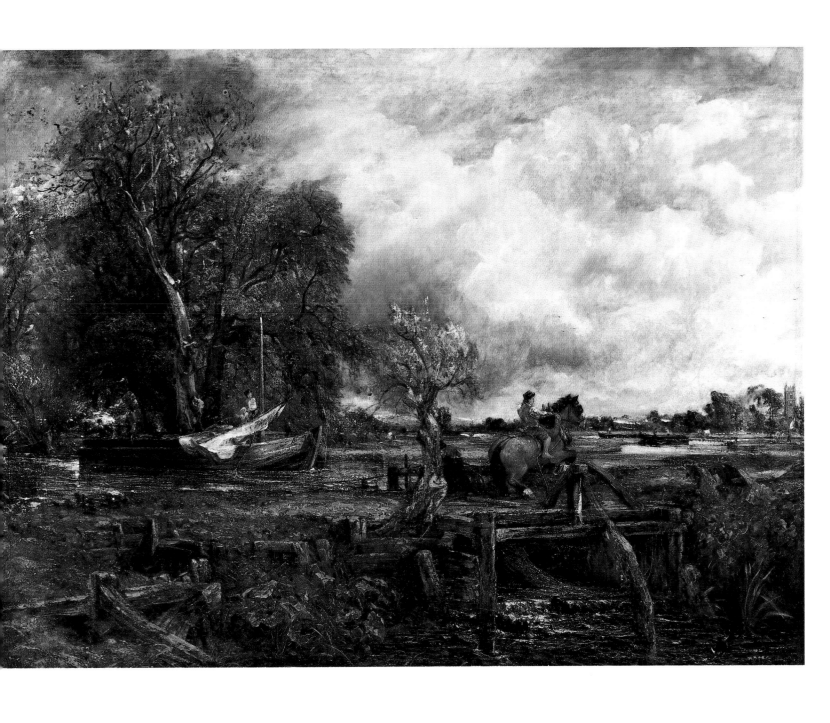

JOHN CONSTABLE.
THE LEAPING HORSE.
Exhibited in 1825. Oil on canvas
135.9 x 180.3 cm.
Royal Academy of Arts, London.

"It's pretty poor!
What's that nasty green thing?
Send it out!"

Constable stood up, picked up his picture, and left, despite the protestations of the President.

What was it in fact that they were reproaching him for? Even more than his perceived lack of finish and his over large brush-strokes, they did not approve of his chromatic harmonies, which they felt were too strong and offended the sensibilities of their eyes, which were accustomed to the subdued tones of Dutch landscapes or to the misty light of Claude Lorrain. What they saw appeared to them to be of an unacceptable vulgarity.

Expanding the influence of the Royal Academy were the wealthy collectors, who through their patronage, enabled artists to survive. One of these, Sir George Beaumont, (1753-1827), had a significant number of contacts with Constable. An amateur painter himself, Sir George also wished to play the role of critic. He rejected Turner's work, which he criticized for its lack of "finish" and its abuse of bright colours, especially yellow. But Turner, who already had the support of the Academy, could afford to ignore Sir George's strictures. Constable enjoyed no such independence. In spite of a friendly invitation to Coleorton, Sir George's country home, Constable was well aware that he did not appreciate his painting. Sir George felt that Constable was running counter to tradition and that his colours were offensive. He preferred the sombre tones of the old masters and liked the patina of age - often achieved by a dealer applying a layer of dirty varnish. One day he compared these tones to those of an old violin, at which Constable took the violin and placed it on the lawn to prove the justice of his own views, but the gesture was useless as Sir George's mind was so much in the past that he could not conceive what Constable was getting at.

Apart from this general blindness to what he was trying to do, there were a few exceptions, but they were rare. Benjamin West, the then President of the Royal Academy, showed himself far more sympathetic than his colleagues, and said to Constable in about 1802: "Don't get discouraged young man, we will hear more of you. You must love nature very deeply to have painted these."

As we have already noted, Constable made enormous efforts, and considerable concessions to popular taste, in his *Scenes of the Stour Valley*, in order that they should be understood and appreciated by the public when they were exhibited at the Royal Academy. Beyond the perfectly legitimate desire to sell his works, he felt it was his duty to act in defense of the countryside. Already, during his lifetime, he had witnessed the progressive deterioration of living standards in his beloved valley. The increasing industrialisation, which was such an important feature of the first half of the 19th century, when the industrial revolution was at its height, threatened not only the traditional pattern of country life, but also the tranquil beauty of the countryside itself. Although Constable was not politically active, he felt morally obliged to try and alert the public to this destruction. His own awareness and memories of the beauty of the valley appeared to him like some

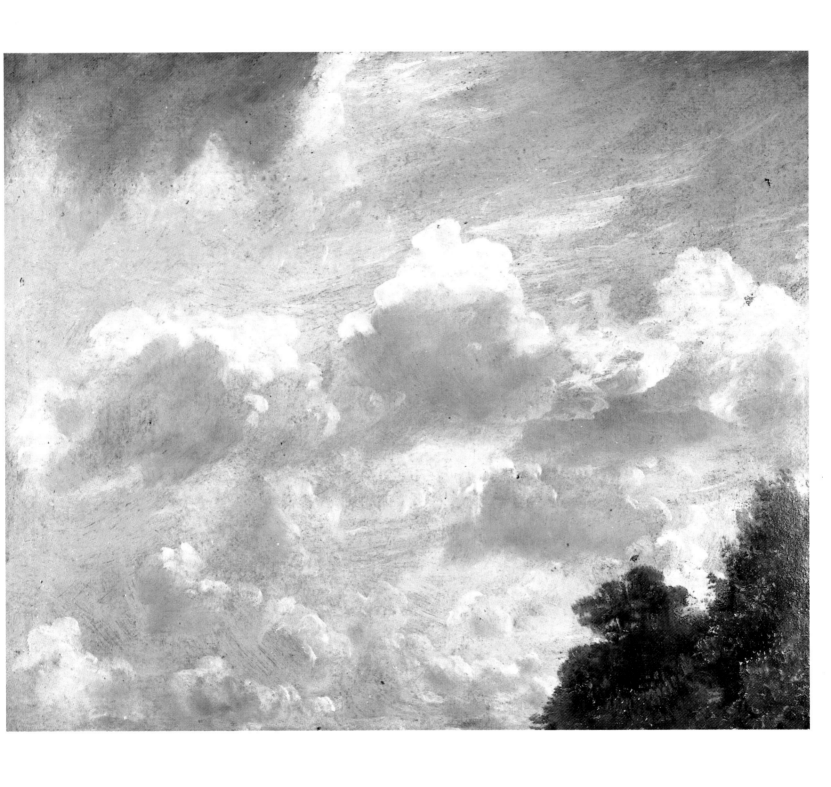

John Constable.

Cloud Study, Hampstead.

1821. Oil on paper laid on wooden panel.

24.2 x 29.8 cm. Royal Academy of Arts.

London.

JOHN CONSTABLE.
WATERMEADOWS AT SALISBURY.
c. 1820 (?). Oil on canvas, 45.7 x 55.3 cm.
Victoria & Albert Museum, London.
This canvas, which was probably painted
about 1820, was not exhibited until 1830.
It is the painting which caused the "mis
understanding" that led Constable to quit
the selection committee at the Academy.

154

form of sacred trust, which he had to pass on through his paintings and share with others. This explains why he strove to adopt a pictorial mode for his big exhibition pictures that was readily accessible to the widest audience, even if by so doing he diluted the intensity of his own vision.

These efforts went largely unrewarded, despite his election to the Royal Academy in 1829, eight years before he died. Constable never knew the pleasure of sharing his vision with the vast English public, still less did he achieve his ambition of making them appreciate his "ecological" message. It was the French, in the wake of Delacroix, who were to become his earliest enthusiastic disciples. As early as 1826, the painter and critic Delecluze deplored the proliferation in France of landscapes painted "in the manner of Constable". A few years later, with Theodore Rousseau and the painters of the Barbizon School, Constable's work found its true heritage, which led to its being appreciated at its proper worth.

JOHN CONSTABLE.
BRIGHTON BEACH, 12 JUNE 1824.
Oil on paper. 12.1 x 29. 5 cm. Victoria & Albert Museum. London.
These oil studies. painted rapidly in one session. are amongst Constable's greatest works.

THE ROMANTIC
VISION

In Western Europe, the beginning of the 19th century was notable for the fact that many artists wished to free themselves from the constraints of classicism, with its references to the Antique, and also to escape from the dictatorship of the various academies. In England, men like Turner and Constable were not yet free of such academic traditions. However, those artists who were a decade or two younger, and who have been grouped together under the name of the Romantic School, desired to find a new basis for their art. They wished to achieve a fresh feeling which would give full rein to their heightened sensibilities; they preferred the Middle Ages to classical Antiquity, and nurtured their vision on dreams, spirituality, apprehension and wonderment as they made contact with such elemental forces as they could identify themselves with.

Certain artists turned almost entirely to nature in all her varied aspects. Amongst them were David Cox, Peter De Wint and the group that formed around Bonington. Others, influenced by the painter-poet William Blake, turned their backs on reality to become Utopian visionaries and created works inspired by their own dream world.

DAVID COX: PAINTER OF WIND AND RAIN

Although he also worked in oils, it was as a watercolourist that David Cox displayed the depth and richness of his sensitivity to nature. Watercolour

DAVID COX.
FLYING A KITE.
1853. Watercolour and gouache over pencil, 27 x 37.8 cm. British Museum, London.

DAVID COX.
GOING TO THE HAYFIELD.

1855-1857. Watercolour and pencil,
32 x 45.4 cm. Yale Center for British Art.
Not long before his death, and possibly
unwillingly, Cox's interpretation of land-
scape came very close to that of modern
art.

was the perfect medium for him, as the rapidity with which he was able to work enabled him to capture those sensations which, towards the end of his life, he received from direct contact with the elements.

This sensibility did not develop spontaneously. He had sought it diligently since he first arrived in London as a young man, in 1804. His previous experience had been restricted to theatre decoration, but in London he received several lessons from John Varley, a highly respected watercolour artist, which helped to refine his tastes. His early works echo the topographical tradition, with a bias towards the picturesque, which was emphasised by visits to Wales and to the continent. It was in this spirit that he painted views of Paris such as *The Pont Des Arts and the Louvre, Seen from the Quai de Conti* (Victoria & Albert Museum).

In the second half of his life Cox reduced the topographical detail to a minimum, and applied himself to trying to capture atmospheric effects. He succeeded so well that it is almost possible to literally physically feel the raindrops and hear the sound of the wind in his watercolours. Cox depicted every nuance and change of weather and climate; sometimes the sun pierces the clouds, sometimes we are faced by great curtains of rain. Cox was able to capture such transitory impressions so effectively that the viewer feels himself absorbed into the scene. In *Flying The Kite* (1853)* everything, from the clouds and the birds down to the grass, seems to submit to the force of the wind, whilst, in contrast, the group of figures, standing like buttresses, and the huddle of houses, resist it. In his view of *Rhyl Sands* (Victoria & Albert Museum, London) the rain merges with the wind to evoke a vision similar to that of Boudin.

This sense of atmosphere, wide open spaces and sky, which Cox had distilled so successfully since the late 1840s, found a new dimension after he had a stroke in 1853, which left him impaired and unable to paint for a time. *Going to The Hayfield* (1855-1857)* is a re-interpretation of an earlier theme, but one that he was able to improve upon in the re-working and inject with an extraordinarily modern feeling.

From 1836, in order to emphasise the atmospheric effects, Cox painted on special heavy paper; this was a sort of unbleached, buff coloured packing paper, the rough texture of which blurred the outlines but unified the vision when washed over with very wet watercolour. In his wide skies, with their scudding clouds, Cox usually included flights of birds, which give an added sense of life and lightness to his scenes.

PETER DE WINT AND THE CALM OF THE COUNTRYSIDE

Whilst Cox's vision was focused on the sky and the elements, that of his contemporary, Peter De Wint, was concentrated upon the earth and its generous gifts, although this did not prevent him from also having a well developed sense of atmosphere.

His earliest works reveal an attachment to the picturesque, but this disappeared soon under the influence of his master, John Varley, who had, to some degree, inherited the pictorial tradition of Girtin. This indirect influence

DAVID COX.
SCOTCH PINES.
Watercolour. Victoria & Albert Museum, London.

PETER DE WINT.
A ROAD IN YORKSHIRE.
c. 1830-1835. Pencil and watercolour,
15.5 x 42.8 cm. Yale Center for British
Art.
Although the composition and colour
range recall Girtin, the serenity of the
scene is typically De Wint.

CLARKSON STANFIELD.
CUTTING AWAY THE MASTS.
c. 1836. Watercolour, gouache, varnished,
26.2 x 39 cm. Whitworth Art Gallery,
University of Manchester.

from Girtin, who had died in 1802, was augmented when De Wint had to copy his watercolours at Dr Monro's. Behind *The Palace, Law Courts and Abbey, Westminster,* there is more than a hint of Girtin's *Eidometropolis* in the colouring, and the similarities do not stop there. The extended format, which De Wint adopted for many of his works, has much the same feeling as Girtin's panoramas, as can be seen in his *Road in Yorkshire* (c.1830-1835)*, which is constructed upon a great curve, not unlike the older artist's *Kirkstall Abbey.* Nevertheless, De Wint's colouring is less portentous than Girtin's. His landscapes are frequently bathed in golden sunshine and have an optimism about them that is typical of the true countryman who has never lost his sense of wonderment.

Harvesting was one of De Wint's favourite subjects, and it gave him the chance to express this sense of wonder and gratitude for nature's bounty. His *Landscape with Harvesters: Thunder Clouds threatening* (c.1820, Victoria & Albert Museum, London) shows this season of plenty, which characterises so many of his watercolours, and also shows the mastery with which he could handle heavy washes. He did not, however, restrict himself in any way to such bucolic scenes. He turned his hand to cityscapes and also painted a number of very sensitive still lives but, despite his diversity and considerable talent, he never achieved wide recognition.

BONINGTON'S AMIABLE VISION

English by birth but French by upbringing, Richard Parkes Bonington was as comfortable with French art as he was with English. Such links had already been forged by the Franco-English artist, Louis Francia, who divided his time between London and Calais, where he took the young Bonington under his wing and taught him about the English watercolour tradition and its techniques, which he practised at the time when he painted *The Beach at Boulogne-sur-Mer* (1821, Musee de Calais).

A spell in the studio of Baron Gros did not seem to make much impression on Bonington or his work, but he met Delacroix with whom he became very friendly in 1825.

Bonington's first exhibited watercolour at the Paris Salon in 1822, *Rouen Cathedral viewed from the Quays* (British Museum, London), shows him still working in a topographical manner with a palette influenced by Girtin's, but a harbinger of his future development had already been glimpsed in the watercolours that he made during a visit to Normandy in 1821, which show a new interest in atmosphere and a move to brighter tones in order to capture the play of light.

During 1824, and parallel with his work as a watercolourist, Bonington made a number of architectural drawings, which show his mastery of this genre. These drawings were destined to appear in the form of lithographic illustrations to two publications by Taylor and Nodier, *A Picturesque and Romantic Journey in Old France* and *Remains and Fragments of Mediaeval Architecture.*

The development that had been hinted at in 1821 was confirmed in 1824 when Bonington found his true vocation. His whole attention was now focussed upon the quest for luminosity, which was apparent in both his

THOMAS SHOTTER BOYS.
BONINGTON'S STUDIO AT 11 RUE DES
MARTYRS, PARIS.
Black lead on tracing paper, 32 x 39 cm.
British Museum, London.

Following pages

RICHARD PARKES BONINGTON.
FISH MARKET NEAR BOULOGNE.
c. 1824. Oil on canvas, 82 x 122.5 cm.
Yale center for British Art.
This work was awarded a Gold Medal at the Paris Salon in 1824, the year that Constable's *Hay Wain* also won a Gold Medal. France had discovered the English landscape painters.

163

RICHARD PARKES BONINGTON.
SELFPORTRAIT.

c. 1825-1826. Sepia wash, heightened
with white, on buff paper. 12.5 x 10.4 cm.
British Museum, London.

RICHARD PARKES BONINGTON.
STATUE OF COLLEONI IN VENICE.

c. 1826. Black lead, watercolour and
gouache, 22.7 x 17.5 cm. Musée du
Louvre, Paris.

Bonington's approach in this depiction of
the great warrior was appropriately
strong and heroic.

watercolours and his oil paintings, which he pursued with increasing success. The emphasis now turned to simplification rather than elaboration.

The compositional devices used in his landscapes often recur, altering little but seeming to be interchangeable. In the foreground he would often place a boat seen against the light, whilst a calm sea gently laps the shore beneath a broad expanse of sky; a serene sunset shedding a pale but warm light across the scene whilst figures, drawn from life, go about their daily tasks, as in *The Fish Market near Boulogne* (c.1824)*. These works are saved from monotony by their remarkable refinement of colouring, which ranges gloriously from ochre to grey, creating a gentle and harmonious atmosphere which imbues the whole composition with a sense of poetry and stillness. If there is any movement it is slow and gentle, like that of fishing boats entering harbour, and becomes a reassuring part of the whole scene.

Even when faced with Turner, who was by this time at the height of his fame, Bonington maintained the originality of his own vision. Wind and waves, to him, were just gentle breezes and ripples, rather than great elemental forces, but he was sensitive to the older painter's use of light, which he often tried to emulate, particularly in *Sunset in the Pays de Caux* (1828, Wallace Collection, London).

The final development of note in his work came about as a result of his trip to Italy in 1826. Although he only spent three months there, it gave him the opportunity to make a considerable number of watercolours, drawings and oil studies, which he re-used for subsequent works. The revelation of the Italian light was not as dramatic for Bonington as it had been for Turner, but, nevertheless, his colours became purer and bolder as a result. His enthusiasm was well served by the dash and brio of his technique, and Delacroix compared the brilliance of his colour to precious stones.

His views of the canals and the Venetian Lagoon, although prodigiously competent, are hardly original, and it is easy to prefer his city scenes such as *The Leaning Tower of Bologna* (c.1826, Wallace Collection, London) or *The Statue of Colleoni in Venice* (c.1826)*.

Like so many of the romantics, Bonington suffered from tuberculosis and, as is symptomatic of the disease, worked at fever pitch towards the end of his short life. He died in the autumn of 1828, at the age of twenty six, "carried away by his own virtuosity", as Delacroix commented. Elsewhere, Delacroix recalled "his facility of brush and stylish touch", and better still, "his hand that was so competent that it ran ahead of his thoughts."

Although his life was brief, his influence was lasting, both indirectly through a number of French artists, but more specifically on a small group of his English friends living in Paris – William Callow, Scarlet Davis and, especially, Thomas Shotter Boys.

In London, another of Bonington's friends, Clarkson Stanfield, primarily a marine painter, revelled in painting tempestuous scenes in the manner of Turner. Stanfield's early life as a sailor had prepared him for this particular genre, and gave an added authority to his rendering of scenes such as *Cutting away the Masts* (c.1836)*, which he set down with an audacity that was unusual for the time.

Visionaries of Another World

About 1825, William Blake, author of *Songs of Innocence* and *Songs of Experience* was at the centre of a group of artists who wished to create their own Golden Age. Apart from Blake, the best known members of this group were Samuel Palmer, John Linnell and Edward Calvert, and they were known as the Shoreham School because they lived and found their vision in this idyllic village in Kent. The outstanding member of the group was Samuel Palmer, who, like Blake, was driven by a mystical reverence for nature. Such reverence, however, did not prevent him studying her with precision. The moon and the shepherd's star, which frequently dominated his early landscapes, produced fantastic lighting effects, which throw up indefinable and mysterious forms, as in *Hilly Scene* (c. 1826), Tate Gallery, London). A little later his style became more heavily laden, as in *The Magic Apple Tree* (c. 1830)*, which is a veritable paeon to fecundity. Not surprisingly the intensity of this rapturous response to nature could not be kept up for long, and by 1832 the Shoreham group had dispersed, and Palmer the great visionary gave way to a watercolourist of less sensibility and originality.

In contrast to these amiable utopians of the Shoreham School, James Ward, another follower of Blake, had a more tragic vision of the world, which was fed by his morbid temperament and fascination with the violence of wild animals, and primitive energy. His *Gordale Scar, Yorkshire* (1811-1815)* is an enormous canvas, in which he represents the grandeur and awesomeness of a great gorge between two rock walls in Yorkshire, at the foot of which there is a large herd of beasts, symbols of a hard and implacable world.

SAMUEL PALMER.

THE MAGIC APPLE TREE.

1830. Watercolour and gouache, 35 x 26 cm.

Fitzwilliam Museum, Cambridge.

For this celebration of fecundity, Palmer chose the most sumptuous colours, juxtaposing the incandescence of the golden corn with the ruby-like apples ripe and ready for gathering.

James Ward.
Gordale Scar, Yorkshire
1811-1815. Oil on canvas. Tate Gallery,
London.

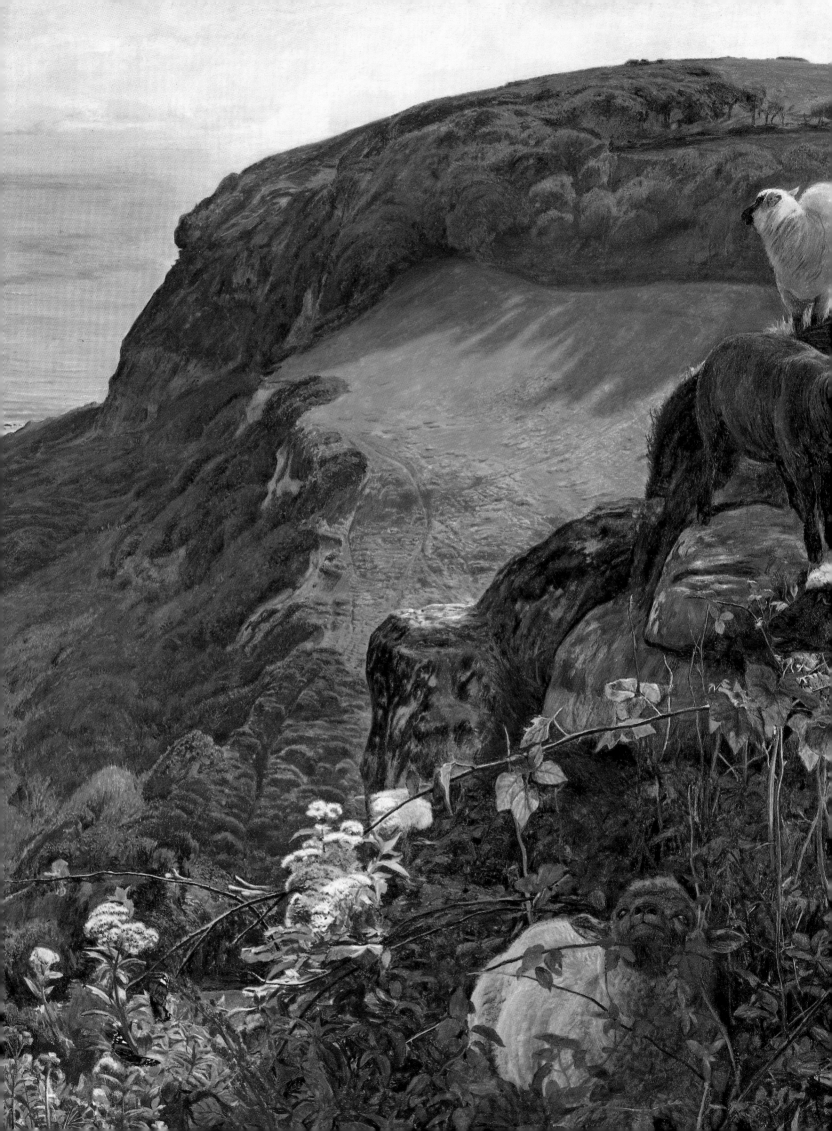

THE PRE-RAPHAELITES
AND VICTORIAN PAINTING

WILLIAM HOLMAN HUNT.
OUR ENGLISH COASTS (STRAYED
SHEEP).
1852. Oil on canvas, 43.2 x 58.4 cm.
Tate Gallery, London.

One day in September 1848 several young artists, who found the stranglehold of the Royal Academy quite intolerable, felt the urge to rebel. They were not the first, of course. Constable and some of the romantics, in their turn, had tried to break the shackles and ignore the rules and regulations laid down by this venerable institution. This new group consisted of seven young artists, but only two – John Everett Millais and William Holman Hunt – need concern us here as being landscape painters of importance.

Hunt, aged twenty one was the oldest, whilst Millais was only nineteen; they were both students at the Royal Academy Schools. They were profoundly affected by the ideas expounded by John Ruskin, another brilliant young man and author of *Modern Painters*, who wished to return to nature, and discard all the artistic accretions that had built up since the Renaissance. He preached about the purity of vision, which had inspired artists before the time of Raphael, hence the name the Pre-Raphaelite Brotherhood – or P.R.B. – whose mysterious initials appeared in lieu of signature on their first paintings in this new vein. The group was less original than they tried to make out, because it followed, to some degree, another school of painters – the Nazarenes – a group of German artists living in Rome, who had also come under the spell of primitive Italian painting.

This desire for a return to nature gave the artists the impetus to paint out of doors as often as they could, and also to seek for absolute truth in the

WILLIAM HOLMAN HUNT.

THE HIRELING SHEPHERD.

1851-1852. Oil on canvas,

76.4 x 109.5 cm.

Manchester City Art Gallery.

Behind the anecdotal incident there is a
beautiful landscape.

representation of every detail. Nothing was too small to be included; every blade of grass was rendered with an intensity of detail that was often disconcerting – there was no need for Ruskin to repeat his dictum that when faced with nature they should "reject nothing, select nothing, disregard nothing." Inch by inch these painters felt obliged to go over their canvases filling in every minute detail, often to the detriment of the composition as a whole.

Pure landscapes are fairly rare amongst Pre-raphaelite paintings, as for the most part the artists favoured scenes from contemporary life, the Bible or mediaeval legend, which were charged with those strong moral or social overtones, that the 19th century English public liked so much. Landscape backgrounds served primarily as a setting for these scenes, but that did not preclude them from being beautiful in their own right.

In their rebellion against the Royal Academy the Pre-raphaelites chose, as part of their credo, to reject everything that they had been taught in its Schools. In rejecting sombre tones they chose to paint in the brightest colours attainable and to give them additional lustre by working over a white ground and avoiding shadows whenever possible. These brilliant hues were juxtaposed, one against another, without gradation or transition, thus producing either a sensation of chromatic richness, or of coloured drawing.

In its strictest sense, the Pre-raphaelite Brotherhood only lasted from 1848 to 1853, when it broke up in the wake of Millais' election as an Associate of the Royal Academy. However, until about 1860, the theories propounded by the Brotherhood continued to find a sympathetic response, with each artist giving them his own interpretation.

Millais, one of the most gifted of the Pre-raphaelites, was not really a true landscape painter until much later in his career, but it is not possible to pass over without comment the beautiful setting of water and plants that he created for *Ophelia* (1852)*, which shows the Shakespearean heroine following her suicide borne away by the river's current. Millais painted the plants in the minutest detail, but managed to avoid diverting the viewer's interest from the focal point. He succeeded in creating an integrated and powerful composition in which beauty, drama and tranquility are united in giving the impression of a mysterious world already sealed like a tomb.

William Holman Hunt was probably the best landscapist amongst the Pre-raphaelites. In his *The Hireling Shepherd* (1851-1852)* it is the human dimension which attracts the viewer's interest, as the young shepherd forsakes his flock to woo the shepherdess. His flushed face and the small barrel at his waist suggest that his advances are emboldened by alcohol - the moral message was ever present with the Pre-raphaelites. However, we know from Hunt's letters that it was the landscape which really interested him, and he painted it on the spot overlooking no salient detail, prior to posing the figures.

In *Our English Coasts. Strayed Sheep* (1852)* figures were omitted, which enabled Hunt to create the masterpiece of Pre-raphaelite landscape painting. His treatment of light is remarkable, and the intensity of detail does not interfere with his overall vision. He tried to regain something of this same feeling in *Fairlight Downs. Sunlight on the Sea* (1852-1858). However, things

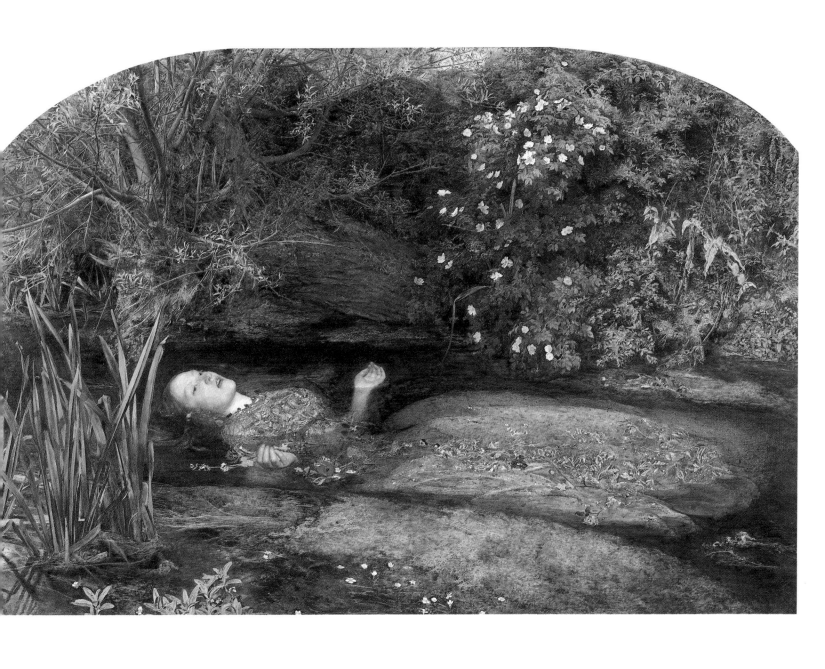

JOHN EVERETT MILLAIS.
OPHELIA.

1852. Oil on canvas, 76.2 x 111.8 cm.
Tate Gallery, London.
Ophelia killed herself after her fiance,
Hamlet, murdered her father. Millais
depicted every detail from Shakespeare's
beautiful text, and managed to retain the
disturbed mood of his poetry.

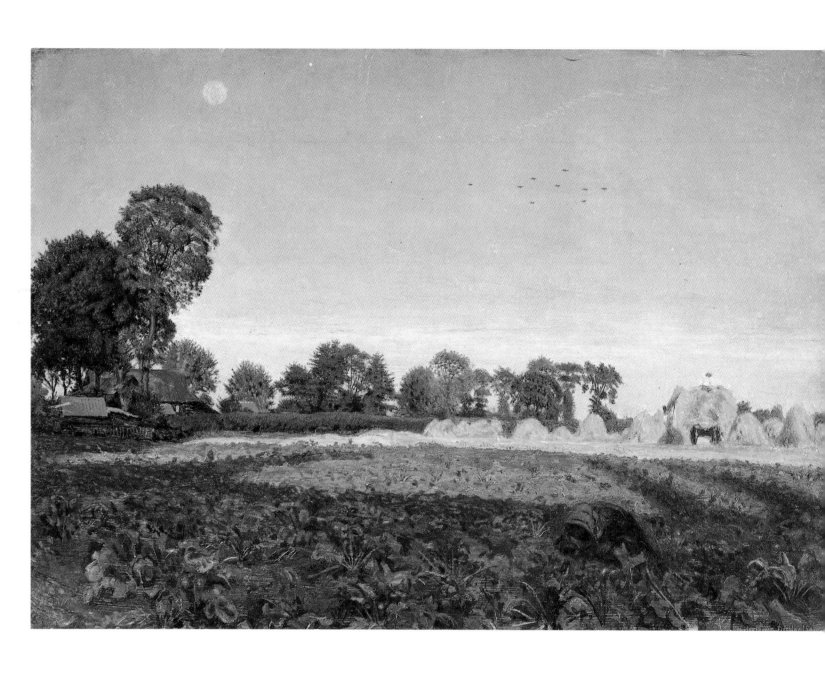

FORD MADOX BROWN.
CARRYING CORN.
1854-1855. Oil on wooden panel,
19.7 x 27.6 cm. Tate Gallery, London.
The Pre-raphaelites sought for a bril-
liance of colour, which suited Brown's
sensibiliy.

WILLIAM DYCE.
PEGWELL BAY. A RECOLLECTION OF
OCTOBER 5TH. 1858.
Painted 1858-1860. Oil on canvas.
63.5 x 88.9 cm. Tate Gallery. London.
This was one of the most popular land-
scape paintings in England at the end of
the 19th century.

changed dramatically in 1853 when Hunt left England for Palestine; his style became harder and his colour more harsh, with the result that his later paintings are generally less attractive.

Another painter, Ford Madox Brown, older than the others and not one of the original members of the Brotherhood, was very close to them in style. From time to time he painted pure landscapes. These are generally fairly modest and intimate works. In *An English Autumn Afternoon, Hampstead* (1852-1855) he uses the two young people to set off the landscape and make it fit comfortably into its oval format. The scene is calm, even ordinary, and without artifice.

Brown was an enthusiast for nature and could not help but be attracted by the scenes he saw as he travelled round the agricultural outskirts of London. He depicted such scenes in *Carrying Corn* (1854-1855)* and *The Hayfield* (1855-1856, Tate Gallery, London), one bathed in glorious sunshine, the other depicted in the cool light of evening. Nothing is idealised, everything is authentic.

John Brett was, in some ways, a victim of Ruskin's preaching. He was swept along by the enthusiasm which had inspired Ruskin when he wrote the chapter on *The Beauty of Mountains* in *Modern Painters*, and went off to the Alps and painted the detailed and skilful picture of the *The Glacier of Rosenlaui* (1856)*. This youthful enthusiasm got spoiled though, when Ruskin, who admired the work, decided that he would personally supervise the painting of Brett's next ambitious Alpine scene, *The Val d'Aosta* (1858, Private Collection), a technical *tour de force* in which the artist attempted to depict every minute detail within an immense panorama. The finished picture, which is not unlike a bad colour photograph, did not find a ready buyer. Eventually Ruskin himself felt obliged to purchase it, but by this time the damage had been done and Brett never regained either his self-confidence or his early breadth of vision.

Another artist attracted to the Pre-raphaelites was William Dyce, but he did not suffer through the contact. After working on murals for the redecoration of the Palace of Westminster, he was deeply impressed by the precision of the Pre-raphaelites and emulated their style in his very personal and rather severe rendering of *Pegwell Bay* (1858)*. The painting can be read on several different levels. It can be seen merely as a beautiful, crepuscular, almost monochromatic, landscape; it can be viewed as a family group – the man on the extreme right is undoubtedly the artist himself, and all the women are members of his family; or, again, it can be taken as pointing a moral message, in the true Pre-raphaelite manner, with the women bent over the sand seeking shellfish, and failing to witness Donati's Comet, which made its appearance in 1858.

Pre-raphaelite painting was not just a revolt against the Royal Academy but was also a protest at the wider tendencies of Victorian painting. The middle classes, which were expanding dramatically during the second half of the 19th century, wanted themselves depicted in large canvases of the social scene, with landscape reduced to the role of an unobtrusive backdrop. William Powell Frith, the acknowledged master of such crowd scenes, gave

JOHN BRETT.
HE GLACIER OF ROSENLAUI.
*1856. Oil on canvas, 44.5 x 41.9 cm.
Tate Gallery, London.*
This minutely detailed depiction, with its Pre-raphaelite obsessiveness, sets this picture apart from other views of glaciers by Francis Towne or Pars.

FORD MADOX BROWN.
AN ENGLISH AUTUMN AFTERNOON,
HAMPSTEAD.
1853. Oil on canvas, 71.7 x 134.6 cm.
Birmingham City Museum and Art Gallery.

179

them what they wanted in *Ramsgate Sands* (1851), *Derby Day* (1856-1858)* and *The Railway Station,* a novel subject in 1862. The precision and skill of these works, in which he captured the spirit of the occasion and the sense of movement, is undeniable, but what they lacked was intellectual and artistic integrity.

The opposite view of Victorian art, with its penchant for moralising, can clearly be seen in Augustus Egg's great trio of paintings, *Past and Present* (1858), in which the theme of sin and punishment is played out against the sinister background of the London docks.

Perhaps it was in order to escape from this oppresive and moralising atmosphere that so many English painters, in the latter part of Queen Victoria's reign, chose to travel. The artists who thus sought for their primary inspiration overseas have already been discussed in the chapter on *Long-range Travellers.* Lord Leighton, though, was a more complex character. Deeply affected, like many other artists of his day, by the Parthenon Marbles, which were displayed in the British Museum, he painted cool, classical works, which eventually gained him the Presidency of the Royal Academy. However, his travels around the Mediterranean gave him the opportunity to paint direct and spirited landscapes, rich in tone and enhanced by an instinctive feeling for the texture of paint.

All these different strands, whether Pre-raphaelite or Victorian, were to be displaced towards the end of the century, through the quest by a new, young, generation of artists, for a pictorial language that they felt to be more authentic. This new language gave greater emphasis to the tonal and harmonic qualities of a work at the expense of anecdotal content. The theories expounded by Whistler, which many regarded as outrageous, played an important role in this revolution.

WILLIAM POWELL
FRITH. DERBY DAY.
1856-1858. Double canvas.
101.6 x 256.54 cm. Tate Gallery, London.

WHISTLER

AND

THE IMPRESSIONISTS

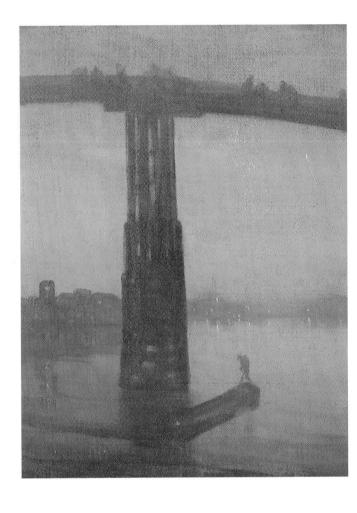

JAMES MCNEILL WHISTLER.
NOCTURNE IN BLUE AND GOLD. OLD
BATTERSEA BRIDGE.
c. 1870-1875. Oil on canvas.
66.6 x 50.2 cm. Tate Gallery, London.

Through the sheer weight of his writings (23 volumes) John Ruskin had firmly impressed his views on the English art-loving public of the second half of the nineteenth century. For him "Truth to nature" was everything; a painting had to have a subject, and it had to represent that subject without rejecting any single detail. A perfect theory for a public partial to the anecdotal.

It needed someone as iconoclastic as James McNeill Whistler to dare to run counter to these theories, and to express his own ideas loudly and forcefully. Whistler was an outrageous aesthete, a born *agent provocateur* and a loner, but he created an art of extraordinary subtlety, in which everything was conveyed through nuances of tone.

Born in America, and having spent part of his childhood in Russia, Whistler refused to succumb to the insular prejudices of Victorian London. He had realised very quickly, whilst at West Point Military Academy, that a career in the army did not accord with his own aspirations, and it was only when he got to Paris in 1855 that he felt at ease. There he led a Bohemian life, but still worked hard to perfect his technique, both as a painter and as an etcher.

In Paris he mixed with a group of young artists who gathered around Courbet. He tended at that time towards realism as can be seen in his *Coast of Brittany* (1861) and *The Blue Wave, Biarritz* (1862) which, through its superimposed bands of colour, already hints at developments to come.

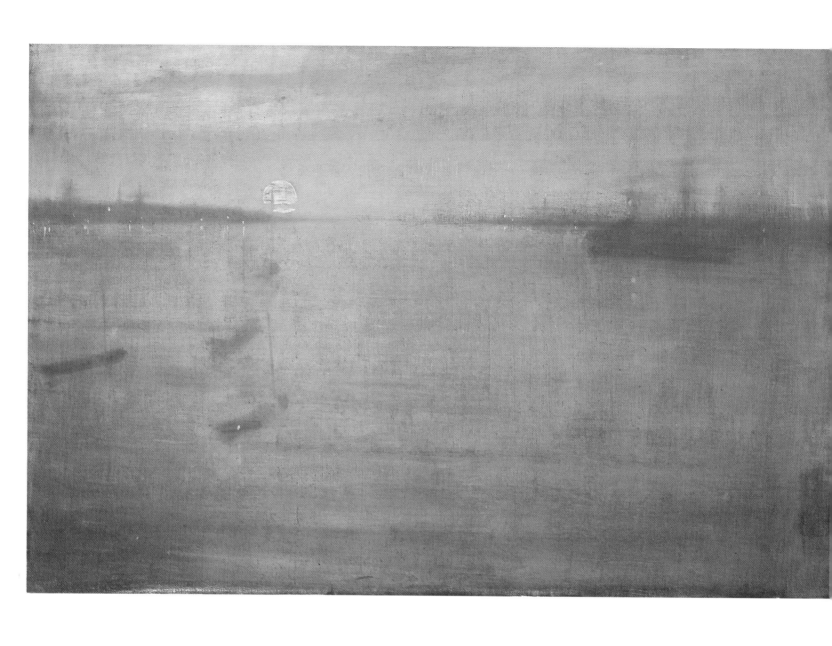

JAMES McNEILL WHISTLER.
NOCTURNE IN BLACK AND GOLD.
ENTRANCE TO SOUTHAMPTON WATER.
1872-1874. Oil on canvas, 50.9 76.3 cm.
Art Institute of Chicago.

184

Within the next four years his work changed dramatically. The only tangible subject matter in *The Beach at Selsey Bill* is space; a space that is almost empty, just a wide expanse of sand against which three barely drawn in silhouettes merely reinforce this feeling of emptiness. It was in Paris, also, that he first discovered "Japonism", and it appears that he, as a painter, saw beyond the immediate attraction of these prints, and intuitively understood the potential revealed by this art form, in which space was as important as subject.

At the time that he was discovering London, where he settled in 1859, he also discovered the magic of her fogs and the beauty of the night, and began to call his landscapes "nocturnes".

The 1860s and 1870s witnessed the production of a sequence of paintings of twilit ports and calm bays sheltering ghostly forms of ships: *The Solent* (1866), *Nocturne in Blue and Gold, Valparaiso* (1866), *Nocturne in Black and Gold, Entrance to Southampton Water, moonrise* (1872 or 1874)* and *Nocturne in Blue and Silver, Battersea Reach* (c.1870). The pictorial elements vary very little. Whistler played upon the theme of an expanse of calm water with reflected lights, silhouettes of boats, an indistinct coastline, and, most importantly, fog, which obliterated every unwanted detail.

In his famous *Ten O'Clock* lecture of 1855, which was translated into French by Mallarme, he tried to explain the attraction that this sort of landscape held for him: "And when the evening mist clothes the riverside with poetry, as with a veil, and the poor buildings lose themselves in the dim sky, and the tall chimneys become campanili, and the warehouses are palaces in the night, and the whole city hangs in the heavens – then the wayfarer hastens home [-] and Nature [-] sings her exquisite song to the artist alone, her son and her master..."

These aesthetic outpourings were barely tolerated in London, and in 1877 a group of Whistler's nocturnes including *Old Battersea Bridge** and *Nocturne in Black and Gold, the Falling Rocket* (c.1874) attracted Ruskin's ire and he wrote that he "had seen, and heard, much of cockney impudence before now, but never expected to hear a coxcomb ask two hundred guineas for flinging a pot of paint in the public's face." This was too much for Whistler, who, in a celebrated law suit, sued Ruskin for libel. Frith, the painter of *Derby Day*, a Royal Academician and one of the witnesses for the defence, said that a piece of wall-paper, or silk, could give the same effect, and this was the general opinion of the matter. Whistler was asked how long he had taken to paint the picture. "Two sessions" was his reply, but he added the rider that it also took him a lifetime's experience.

Whistler won the case, but was bankrupted in the process and also lost potential sales. Like Constable before him, but with less diplomacy, he had projected a vision which the public was unable to appreciate. Where they had expected anecdote and detail, he had only offered tone and line. Happily for him, Whistler was a master etcher, so he was still able to earn a living. In his *Venetian Series* of etchings he continued his research into atmospherics and diffused light effects, this time through the use of a broken line. His ability to evoke atmosphere, as in *Nocturne:Palace,** was extraordinary, but, once again, the public failed to understand what he was doing, and said that the plates were unfinished.

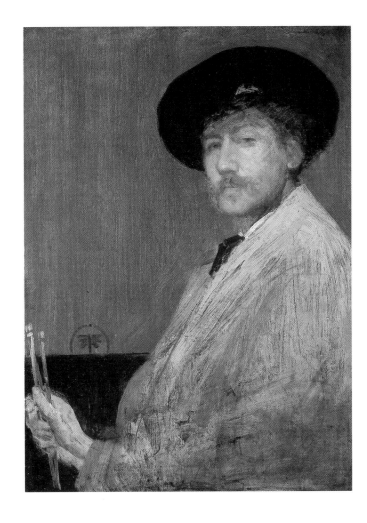

James McNeill Whistler.
Selfportrait.
Oil on canvas. Private Collection.

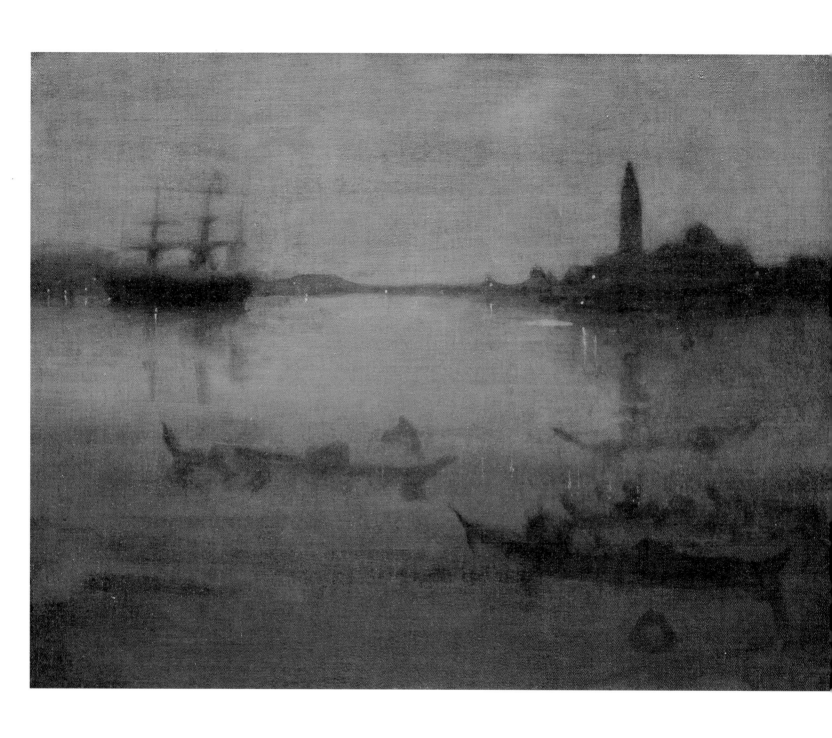

JAMES McNEILL WHISTLER.
THE LAGOON, VENICE. NOCTURNE IN
BLUE AND SILVER.
c. 1880. Oil on canvas, 51 x 66 cm.
Museum of Fine Arts, Boston.

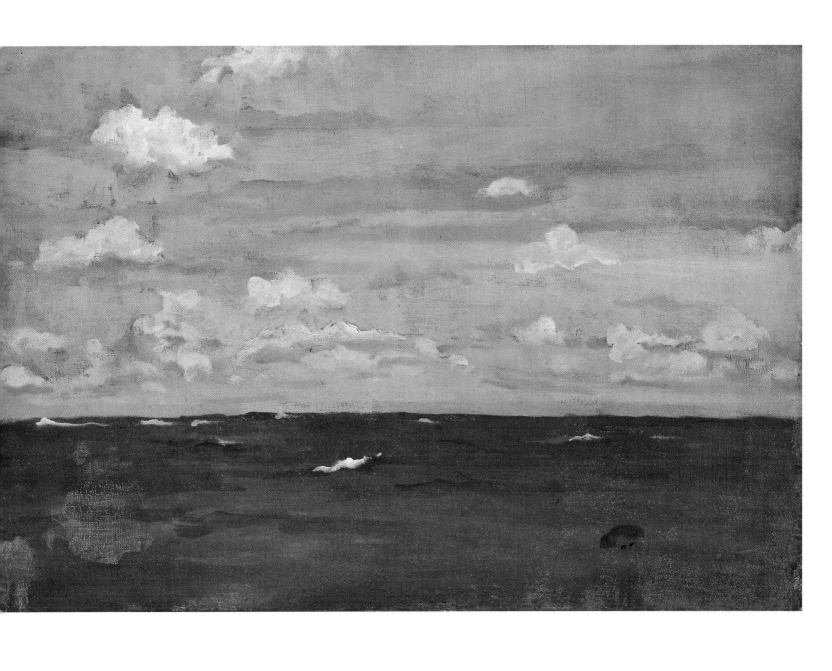

JAMES McNEILL WHISTLER.
VIOLET AND SILVER. THE DEEP SEA.
c. 1892. Oil on wooden panel. Art Insti-
tute of Chicago.

James McNeill Whistler.

Nocturne. Palace.

One of the Twenty Six Etchings of the
Second Venetian Series. Bibliotheque
Nationale, Paris.

Yet the artist did not hesitate to put himself out to explain his objectives. With *Nocturne in Grey and Gold, Snow in Chelsea* (1878, Fogg Art Museum) he refused to attach the slightest anecdotal incident to the figure in the snow and just said: "All that I know is that my arrangement of blue and gold is the basis of my picture."

Up to about 1880 one nocturne followed another, but it is fair to say that some of the later ones, such as *The Lagoon, Venice. Nocturne in Blue and silver* are more easily read. Did Whistler think that he had finally exhausted this theme? After the velvety night of the nocturnes, he now chose to paint in full daylight, and the movement of waves became his chief pre-occupation. His earlier methods of constructing pictures in tonal bands continued, but his almost monochrome palette was carefully calculated to emphasise the power of the chromatic variations of the sea. The splendid gradations, ranging from blue to purple, in *The High Sea, Violet and Silver* (c.1892)*, depict the precise moment when the waves break in a swirl of foam and mirror the clouds scudding across the sky.

By the time Whistler painted these pictures of breaking waves his talent was widely appreciated, but people have consistently misunderstood the meaning of his art. He is usually classified alongside the impressionists, but this is not correct. Whereas the impressionists were fragmenting their brush-strokes to capture the vibrancy of light, and, also, painting in front of the motif, Whistler was working in the studio and had, from 1865, subdued his tones and dissolved the form of his subject matter in fog and gloom. What is impressionistic about Whistler is that he sought to capture psychological impressions, states of the soul.

TWO ENGLISH IMPRESSIONISTS

French impressionism found only a belated and limited response the other side of the Channel. The two English artists we will look at here, Steer and Sickert, were both born in 1860, shortly before the Salon des Refuses.

Despite a spell in Paris from 1882 to 1884, Philip Wilson Steer did not benefit from contacts with young French painters, because of his inability to speak the language. Thus, incapable of taking part in discussions, he was never really in touch with the latest theories, but he did see plenty of impressionist paintings, most significantly, the Manet retrospective of 1884, and responded instinctively to their beauty and interest. Without copying the Fench, he developed his own style of impressionism as can be seen in *Girls Running, Walberswick Pier* (1894)*, with its acid tones, luminosity, broken brush-work and general feeling of life, which characterise the French works. This canvas, and several others from the last years of the century, show us that Steer could be considered then as one of the most promising English land-scape artists.

Unfortunately indolence got the better of him, and from about 1900 he increasingly turned to the past in order to find his inspiration. His view of *Richmond Castle* (1903) seems little more than a half-hearted echo of Constable. In his watercolours, though, he went on creating works that were

WALTER RICHARD SICKERT.
SANTA MARIA DELLA SALUTE, VENICE.
c. 1901. Oil on canvas. 55.8 x 45.7 cm.
Royal Academy of Arts, London.

PHILIP WILSON STEER.
GIRLS RUNNING. WALBERSWICK PIER.
1894. Oil on canvas, 62.2 x 92.7 cm.
Tate Gallery, London.

full of charm, right up until the end of his life. In these watercolours, which are simple and unlaboured, he was able to regain some of the vitality which characterised the best of his earlier works.

Walter Richard Sickert, unlike Steer, had many contacts with the artistic life of France. As a young man he worked with Whistler and succumbed for a time to his influence. It was Whistler who introduced him to Degas with whom he remained very close, painting numerous scenes of the music-hall as well as interiors. His landscapes, especially those painted in Dieppe and Venice, have points in common with those of the impressionists, but differ from them in their rather sombre tonality. Sickert frequently painted over a brown ground, and the texture of his paint could, on occasions, be highly wrought. *Santa Maria della Salute, Venice* (1901)*, which Sickert chose to present to the Royal Academy as his Diploma work, when he was elected in 1935, when compared to Monet's views of *Rouen Cathedral* seems much more like an architectural study, with the forms clearly defined, rather than fragmented by light.

RESEARCHES OF THE POST-IMPRESSIONISTS

At the very beginning of the 20th century there were some artists who firmly opposed the influence of continental painting at all; for Henry Tonks, Professor at the Slade School of Art, London University, where he taught many young artists and who was deeply attached to the English tradition, Cezanne represented the enemy. It was in part at least thanks to Sickert, and despite the influence of Tonks, that post-impressionism began to be recognised in England. Sickert had contacts and meetings with many artists and groups of admirers; one such group came together under the title of the Camden Town Group, taking its name from an area of north London. In 1910 and 1912 two exhibitions were held of French post-impressionism, which revealed for the first time to English audiences the results of the researches of those continental artists, who had emphasised line, volume and proportion in their efforts to achieve greater formal unity in their paintings.

Amongst the members of the Camden Town Group was Camille Pissarro's son, Lucien, a landscape artist who had settled in London. He acted both as a mentor on matters concerning French painting, and as a direct link with the impressionists and post-impressionists. Others of the Camden Town artists looked more directly to Gauguin for their inspiration, as was the case with Robert Bevan, who had spent two years in Pont Aven. Bevan painted city scenes in a semi-pointilliste technique like *Cab Yard at Night* (1910, Brighton Art Gallery).

Spencer Gore through the freshness of his vision and because of his technique, remained close to impressionism. He produced a number of excellent landscapes, but unfortunately his premature death from influenza cut short a promising career.

Charles Ginner, who had been born in France and studied at the Ecole des Beaux Arts, helped to disseminate post-impressionist theories in England. His landscapes, which were firmly constructed and thickly painted in a

HAROLD GILMAN.
CANAL BRIDGE, FLEKKEFJORD.
c. 1913. Oil on canvas. Tate Gallery.
London.

mosaic of minutely applied brush-strokes, sometimes with the outlines painted in for added emphasis, produced a reassuring sense of permanence as in *Leeds Canal* (1914, Leeds City Art Gallery) and many other urban views.

When another member of the Camden Town group, Harold Gilman, was disorientated by the 1910 exhibition, *Manet and the Post-impressionists*, it was Ginner who helped him to overcome his difficulties by taking him to Paris, where he discovered the work of Cezanne and Van Gogh. Gilman's paintings are both soundly structured and sensitive at the same time; qualities which allow them to be classified as "neo-realist", the term coined by Ginner and Gilman in an effort to define the theories which underpinned their approach to painting. Gilman's *Canal Bridge* (1913)* is a good example of his work, both for its original viewpoint and for the sympathy with which he treats this urban scene. Gilman only painted things he loved.

Landscape painting from post-impressionism to fauvism is brilliantly represented in British art by the work of the Irish painter, Roderick O'Conor. In the masterly and uncompromising stripes of his *Yellow Landscape* (1892)* it is quite clearly the influence of Van Gogh that was still dominant, but after that, O'Conor went to work with the Pont Aven Group. Working alongside Gauguin helped him to clarify his own vision, and this emerged triumphantly in *The Wave* (1898, York City Art Gallery). His later works, with their vigorous use of colour, are often close in feeling to those of the Fauves.

RODERICK O'CONOR.
YELLOW LANDSCAPE, PONT AVEN.
1892. Oil on canvas, 67.6 x 91.8 cm.
Tate Gallery, London.

THE BEGINNING
OF THE TWENTIETH CENTURY

C.R.W. NEVINSON.
A BURSTING SHELL.
1915. Oil on canvas, 75.5 x 55.5 cm.
Tate Gallery, London.

Du...uring the first half of the 20th century two conflicting trends dominated English painting. On the one hand, artists were seeking for greater and greater freedom, with everyone striving to create his, or her, own personal style, whilst on the other hand, the period was marked by the coalescing of numerous small groups, often destined to be short-lived. These groups were sometimes formed to promote a single theory or idea, like Vorticism, or else they gathered themselves round a dominant personality, as was the case with the *Seven and Five* and *Unit One*, with Ben Nicholson. The only common characteristic amongst landscape painters was their rejection of straightforward representation, which they left to photography. Early in the 20th century artists came to realise that in painting, colour, form and composition were the important elements and, through them, it was possible to express an idea or a feeling. It was along these lines that Henri Matisse pursued his researches, and it was the principles which he evolved that he taught to the students, who frequented the art school he founded in 1908.

Besides Matisse, every continental art movement – futurism, cubism, surrealism – sought in one way or another to express ideas in paint. These movements influenced English art, but in the process always acquired a peculiarly national flavour.

The divide that separated the 20th century from the preceding one can be seen in the differences between Roderick O'Conor and Matthew Smith.

O'Conor, although he used a technique that was not dissimalar to that of the fauves, treated representation in much the same way that Van Gogh had. Matthew Smith went beyond this point, having overcome the problems of his own neurosis. Neither early contact with fauvism, nor a brief spell at Matisse's school had produced any worthwhile results, but at the end of the war, whilst suffering from deep depression, Smith went to Cornwall. It was there, whilst recuperating, that he began to produce a remarkable group of sumptuous fauve landscapes, such as *Winter Evening* (1920), in which he laid the trees in in rose red against a blue-black sky; but whilst this gave him the freedom to express his feelings, his earlier discipline harmonised the whole and turned it into a work of art.

Even freer than these Cornish landscapes are those that he painted in Provence (c.1932), which show him moving towards an art based on spontaneity and on the sheer joyousness of the act of applying paint to canvas. These works exude spontaneity.

VORTICISM

Both cubism and vorticism made an impact in London between 1910 and 1912, due to various exhibitions. The violence of the theories of Italian futurism accorded well with this period of disquiet and general agitation, which preceded the outbreak of the First World War. Marinetti, the Italian protagonist of futurism, provoked a lively response from Wyndham Lewis, who launched "vorticism", which was a sort of English futurism. Vorticism took its name from the "vortex", which Lewis regarded as the heart of the whirlwind, the eye of the storm. In its review, "BLAST", which he created in 1914, Lewis glorified the efficiency of the machine compared to the sensitivity and gentleness which had been the hallmark of English painting up to that time. This attitude was hardly propitious for the art of landscape painting. During the war, however, whilst serving as an official war artist, Lewis had to find a means of putting his theories into practice. Uniting cubism and vorticism he painted several enormous canvases, including *A Battery Shelled* (1919) for the Imperial War Museum. After 1920 he painted less, but in 1936 *The Surrender of Barcelona* (Tate Gallery) was an attempt to create an urban scene based on the principles of the "clean and hard" volumes which he had extolled during those earlier years. Despite these paintings, it is as a theoretician that Lewis is best remembered.

Another top rank artist among the futurists and vorticists was C. R. W. Nevinson. His *A Bursting Shell* (1915)* may owe a debt to Balla's *Street Light* (1909) but the treatment of the subject is enlivened and enriched by the way that Nevinson has depicted the fracturing of the space immediately surrounding the explosion and by the impression of movement that he has managed to convey.

In the quest to depict movement, Stanley Cursiter adopted a different style. Under the influence of such works as Severini's *Panpan at Monico* (1910) and *The Boulevard* (1911), Cursiter adopted a kaleidoscopic vision for his ambitious work, *The Sensation of Crossing the Street. The West End, Edinburgh* (1913)

MATTHEW SMITH.
LANDSCAPE IN PROVENCE.
Victoria & Albert Museum, London.

MATTHEW SMITH.

LANDSCAPE.

Oil on Canvas. Messrs Bonhams, London.

Although attracted to vorticism early in his career, David Bomberg was never, strictly speaking, attached to the movement. At this period he concentrated on painting highly formalised, and sometimes almost totally abstract, figures in movement. His landscapes date from much later when he had returned to a more naturalistic style. He painted a lot in Spain and around the Mediterranean.

In these works, his colour is hot and sensuous, and the thickness of his paint accentuates the effects of light and vitality, which, in some ways, recall the stylised figures of his early work. *The Valley of La Hermida* (1935)* shows quite clearly how he used light, through the medium of colour, to structure these landscapes.

In England, although the war may have supplied the perfect subject matter for the vorticists, it also sounded the death-knell of the movement.

THE INFLUENCE OF SURREALISM

During the 1920s the aura of the School of Paris attracted many young English artists to France. Some of these submitted to the attraction of surrealism, and to the appeal of a world obsessed with the absurd or with the occult.

Due to lack of funds Paul Nash had been unable to visit Paris, but after an unhappy childhood he found his inspiration through contact with nature, which he treated in a vaguely surrealist and poetical manner. From his earliest drawings of about 1911, night, trees and harvest time were the harbingers of a disturbing poetical message. During the war he could not help but feel sickened by the scenes of destruction with which he was surrounded, and he captured this feeling of desolation in many works, the most haunting of which bears the ironic title *We are Making a New World* (1918)*.

After the war it was the sea which served to bring him to the height of his powers. In order to evoke rather than depict the sea, he stylised the forms and captured the movement of the waves. *The Sea in Winter* (1925-1937) and *The Shore* (1923, Leeds City Art Gallery), despite their titles, and despite the extraordinary feeling for space that he manages to convey, are very close to almost total abstraction. They are depictions of silence, purity and immutable perfection, but at the final point he never lost touch with reality. Nash exploited the possibilities opened up by abstract painting, although he did not wish to go that far himself. He explained in an article that it was his intention to try and achieve a symbolic representation through seeking out an appropriate formula. He referred to non-figurative painting as "a pure, unfettered, joy" but he never abandoned himself to it completely.

It was in a different way that, towards the end of his life, he exceeded the bounds of the visible world. In his later landscapes, devoid of all human presence, the hills and wastelands are peopled with strange phantom forms. These are not emanations of the unconscious, like those that inspired the French surrealists, but natural objects transformed by the fertility of his imagination, as in *Monster Field* (1939, Durban Art Gallery).

Soon, however, the monsters were to assume a threatening and tangible reality. With the Battle of Britain, the sky, as well as the ground, was filled

DAVID BOMBERG.
VALLEY OF LA HERMIDA.
1935. Oil on canvas, 91.5 x 109 cm.
Sheffield City Art Galleries.

Paul Nash.
We are Making a New World.
1918. Oil on canvas, 71.1 x 91.4 cm.
Imperial War Museum, London.

ALFRED WALLIS.

ST IVES.

c. 1928. Oil, pencil and crayon on card-
board, 25.7 x 38.4 cm. Tate Gallery,
London.

with great propellered monsters, which Nash painted not only in flight, but also crashed and crushed, as in *The Death of a Dragon* (1940, Asmolean Museum, Oxford).

Edward Wadsworth's researches lead him in a different direction. After a flirtation with vorticism as a young man, he went on to paint views of seaports, imbued with an eery sense of unnatural calm and stillness, which convey a disturbing feeling of large spaces totally devoid of human presence, in the manner of de Chirico. Whilst Nash added supernatural presences to his landscapes, Wadsworth suppressed people and made time stand still.

The imaginary world of Stanley Spencer was very different from that of Nash and Wadsworth. Like William Blake, with whom he is sometimes compared, he had visions and, being deeply religious, he translated these into Biblical scenes in which landscape provides the background. About 1935-1939, however, he painted a number of highly detailed landscapes, which put one in mind of the pre-raphaelites. These were most frequently views of Cookham, a village on the river Thames, where he was born and which he loved dearly, It would appear from paintings such as *Cookham Moor* and *Gardens in the Pound, Cookham* (1936, Leeds City Art Gallery) that Spencer wished to create an image of England, which would preserve it for ever from encroaching modernisation.

THE ST IVES GROUP

St Ives, a delightful fishing village in Cornwall, became a place of refuge in 1940 for many artists, who wished to get out of London. It had, in fact, been popular with a number of artists, who had lived and worked there since the beginning of the century, but most of these had worked in a traditional, vaguely post-impressionist manner, like Borlase Smart.

It was not until 1928 though, with the arrival of Ben Nicholson and Christopher Wood, that St Ives seriously took its place in the annals of art history. During one of their walks these two artists discovered Alfred Wallis's extraordinary paintings nailed to the wall of his house. The man, like his works, was unusual. He had been a sailor for much of his life and then a marine scrap merchant; it was only after the death of his wife in 1920 that he took up painting "in order to keep himself company". He wanted to set down his memories of the village as it had been in the old days before modernisation began to change it, and he worked on scraps of cardboard given to him by the local grocer. In his paintings objects are shown in a completely idiosyncratic way, without any form of visual coherence. Some objects are depicted from above as though they are on a map, whilst others are shown from the side. In commenting on *St Ives* (c,1928)* Nicholson repeated that Wallis had said: "I don't like houses, give me a boat and you can have all the houses in the world." He painted them, nevertheless, with the lighthouse proudly erect,beside the moored boats lined up along the quayside. For paint he used a limited range of industrial paints from the boatyard – mainly blue, green, brown and black – with the result that his paintings give an impression of vigour rather than subtlety.

IVON HITCHENS.
DAMP AUTUMN.
1941. Oil on canvas. 40.6 x 74.3 cm.
Tate Gallery, London.

In these works Wallis involuntarily anticipated the naive and unsophisticated language, which certain London-based artists were seeking to achieve. Nicholson and Wood were immediately beguiled by it and emulated Wallis's innocence. Wood was the best placed of the two to respond to this new influence as he had already been introduced to *avant garde* painting in Paris by his friend, Albert Kahn. He already knew the work of Picasso and the Douanier Rousseau. This contact with Wallis in 1928 made him seek for a greater simplicity in his own paintings and to try and achieve a new richness of colour and variety of texture, as can be seen in *The Harbour, Mousehole* (1930)*.

Ben Nicholson was less influenced by this meeting with Wallis in 1928, though *Porthmeor Beach* (1928) shows us clearly that he was by no means insensitive to the old sailor's visions. Born into a family of artists, Nicholson was already too sophisticated to adopt this approach for long, and he evolved his own non-figurative style under the influence of Mondrian and a number of other friends encountered in Paris in 1932-1933. The Second World War, though, brough him back to St Ives, which remained his base from 1939 to 1958. He sometimes created more figurative works, albeit very stylised, in which he liked to juxtapose still life and landscape seen through a window. *Still Life and Cornish Landscape* (1944)* was the painting from this series that he preferred himself, though these successes did not inhibit him from working principally in a totally non-figurative manner.

Ben Nicholson and his wife, Winifred, belonged to a group of London-based artists entitled *The Seven and Five Society*, consisting of seven painters and five sculptors, in which every one was free to adopt the style that suited them best. Among the painters in the group were Frances Hodgkins, whose landscapes are agreeably poetic, and most importantly for this study, Ivon Hitchens, who pursued a systematic study of shape and form, experimenting with several styles in turn. One of his earliest works, *The Curved Barn* (1922, Pallant House, Chichester), made up of highly charged masses and thrusting curves, reveals the influence of cubism combined with a futurist inspired dynamism. This was superseded in the 1930s by a period of pure abstraction before he came back once again to a figurative landscape style in 1937. His style, though, was more intuitive than realistic, being based on psychological and sensory impressions, which he translated into long elegant sweeps of colour. Rather than precise representation, it was the feeling of the seasons that he evoked, as can be seen in *Damp Autumn* (1941)*, a work in which he attempted to capture the very essence of the countryside where he lived. In other works he simplified the elements to such a degree that, once again, they border on almost total abstraction.

THE RETURN TO THE FIGURATIVE TRADITION

In the profusion of artistic movements, whch abounded in London in 1936, an artist, who was well known at that time for his non-figurative work, wrote in an article entitled *The Painter's Object* that a valuable object had been lost, and that it was now high time for a return to the English landscape tradition, which could be enriched at the same time by lessons learnt from surrealism.

BEN NICHOLSON.
STILL LIFE AND CORNISH LANDSCAPE.
1944. Oil on wooden panel, 78.7 x 83.8 cm.
Collection IBM Gallery of Science and Art.

CHRISTOPHER WOOD.
THE HARBOUR, MOUSEHOLE.
1930. Oil on canvas. 49 x 63.5 cm.
Glasgow Museum and Art Galleries.
Mousehole is a small fishing port on the
southern coast of Cornwall. Wood
painted there the year he was killed by a
train at the age of 29.

LAWRENCE STEPHEN LOWRY.
THE POND.
Tate Gallery, London.

The artist in question was John Piper, who adopted forthwith a more traditional style in order to paint the architectural monuments of Great Britain, with which he had been fascinated since he was fourteen years old. The imminence of war, which everybody anticipated, gave an added drama and sense of urgency to these works. Piper depicted these old buildings with a merciless eye, harping on their crumbling state and certain destruction. This destruction was, in many cases, brought about in the next few years by bombs. In 1940 Piper was appointed an official war artist, charged with making a record of war-damaged buildings. Unhappy chronicler of so much destruction, he painted an extended series of dramatic scenes taken directly from life, including scenes of damage caused by air raids, drawn on the spot in their immediate aftermath. It was in Bristol that he painted *Redland Park Congregational Church* * open to the skies, and in which charred forms and touching gothic ruins are juxtaposed. At Bath, an eighteenth century architectural jewel of a city, he selected the gutted facade of *Somerset Place* (1942) silhouetted against the night sky.

Piper was a well-known artist, who came back to figuration because of his love for old stonework. L. S. Lowry was a totally different case. Apart from a few rare exceptions, he painted almost exclusively in the working class areas around Manchester. His subject matter consisted of streets devoid of interest, factory exits, canals carrying overburdened barges, fairgrounds and public entertainments and, above all, human beings scurrying like ants, solitary and indifferent with no warmth of contact between them.

Although there are no social overtones to these landscapes no one can overlook his work. Lowry was not a socially aware artist, nor was he a political militant: he simply painted the *Industrial Landscape* (1930)* that he saw around him. He had been born into this environment, he lived alone in it, and he neither knew nor wished for anything different. He depicted these industrial suburbs in detail and in a distinctive style, using an extraordinary subtlety of tone, which transmuted the smoke filled sky and the disgustingly dirty canals between blackened banks, into shades reminiscent of mother-of-pearl.

Sometimes, although not very often, Lowry went to the coast. He liked the sea and boats, and his canvas, *The Sea* (City of Salford Art Gallery), through the extreme sensibility which it reveals, could make more than one dedicated artist green with envy.

Another industrial town, Bolton, became the object of a sociological survey, "Mass Observation", as early as 1938, when it was painted by a group of artists, including Graham Bell, an intellectual Londoner. Despite his socialistic beliefs, Bell shunned the idea of making propagandist images, but instead, like Lowry, evoked differnet aspects of life in the city.

THE ARRIVAL OF KOKOSCHKA

Oskar Kokoschka was an Austrian by birth but became a naturalised English citizen in 1947. He had fled from his homelamd in 1939, following the Nazi campaign against degenerate art, and had found refuge in England,

LAWRENCE STEPHEN LOWRY.
INDUSTRIAL LANDSCAPE.
1934. 43.2 x 53.3 cm. Private Collection.

JOHN PIPER.

REDLAND PARK CONGREGATIONAL
CHURCH, BRISTOL.

*1940. Oil on canvas, 61 x 51 cm. Pallant
House, Chichester.*

When painting these scenes of bomb
damage, Piper tried to find poignant
accents like the colour rose on the rose
window, but he was often reproached for
being too theatrical.

but he never allowed himself to be absorbed into the artistic life of his adopted country. At the time he left Austria he was already a distinguished expressionist painter, with many remarkable portraits to his credit.

He had volunteered for the army in 1914, and had been seriously wounded and left for dead on the battlefield. It was during his recuperation in Dresden that he began to paint once again. *Dresden, Neustadt V* (1922) is a brutal vision, an arrangement in primary colours, which expresses the fevered vision and disturbed psyche of the artist.

During the ensuing years, although he remained essentially a portrait painter, Kokoschka produced many landscapes and, due to his extensive travelling, continually found new themes. As time went on he evolved a style that became less agitated and more coherent, as expressionism gradually gave way to a more realistic approach,, which allowed him to amplify the feeling of space. To emphasise this he would select two different angles from which to study the same scene - for example two different rooms, far apart, in the same hotel - and then combine the two viewpoints into one painting. His colour also became simpler and less strident during this period, and in a painting like *Large Thames View I* (1926)*, one can see him giving himself up to the sensual pleasures of pure colour.

After the Second World War (which marks the end of this study), Kokoschka continued to paint sumptuous landscapes in his very personal style, which was neither fauve nor expressionist, nor post-impressionist. These landscapes are always remarkable for the exuberance of their colour and the boldness of his vision.

THE NEO-ROMANTICS TRANSFIGURE NATURE

A group of artists, who imposed their own sensitivity on nature, were grouped together under the heading of the neo-romantics. Among them was Graham Sutherland, one of the best known English painters of the 20th century, who became a painter and found his true vision, largely because of the Wall Street crash of 1929 and the ensuing depression. Until that time he had earned his living as an engraver and etcher, working in a pastoral manner inspired by his deep admiration for the work of Samuel Palmer. His two exhibitions, in 1925 and 1928, had already secured him many admirers, but the financial crisis upset everything, and the print market collapsed completely; nothing was selling any longer. Forced to take any work that was offered, Sutherland turned to commercial decoration, and it was at that time that he started to paint, producing some landscapes in Cornwall and Dorset. His earliest landscapes were fairly traditional, but gradually they became freer and more expressive.

A visit to Pembrokeshire in Wales in 1934, where he was to return each year, with its rugged and rock-strewn landscape, gave him the opportunity to find his true voice. "The whole place seems to be exaggerated, the light, the shadows and the general decay," he wrote. There are dark forces about, the sombre and aggressive side of nature, which give their own particular tone to the *Welsh Mountains* (1938, Private Collection).

Oskar Kokoschka.
London, Large Thames View I.
1926. Oil on canvas. 90 x 130 cm.
Albright-Knox Art Gallery, Buffalo.

Alongside his devotion to Palmer, Sutherland responded to the abundance and goodness of nature. He had, like Palmer, seen nature in mystical form and had glorified her, but now the clear line and dashing stroke, which he had mastered as an engraver, enabled him to capture the shapes of natural forms. His *Entrance to a Lane* (1939)* does not so much depict nature, rather it evokes, transfigures and re-organises the components of the scene – foliage, and the play of light and shade. Here, without being either figurative or abstract, Sutherland poured out his impressions and rendered the scene before him. Everything here is suppleness and poetry. All this, however, was to be brutally interrupted by the war, during which he, like many others, served as an official war artist covering and recording a wide range of war-time activities.

After the war, alongside the portraits and religious works which occupied much of his time, he continued to paint landscapes, but these were now imaginary, made up of re-arranged natural elements, which allowed him to delve deeply into the mysteries of nature and to depict her in a state of ecstasy.

Sutherland's own emotional response to nature inspired many other artists, including his pupil, John Craxton, and others such as John Minton who knew him for a while.

Victor Pasmore was also a very sensitive and lyrical landscape painter before the war. He too must be classified among the neo-romantics. *The Park* (1947)* is a very stylised vision; this reduction of landscape to its barest essentials heralded Pasmore's imminent change to total abstraction, which came about the following year, having become aware that beauty of line was akin to musical harmony.

AND AFTER?

At the end of the Second World War, the dominance of the School of Paris gave way to that of the School of New York. For many artists the whole orientation and object of painting were drastically changed, and the idea of representation was abandoned under the influence of a movement which transformed and reorganised the visible world in order to express emotions or mental states. For many, it was the end of landscape painting conceived as the description of the natural world; it represented the inexorable progress of a different art which, in England, had witnessed the grouping, around Ben Nicholson and Paul Nash, of Unit One as a body of non-figurative artists. The centre of interest was no longer before the artist, it was inside him.

It is the magnitude of these changes, which lead us to choose the Second World War as the closing point of this study.

However, it must be said that since the war, a strong and lively current in favour of figurative landscape, in the traditional sense of the term, has continued in Great Britain. It is the originality of English painting that has permitted it to continue in this way, despite the pressure from international styles, which have been pushing in a contradictory direction. The artists concerned were neither retrograde nor reactionary, they wanted to move

ahead to find new means of expression which accorded more closely with their humanitarian and socialist beliefs.

The movement most often associated historically with these twin ideals was the "Kitchen Sink School", which developed during the 1950s, parallel with certain European movements which also favoured realism. The school took its name from the wish of the various artists to take their themes from the humdrum activities of everyday life.

One can verify in a general way the fact that the tradition was not dead from the annual exhibitions at the Royal Academy, which included both abstract and figurative work; traditional landscape painting constituted by far the largest part.

Amongst dealers too, landscapes continued to find a ready market. More than in any other country, the landscape tradition in England has resisted the assault of non-figuration.

VICTOR PASMORE.
THE PARK.
1947. Oil on canvas, 110 x 78.5 cm.
Sheffield City Art Galleries.

A GLANCE BACKWARDS

The richness and variety of the English school of landscape painting sprang from the contiuous struggle between the two main tendencies which dominated it: realism and poetry. These tendencies and the alliance between them, which is often surprising to continentals, give, in the final analysis, the weight and uniqueness to the English sensibility.

Realism and poetry were in opposition in painting, in much the same manner as romantic poetry was opposed to the industrial revolution. These two, in their complementariness, are the foundation stones of Great Britain.

As far as landscape painting is concerned, everything started at the end of the 16th century at the time when, thanks to the bias of poetry, people associated nature and beauty. This was a fragile alliance, only perceived by a few enlightened spirits, and for long ignored by the majority, thus benefitting realism, to which the art of the topographer can be equated. Stubbs himself, despite his realistic tendencies, was in truth a poet of animal life, although almost no one appreciated it. Equally, no one appreciated the profoundly poetic inspiration that shone through the landscapes of Wilson and Gainsborough. The former bedazzled by the beauty of Italy, and the latter a born poet. It was these two who elevated English landscape painting to the rank of an international school, recognised by the Academy, even if it continued to be mocked by self-professed connoisseurs.

From the end of the 18th century until the death of Turner, different ingredients came together to create a new art. A shared and potent enthusiasm favoured the emergence of the romantic poetry of Wordsworth and Byron, as well as the masterpieces of landscape painting. Each of the major artists contributed something of his own personality: the watercolourists combined transparency with brilliance of colour, to express their sensibility, Turner conquered atmosphere and space, Constable sang of a more earthy profundity, Cox tackled wind and rain, whilst Bonington scattered his canvases with the reflected light of precious stones.

The situation was reversed in the second half of the 19th century, when creativity was almost suffocated under a blanket of realism and moralising. It is almost possible to overlook, at this period, the fact that landscape existed in its own right. It took another painter-poet, Whistler, to revive the art and, through the medium of the London fog, open the way to the 20th century.

After that, the tone became more serious. The often predicted war darkened the shadows, and landscape then became, for some, a passionate celebration of the threatened world. Others searched, through nature, for the roots of humanity in the hope of finding a *raison d'être* for their existence and their personality. This quest sometimes took on a mystical dimension, as religion had failed to answer such questions. Poetry, which was ever present, took on a tragic tone, but did not disappear.

Just as the poet, John Keats, wrote "A thing of beauty is a joy for ever", so is a work of art also a joy for ever.

GRAHAM SUTHERLAND.
ENTRANCE TO A LANE.
1939. Oil on canvas. 59.7 x 49.5 cm.
Tate Gallery, London.

WHO WERE THESE PAINTERS?

J.T. SMITH.
TURNER IN THE PRINT ROOM OF THE
BRITISH MUSEUM.
c. 1825. Pencil and watercolour.
22.2 x 18.4 cm. British Museum, London.

ALEXANDER, WILLIAM
1767-1816. Draughtsman working in the traditional manner. Participated in Girtin's drawing club and frequented Monro's Academy at the same time as Turner. Accompanied Lord Macartney's Embassy to China (1792-1794) as draughtsman. The only artist of his time to see the interior of China, he re-worked much of the material he had gathered there after his return to England.

BEVAN, ROBERT POLHILL,
1865-1924. Spent two years (1893-1894) with Gauguin at Pont Aven. Admired Pissarro and the neo-impressionists from whom he adopted his broken brush technique. Often painted pictures of horses in urban settings.

BOMBERG, DAVID
1890-1957. A pupil of Sickert's, before studying at the Slade School. Took part in the vorticist exhibition of 1915. Later painted figurative landscapes in Spain and the Mediterranean countries. He exercised an important influence on other painters through his teaching.

BONINGTON, RICHARD PARKES
1802-1828. Born near Nottingham. His family later moved to Calais, where he met Louis Francia. He went to Paris, and travelled in northern France, and then visited Venice. He was a friend of Delacroix's, who wrote discerningly in his *Diary* of Bonington's paintings.

BOYS, THOMAS SHOTTER
1803-1874. A friend of Bonington's, by whom he was influenced. A very competent draughtsman of architectural scenes. Divided his life betwen London and Paris.

BRABAZON, HERCULES BRABAZON
1821-1906. A rich amateur, he never wished to be regarded as a professional artist. His first exhibition was held in 1891, when he was already 70. The freedom of his technique heralded the art of the 20th century.

BRETT, JOHN
1831-1902. Admitted to the Royal Academy Schools in 1853; was inspired primarily by Ruskin's writings. The landscapes he painted under this influence were not received well at the Royal Academy. In 1863 he began to travel through the Mediterranean in his own boat. He mainly painted seascapes and coastal scene

BROWN, FORD MADOX

1821-1893. Born at Calais. Early artistic training in Belgium. Although older than the others, he was closely linked to the pre-raphaelites, through his friendship with Rossetti, one of the original members of the Brotherhood. He led a retiring and difficult life at Hampstead, Finchley and, finally, Manchester.

CANALETTO, ANTONIO

1697-1768. An Italian painter, born in Venice, where he painted popular views, which achieved great success with English collectors. Worked in London from 1746 to 1755 with two stays in Venice in 1750-1751 and 1753-1754. Had considerable influence on the development of English landscape painting.

CLEVELEY, ROBERT

1747-1809. Son of John Cleveley the elder (c.1712-1777), a naval worker, who subsequently became a painter. He and his twin brother, John Cleveley the younger (1747-1786), always lived in a naval environment. Under the patronage of Charles II and his successors, the three of them brought the Dutch tradition of marine painting to England. Robert Cleveley exhibited regularly at the Royal Academy, and became Marine Painter to the Prince of Wales

CONSTABLE, JOHN

1776-1837. Born at East Bergholt, in Suffolk. During his youth he worked in his father's mills, and only drew in his leisure moments. From 1799 he lived in London, where he enrolled at the Royal Academy Schools. He first exhibited in 1802. His progress was very slow. Nature was his essential source of inspiration. After his election in 1819 as an Associate of the Royal Academy, he painted large *Scenes of the Stour Valley*. In 1829 he was finally elected to the Academy, but, his wife having died in 1828, he suffered from severe depression, which he expressed in his view of *Hadleigh Castle*. Died in London.

COTMAN, JOHN SELL

1782-1842. Born at Norwich. He moved to london in 1798. First exhibited at the Royal Academy in 1800. The same year he was awarded the silver palette of the Society of Arts. Made a number of visits to Wales and Yorkshire. Rejected by the Society of watercolour painters he began to paint in oils. He exhibited at the Norwich Society of artists. In 1812 he settled at Yarmouth under the protection of the banker-archaeologist Dawson Turner. Made three visits to Normandy for the express purpose of drawing gothic architecture. Opened a drawing school at Norwich, which lent the pupils drawings to copy. Despite many serious fits of depression he was appointed professor at King's College, London, in 1834. He then lived in London until his death.

COX, DAVID

1783-1859. Born near Birmingham. He was apprenticed first to a medalist, after which he became a theatrical scene painter. Settled in London in 1804. He travelled widely throughout his life in Wales and the North of England, then in France (1829 and 1832). Early in his career he painted in a detailed and topographical manner, but changed his approach as he became interested in the more ephemeral aspects of landscape which he treated much more broadly. He was a drawing master and also published teaching manuals.

COZENS, ALEXANDER

1717(?)-1786. Born in Russia. After a stay in Rome he became a fashionable drawing master in London, which allowed him to compile several treatises on art, which were published between 1759 and 1785, of which the last was *A New Method of assisting the Invention in Drawing Original Compositions of Landscape*. He taught drawing at Eton from 1763 to 1768. He was a close friend of the rich Maecenas William Beckford.

COZENS, JOHN ROBERT

1752-1797. Born in London, son of Alexander Cozens, who taught him drawing. In 1776 he made his first visit to Italy with the writer and theoretician of the art of the picturesque, Richard Payne Knight. He remained in Rome in 1778, returning to London in 1779. A close friend of William Beckford's, he returned to Italy with him in 1782. Back in England again in 1783. He began to show signs of madness in 1794. Looked after in an asylum run by Dr Monro, a great collector of drawings. Received financial help from Sir George Beaumont. Died in London.

CROME, JOHN

1768-1821. Self-taught. Started as a sign-painter, then became a drawing master. Influenced by Dutch painting. In 1803 he was a founder of the Norwich Society of Artists, of which he remained the most important painter member. He primarily painted landscapes of East Anglia, where he lived throughout his life.

CURSITER, STANLEY

1887-1976. Scottish painter, who briefly attached himself to vorticism. Director of the National Gallery of Scotland from 1930.

DAYES, EDWARD

1763-1804. Topographical landscape artist. Painted many views of picturesque ruins and complex architectural subjects, which show off his skill. He was Turner's master, and his pupil copied him at the beginning of his career. He was driven by his irrascible nature to write spiteful accounts of his contemporaries. He committed suicide at the age of 40.

DE WINT, PETER

1784-1849. Admitted to the Royal Academy Schools in 1809. He was also very influenced by Girtin. He lived in London and Lincoln, where he earned his living as a teacher. He made only one foreign visit, to Normandy in 1828. He was elected a member of the Watercolour Society in 1811.

DYCE, WILLIAM

1806-1864. Born in Aberdeen, the son of a professor of medicine, he always retained an interest and a proficiency in science. From 1844 he painted murals for the interior of the Palace of Westminster, and then at Osborne House, thanks to the patronage of Prince Albert. Having admired the paintings of the pre-raphaelites from 1850, he persuaded Ruskin to treat them seriously.

FRANCIA, LOUIS

1772-1839. French painter. Spent much of his life in London, where he came under the influence of Girtin. Contributed to the propagation of English art in France.

FRITH, WILLIAM POWELL

1819-1909. Born in Yorkshire. Studied at the Royal Academy Schools. Painted large scale pictures of contemporary life, which achieved great popularity due to their richness of anecdotal subject matter.

GAINSBOROUGH, THOMAS

1727-1788. Born at Sudbury, Suffolk. Arrived in London in 1740. Trained in various London studios, particularly that of the French artist, Hubert Gravelot. Started by painting Dutch influenced landscapes and portraits. Settled at Bath in 1759, where he earned his living painting fine portraits whilst painting landscapes for his own pleasure. The latter were imaginery works often painted from models, which he made himself. In 1768 he was the only artist living in the provinces who participated in the foundition of the Royal Academy. He greatly admired the work of Rubens. In 1774 he settled in London at Schomberg House, where he exhibited his own work after disagreements with the Academy. Protected by King George III and Queen Caroline. At the end of his life he turned to genre painting with scenes of rural life, which sometimes achieved great success. Had little influence after his death in 1788, but his landscapes achieved a belated popularity.

GILMAN, HAROLD

1876-1919. Student at the Slade School in 1897, where he met Spencer Gore. Became one of the circle of Sickert's friends and contributed to the founding of the Camden Town Group in 1911. Influenced by Van Gogh and Gauguin he adopted the use of brilliant colour. With Charles Ginner he founded an art school, where they both taught.

GINNER, CHARLES

1878-1952. Born at Cannes in the South of France. Trained at the Ecole des Beaux-Arts, Paris. Moved to London in 1910, and became very close to Gore and Gilman. Member of the Camden Town Group. Elected an Associate of the Royal Academy in 1942.

GIRTIN, THOMAS

1775-1802. After a short apprenticeship with Edward Dayes, he continued his training by drawing architectural elevations for an archaeologist, James Moore. He met Turner with John Raphael Smith, the publisher for whom he worked. From 1794 he rejected the topographical style of Dayes. Collaborated with Turner at Monro's Academy. Extensive travels throughout Britain led him to adapt his vision, particularly after 1796. He had found his own style, characterised through abandoning monochrome washes and applying spreading areas of colour onto a slightly tinted cartridge paper. During the last years of the 18th century he painted a panorama of London in oils, the *Eidometropolis* : he undoubtedly dreamed also of making a panorama of Paris. He began working in 1801 with this objective in sight, but died of tuberculosis the following year. If he had lived longer he would have become one of the greatest of English landscape artists.

GORE, SPENCER

1878-1914. Studied at the Slade School, where he met Gilman. First president of the Camden Town Group. Died at the age of 36.

HAYTLEY, EDWARD

Active from 1740 to 1761. Landscape painter; he also painted some small format portraits in the style of Arthur Devis.

HILLIARD, NICHOLAS

1547 (?)-1619. Miniature painter, who had trained as a goldsmith in his father's workshop in Devonshire. Court painter. Painted many miniatures of the Queen and her courtiers. Wrote a treatise on the art of the miniature, and raised this form of painting to the highest level.

HITCHENS, IVON

1893-1979. Trained at the Royal Academy Schools. After working as a decorator, turned to landscape painting under the influence of Cezanne, Braque and Matisse. The bombing of his London studio in 1940 led him to settle near Petworth in Sussex, where he painted landscapes vibrating with colour, which sometimes come close to abstraction. In 1956 he represented Great Britain at the Venice Biennale.

HODGES, WILLIAM

1744-1797. Accompanied Captain Cook's second voyage (1772-1775) in the capacity of draughtsman. Elected to the Royal Academy in 1787, due to his reputation as a painter of exotic subjects.

HOLLAR, WENCESLAS

1607-1677. Born in Prague. Left Bohemia for religious reasons in 1627. Met the Earl of Arundel at Cologone in 1636, who brought him to England. Drew the principal buildings in London as well as the fortifications of Tangier.

HUNT, WILLIAM HOLMAN,

1827-1910. Worked first of all in an office. Entered the Academy Schools in 1844. Ruskin's *Modern Painters* influenced him enormously in 1847 in his search for a new style. Original member of the Pre-Raphaelite Brotherhood in 1848. Went to Egypt in 1853. Later made a number of visits to the mediterranean countries. Published his autobiography, *Pre-Raphaelitism and the Pre-Raphaelite Brotherhood* (1905).

JAMES, WILLIAM

Active from 1740 to 1771. Influenced by Canaletto he tried to give his views of London a natural feeling by, for example, painting ripples on water, but this tended to become very repetitive.

KOKOSCHKA, OSCAR

1886-1980. Born in Austria. Worked first of all in a violently expressionist style. Seriously wounded during the First War. Convalesced at Dresden, where he also taught. Fled from Germany in 1939. Became a British subject and lived at Villeneuve on Lake Geneva.

LAMBERT, GEORGE

Circa 1700-1765. Influenced by Wootton. Said to have been a theatrical scene painter. Some wealthy collectors asked him to paint landscapes to decorate their house. Precursor of Wilson. Until recent times was totally forgotten.

LEAR, EDWARD

1812-1888. Best known for his *Nonsense Poetry*. During a life in which he was continually travelling, he made an enormous number of drawings and highly detailed and lively watercolours of Europe and the Middle East. Towards the end of his life he made a long tour of India.

LEIGHTON, FREDERIC, LORD

1830-1896. Son of a doctor,who, thanks to wide travel in Europe, was refined and spoke several languages. Painted in a classical manner. Elected President of the Royal Academy in 1878, and was ennobled in 1896.

LEWIS, JOHN FREDERICK

1805-1876. Sought to rival in watercolour the precision of oil paint in achieving highly wrought surface detail. Travelled in Spain, and then spent ten years in Cairo. Achieved an enormous success with his harem scenes.

LEWIS, PERCY WYNDHAM

1882-1957. Painter and writer. Studied at the Slade School and then travelled extensively. Disappointed by the half-heartedness and inadequacy of English art he founded vorticism. His rare landscapes are war paintings. Gradually gave up painting for literature, especially his two works of autobiography.

LOWRY, LAWRENCE STEPHEN

1887-1976. After studying at local art schools, he lived an unremarkable life in the outskirts of Manchester. Never travelled abroad. His talent was recognised belatedly, but in 1955 he was invited to become an Associate of the Royal Academy, and was elected to full membership in 1962. The museum at Salford has a remarkable collection of his works.

MILLAIS, JOHN EVERETT

1829-1896. Born into a modestly rich family. Arrived in London in 1838. His parents wished to develop his precocious artistic gifts. In 1840 he was the youngest pupil at the Academy Schools. Joined with his friend William Holmand Hunt to found the Pre-Raphaelite Brotherhood. Spent the summer of 1853 in Scotland with Ruskin, and fell in love with Ruskin's wife, Effie. The Ruskins divorced and Millais married Effie in 1855. He produced and sold many paintings. Elected President of the Royal Academy shortly before his death in 1896.

MULLER, WILLIAM JAMES

1812-1845. Influenced by the works of Cotman. Wanted to make a name as an oil painter, but is best known for his watercolours painted in France and the Near East. His promising career was cut off by his premature death at the age of 33.

NASH, PAUL

1889-1946. Trained at the Slade School. In his war paintings he depicted man's destruction of nature. Influenced by Cezanne and the surrealists, he sometimes transformed natural objects into supernatural creatures within a landscape. Wrote an autobiography, *Outline*, published in 1949.

NEBOT, BALTHASAR

Active from 1730 to 1765. Of Spanish origin, he arrived in London in 1729-1730. Painted landscapes and urban scenes in London and Yorkshire.

NEVINSON, CHRISTOPHER RICHARD WYNNE

1889-1946. Trained at the Slade School and then at the Academie Julian in Paris (1912-1913). Participated in the vorticist exhibition in London in 1915. Disagreed with Wyndham Lewis over *A Futurist Manifesto: Vital English Art, 1914*, but collaborated in the review "BLAST". After the war he developed a much more traditional approach to painting. Wrote an autobiography, *Paint and Prejudice*, 1937.

NICHOLSON, BEN

1894-1982. Son of the painter William Nicholson. Studied at the Slade School and then travelled abroad. During the 1920s his work was influenced by that of his first wife, Winifred. Later, he evolved towards non-figuration, and married the sculptor, Barbara Hepworth. In Paris he became a member of the movement Abstraction-Creation. During his second period at St Ives (1939-1958) he painted some figurative landscapes.

NICHOLSON, FRANCIS

1753-1844. Drawing master to various wealthy families. Founder member of the Society of Painters in Watercolours in 1804. Author of a manual on landscape painting published in 1820:*The Practice of Drawing and painting Landscapes from Nature in Water Colours*, in which he extolled a very traditional approach to art.

NICKOLLS, JOSEPH

Active from 1726 to 1755. Very little known but of undoubted talent. Painter of topographical views of London and creator of decorative scenes of Vauxhall gardens, the great 18th century pleasure gardens in South London.

O'CONOR, RODERICK

1860-1940. Born in Ireland, O'Conor spent much of his life in France. Probably met Van Gogh. In 1892 he settled at Pont Aven and was there when Gauguin returned from Tahiti in 1893. Anticipated the fauves in his direct application of primary colours. Exhibited at the Salon d'Automne up to 1930.

OLIVER, ISAAC

1556-1617. Miniaturist. Member of a huguenot family from Rouen who had taken refuge in England. Pupil of Hilliard. Travelled in Italy and studied Italian art. His works show a desire for realism.

PALMER, SAMUEL

1805-1881. Born in London. Met William Blake in 1824, which resulted in a dramatic change in his life. Lived at Shoreham from 1824 to 1832. During this period he produced a series of remarkable works in a style that was both bucolic and mystical. Later in his life he produced more conventional watercolours. Illustrated the works of Milton.

PARS, WILLIAM

1742-1782. Watercolourist. Member of the free Society of Artists from 1763. Travelled on the continent, in Asia Minor, Greece and also visited Rome. Elected an Associate member of the Royal Academy in 1770.

PIPER, JOHN

1903-1992. After a visit to Paris in 1933 painted non-figurative works, however, his abiding interest in architecture, which he had had since he was a teenager, drew him back to figurative painting in 1938. He painted landscapes, buildings and monuments damaged during the war. Considered as a neo-romantic.

PISSARRO, LUCIEN

1863-1944. Son of Camille Pissarro. Taught by his father and also influenced by the divisionist technique of Seurat and Signac. Settled in England in 1890. Painted landscapes, helped with schemes of decoration and also published. Founded the Eragny Press in 1894.

ROBERTS, DAVID

1796-1864. Specialised early on in scenes of Spain and the mediterranean in watercolour and oils. The drawings and watercolours which he made during his travels in the Near and Middle East (1838-1839) ,which were engraved, brought him considerable success with the publication of *The Holy Land and Egypt*. One of the outstanding painters of his day.

SANDBY, PAUL

1729-1809. Born in Nottingham. In 1741 he was appointed, along with his brother Thomas (1721-1798), as a military topographer at the Tower of London and then in Scotland. From the time of his return to London in 1752 he frequently visited his brother at Windsor. They were both founder members of the Royal Academy in 1768. Travelled in Wales with Sir Joseph Banks, 1771. Often mixed gouache and watercolour. He also painted in oils (mostly lost), which enabled him to be an Academician. Died in London in 1809.

SCOTT, SAMUEL

c. 1702-1772. Was the best English marine painter, and imitated William Van de Velde, before turning to views of London, which he painted from 1740, in the style of Canaletto.

SIBERECHTS, JAN

1627-c.1703. Landscape painter from Antwerp; came to England in 1673 or 1674. Was the first artist to concentrate as much on atmosphere as on buildings in his English landscapes.

WALTER RICHARD SICKERT

1860-1942. Influenced by his friend Degas. Became one of the leaders of the London impressionists. In opposition to late Victorian realist painting, he was an activist in various independent artists' groups. He lived in Dieppe on and off from the 1880s to about 1920. Visited Venice frequently. Elected to the Royal Academy in 1935, he resigned the following year. Towards the end of his life used photographs to provide subjects for his paintings.

SKELTON, JONATHAN

c.1735-1759. Very little known during his life. The one remarkable event was a visit to Italy in 1757. He remained in Rome for fifteen months in great poverty and died early in 1759. Totally forgotten thereafter, until his work was rediscovered in 1909, when his drawings appeared at auction.

SMITH, MATTHEW

1879-1959. Trained at Manchester, then at the Slade School and in France where he attended Matisse's Academy in 1911. Started as a fauve but became more expressionist as in his *Fitzroy Street Nudes* (1916) which made him into a celebrity. After a period in Cornwall (1920), he divided his life between France and England. In his paintings of nudes, still life and landscapes he showed an extraordinary mastery of colour.

SPENCER, STANLEY

1891-1959. Born at Cookham in Berkshire. Studied at the Slade School (1908-1912) with Henry Tonks. His long career gave him the chance to impress upon the public an idiosyncratic religious vision. His landscapes, are much more traditional, and led him to be regarded as a latter-day pre-raphaelite. Elected to the Royal Academy in 1950, and knighted in 1959.

STANFIELD, CLARKSON

1793-1867. Spent his early life as a sailor. Elected to the Royal Academy in 1835. His landscapes are primarily coastal and marine scenes painted in a realistic style. His oil paintings and his watercolours were considered by some of his contemporaries to equal those of Turner.

STEER, PHILIP WILSON

1860-1942. A notable figure amongst the English impressionists. Was in Paris from 1882 to 1884. Came under the influence of Whistler. Lived in Chelsea and painted the English landscape. Taught at the Slade School from 1893 to 1930.

STUBBS, GEORGE

1724-1806. Born in Liverpool. From 1744 to 1752 studied anatomy and carried out dissections at York. Visited Italy in 1754. During 1758-1759 worked on *The Anatomy of the Horse*, which appeared in 1766. Elected an Associate of the Royal Academy in 1780 and a full Academician in 1781, but resigned shortly afterwards following a disagreement. In addition to painting horses and hunting, he painted wild animals, scenes of rural life and conversation pieces.

SUTHERLAND, GRAHAM

1903-1980. Engraver and etcher. Commenced painting in 1935. Early in his career was attracted by surrealism, but moved towards the neo-romantics. From 1947 spent a part of each year in the French Midi.

TOWNE, FRANCIS

1739 (1740?)-1816. Born at Exeter, where he was to spend the greater part of his life. After training in London he returned to Exeter and painted in oils. He made topographical drawings and also taught drawing. He had ambitions as an oil painter, but his posthumous fame is based entirely on his watercolours. He developed his own individual style from 1770 which was refined by visits to Wales (1777) and Italy (1780-1781). Not being recognised in London, he organised an exhibition of his work in 1805, but this was not a success. His art remained unappreciated until the 2oth century.

TURNER, JOSEPH MALLORD WILLIAM

Born in 1775 (or 1777?) in the Covent Garden area of London. He enrolled as a student at the Royal Academy Schools in 1789: exhibited his first watercolour in 1790 and his first oil painting in 1796. His ability was quickly recognised. He was elected an Associate of the Royal Academy in 1799 and took up residence in Harley Street. He became a full Academician in 1802 and made his first visit to France and Switzerland. Visited the Louvre. Opened a gallery in Harley Street in 1804 to show his own work. His mother, who had gone mad, died the same year. In 1806 moved to a house in Hammersmith close to the Thames. Elected Professor of perspective at the Royal Academy in 1807. Lived with Mrs Danby, widow of a musician. Gave his first lecture on perspective in 1811. The same year he also moved from Hammersmith to Twickenham. In 1819 he rebuilt his house at the corner of Harley Street and Queen Ann Street, and added on an exhibition gallery. Made his first visit to Italy in August 1819 and visited the continent nearly every year thereafter. In 1829, the death of his father, who had always lived with him, was a sad blow. Stayed at Petworth with Lord Egremont in 1830 to regain his mental composure. The year 1840 was marked by his first meeting with John Ruskin who, through his writings, was to become his greatest champion. Last visit to Venice in 1840. Last foreign journey in 1845. From 1846 lived in Chelsea in a house in Cheyne Walk with Mrs Booth. Exhibited for the last time at the Royal Academy in 1850. Died in Chelsea on 19th December 1851. Buried in St Paul's Cathedral.

N.B. One must not confuse J.M.W. Turner with William Turner, known as Turner of Oxford (1789-1862) a good, but lesser, watercolourist.

VAN DE VELDE

William the Elder (c.1611-1693), originally from Leyden, moved to London with his son, William the Younger (1633-1707). The two artists, both marine painters, worked in Amsterdam up to 1672 when they left Holland for England.

VAN DYCK, ANTHONY

1599-1641. Flemish painter who moved to London in 1632. Returned to Holland twice, in 1634 and 1640. Dominated the artistic world of his time. Died in London at the age of 42.

WADSWORTH, EDWARD

1889-1949. Close to Wyndham Lewis in 1913-1914. Participated in the post-impressionist and futurist exhibitions of 1913. Later, primarily painted coastal and port scenes. Illustrated several books.

WALLIS, ALFRED

1855-1942. At the age of 9 went to sea as a ship's boy, then became a fisherman between Cornwall and Newfoundland. Later he became a marine scrap merchant (1890-1912) until he retired. Began painting very late in life (about 1925), after the death of his wife.

WARD, JAMES

1769-1855. Animal painter, who always wished to rival Rubens. Greatly influenced by William Blake. Firmly convinced of the immorality of his age he turned to primitivism. Painted large pictures of animals fighting, in a style that was both hard and austere.

WEBBER, JOHN

1751-1793. Draughtsamn to Captain Cook's third voyage (1776-1780). Had been apprenticed to Johann Ludwig Aberli, a Swiss painter and engraver, from 1767, then worked in Paris before returning to London in 1775.

WHISTLER, JAMES ABBOTT MCNEILL

1834-1903. American by birth. Spent childhood in Russia followed by schooling in England. In 1851 he enrolled at the West Point Military Academy , which he left in 1854. The rest of his life was divided between London and Paris. In 1855 he decided he was going to be an artist and went to Paris. In 1858 he produced some etchings. In 1865 he visited South America and painted maritime views of Valparaiso. In 1871 he began to paint nocturnes of the river Thames. Attacked by Ruskin in 1877 he started a law-suit against him. Financially ruined, he left for Venice with a commission for etchings from The Fine Art Society. Painted portraits and landscapes as well as etching. At the 1900 International Exhibition in Paris he was awarded the gold medal for painting and for engraving. Died in London in 1903.

WILSON, RICHARD

1714-1782.Born in Wales. The Son of a clergyman, he received a sound education. Started as a portrait painter, but found his vocation as a landscape artist during an extended visit to Italy (1750 to 1757 or 1758). From that time his paintings can be divided into three groups: views of Italy, which he continued to paint even after his return to England, English landscapes in an Italianate manner, and finally views of country houses. Was the first truly great English landscape painter: unappreciated, he lived in considerable poverty despite his post as librarian to the Royal Academy.

WOOD, CHRISTOPHER

1901-1930. Largely taught by the example of his friends in Paris, then came under the influence of Alfred Wallis in St Ives. His landscapes from this period are both sophisticated and naive. It is unclear whether his death under a train at Salisbury station was accident or suicide. He had been introduced to opium by Jean Cocteau.

WOOTTON, JOHN

1682(?)-1764. First mentioned as a horse painter in 1714. He remained the principal horse painter to the nobility before Stubbs. He also painted battle scenes and country houses. His landscapes were influenced by Claude Lorrain.

WRIGHT, JOSEPH.

Known as Wright of Derby. 1734-1797. Did his apprenticeship in London with the portait painter, Thomas Hudson, from 1751 to 1753, and then again from 1756 to 1757. Lived in Derby from 1777. His earliest paintings represented groups of people taking part in scientific experiments. Throughout his life he continued to paint portraits, but turned increasingly to landscape from 1770. A stay in Italy from 1773 to 1775 encouraged him in this. Elected an Associate of the Royal Academy in 1781, he resigned soon after following a disagreement.

MAIN PLACES
MENTIONED IN THE TEXT

Aberdeen	1		Liverpool	29
Ambleside	2		Manchester	30
Bath	3		Medway	31
Birmingham	4		Mousehole	32
Brighton	5		Newmarket	33
Bristol	6		Norwich	34
Borrowdale	7		Nottingham	35
Cader Idris	8		Osmington	36
Cardiff	9		Pegwell	37
Chichester	10		Petworth	38
Cookham	11		Ramsgate	39
Cowes	12		Rhyl	40
Derby	13		Rochester	41
Dolbadern	14		St Ives	42
East Bergholt	15		Salford	43
Edimbourg	16		Salisbury	44
Eton	17		Shoreham	45
Exeter	18		Solent	46
Farnley Hall	19		Southampton	47
Glasgow	20		Staffa	48
Goodwood House	21		Stour Valley	49
Gordale	22		Stourhead	50
Greenwich	23		Sudbury	51
Hampstead	24		Swansea	52
Henley	25		Weymouth	53
Hounslow	26		Windsor	54
Leeds	27		Yarmouth	55
Lincoln	28		York	56

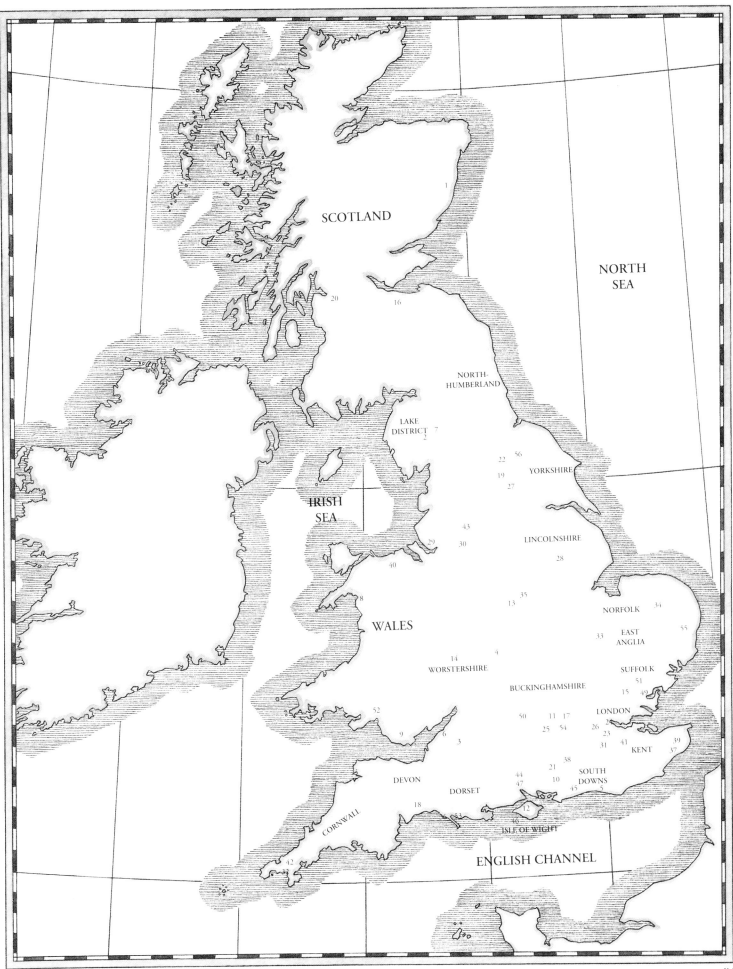

SCOTLAND

NORTH
SEA

1

20 16

NORTH-
HUMBERLAND

LAKE
DISTRICT 7
 2

22 56
19 YORKSHIRE
 27

IRISH
SEA

43
29 30 LINCOLNSHIRE
 28

40

35
8 13 NORFOLK 34

WALES 33 EAST 55
 ANGLIA

14 4
WORSTERSHIRE SUFFOLK
 51
 BUCKINGHAMSHIRE 15 49

52 50 11 17 LONDON
9 25 54 26 2
 6 23
 3 31 41 KENT 39
 38 37
 21 SOUTH
 44 10 DOWNS
DEVON 47 45 5
 DORSET

18 12
CORNWALL 6
 ISLE OF WIGHT

ENGLISH CHANNEL

42

INDEX OF NAMES

Figures in italics refer to names mentioned in the captions accompanying reproductions.

Académie Julian 215
Ackermann 86
Albert, Prince 213
Alexander, William *124*, 125, 212
Aquatint 27, 36
Arne, musician and friend of Gainsborough 64

Balla, Giacomo 196
Banks, Sir Joseph 216
Beaumont, Sir George 81, 118, 144, 152, 213
Beckford, William 36, 74, 99, 213
Bell, Graham 205
Bevan, Robert 190, 212
Bicknell, Maria 138
Blake, William 157, 168, 201, 216, 217
Bomberg, David 198, 212
Bonington, Richard Parkes 74, 108, 157, 163-166, 211, 212
Boys, Thomas Shotter *163*, 166, 212
Brabazon, Hercules 131, 212
Brett, John, Polhill 177, 213
Brooking, Charles 21
Brown, Ford Madox *174*, 177, *178*, 213
Burke, Edmund 10
Byron, George Gordon, Lord 211

Camden Town Group 190, 214
Callow, William 166
Calvert, Edward 168
Canaletto, Antonio Canal, called 11, *17*, 22, 29, 81, 213, 214
Cézanne, Paul 13, 190, 193
Charles I, King 17, 18
Charles II, King 213
Chirico, Giorgio de 201
Christie's 9
Claude, see : Lorrain
Cleveley, Robert, 33, 213
Cocteau, Jean 217
Colour beginnings 36, 120
Constable, John 8, 12, 27, 77, 120, *135*, 137-156, 157, 171, 188, 190, 211, 213
Cook, James, Captain 125
Cotes, Francis *4*
Cotman, John Sell *73*, 86-93, 137, 213
Courbet, Gustave 185
Cox, David 157-159, 211, 213
Cozens, Alexander 35-38, 60, 67, 73, 74, 99, 145, 213

Cozens, John Robert 70, 74-77, 80, 81, 98, 99, 102, 123, 128, 144-213
Craxton, John 208
Crome, John 135-137, 213
Cromwell, Oliver 17
Cubism 195, 196, 202
Cursiter, Stanley 198, 213
Cuyp, Aelbert 49, 56

Davis, John Scarlet 166
Dayes, Edward 9, 29, 32, 80, 81, 98, 213, 214
Degas, Edgar 190, 216
Delacroix, Eugène 137, 145, 149, 155, 163, 166, 212
Delécluze, Étienne-Jean 155
Devis, Arthur 32
De Wint, Peter 157, 159-163, 213
Dilettanti Society 125
Douanier, Henri Rousseau, called the 202
Drawing Club (Girtin's) 87, 212
Dughet, Gaspard 25, 51
Dyce, William *176*, 177, 213

Egg, Augustus 180
Egremont, Earl of 114
Eidometropolis 86, 163
Eidophusikon 64
Elizabeth I, Queen 14, 15
Elgin, Lord 123
English Renaissance 15
Essex, Earl of 15
Expressionism 206

Farington, Joseph 81, 99
Fauvism 13, 193, 196
Fawkes, Walter 114
Fine Art Society, the 217
Fisher, John 141
Francia Louis 163, 212, 214
Frith, William Powell 177, *181*, 185, 214
Futurism 13, 195, 196, 202

Gainsborough, Thomas 8, 10, 11, 25, 27, 40, 51, 56-66, 73, 81, 135, 144, 211, 214
Gauguin, Paul 13, 190, 193
George III, King 36, 55, 214
Gilman, Harold *191*, 193, 214
Ginner, Charles 193, 214
Girtin, Thomas 8, 9, 32, 77, 80-86, *87*, 88, 95, 98, 99, 144, 159, 163, 214

Gore, Spencer 193, 214
Grand style or grand genre 9, 56, 108
Grand tour 11, 21, 55, 74, 123
Gravelot, Hubert François Bourguignon, called 56, 214
Grey wash 32, 80, 88
Gros, Baron 163

Hardwicke, Lord 25, 27, 60
Haytley, Edward 32, 214
Hazlitt, William 118, 120
Henry VIII, King 15
Hepworth, Barbara 215
Hierarchy of genres, the 9
Hilliard, Nicholas *14*, 15, 214
Hitchens, Ivon *201*, 202, 214
Hobbema, Meindert 56, 135
Hodges, William 125, *126*, 214
Hodgkins, Frances 202
Holbein, Hans 15
Hollar, Wenceslas 18, 25, 214
Hunt, William Holman 171, *172*, 214

Impressionism 12, 188, 193
Industrial Revolution 56, 67-71, 152

James, William 29, 214
Japonism 185
Jockey Club, the 11, 39
Joli, Antonio 11, 21
Jones, Thomas 123

Kahn, Albert 202
Keats, John 211
Kitchen Sink School 209
Kokoschka, Oskar 13, 206, *207*, 215
Knight, Richard Payne 10, 74, 213

Lambert, George 40, 51, 215
Lear, Edward 131, 215
Leighton, Frederick, Lord 180, 215
Lemaître, Henri 64
Lewis, John Frederick 131, 215
Lewis, Percy Wyndham 13, 196, 215
Linnell, John 168
Lorrain, Claude Gellée, called the 25, 40, 42, *52*, 55, *56*, 57, *64*, 84, 99, 102, 137, 144, 152
Loutherbourg, Philippe de 64
Lowry, Lawrence Stephen *204*, 205, 215

Macartney, Lord 125

Mallarmé, Stéphane 185

Malton, Thomas the Younger 9, 98

Manet, Édouard 188, 193

Marines 11, 18-20, 32, 33, 141

Marinetti, Filippo Tommaso 13, 196

Matisse, Henri 195

Matisse's Academy 195, 196

Millais, John Everett 171, 172, *173*, 215

Minton, John 208

Moore, James 81, 214

Monamy, Peter 21

Mondrian, Piet 13, 202

Monet, Claude 121, 190

Monro Dr 77, 81, 163, 213

Monro's Academy 77, 81, 87, 98, 212, 214

Müller, William James *126*, 128, 131, 215

Nash, Paul 198, *199*, 201, 208, 215

Nebot, Balthasar 22, 215

Neo-romanticism 206, 208

Nevinson, Christopher *195*, 196, 215

Nicholson, Ben 13, 195, 201, 202, 208, 215

Nicholson, Francis 29, 215

Nickolls Joseph 32, 215

Norwich School 135, 137

O'Conor, Roderick 13, 193, 196, 215

Oliver, Isaac 15, 215

Palmer, Samuel 168, 206, 208, 216

Palmerston, Lord 128

Pars, William *123*, 125, 128, 216

Pasmore, Victor 208, *209*

Picasso, Pablo 205

Piper, John 205, *206*, 216

Pissaro, Camille 121, 190

Pissaro, Lucien 190, 216

Picturesque, the 10, 11, *27*, 93, 95, 98

Pont-Aven Group 13, 93

Pope, Alexander 40

Postimpressionism 190, 193

Poussin, Nicolas 25, 40, 42, 51, 55

Preraphaelites 12, 171-179, 201

Price, Uvedale 10

Proust, Marcel 138

Prout, Samuel 10, *11*

Reynolds, Sir Josuah 9, 10, 56, 64

Richmond, Duke of 22, 42

Roberts, David 128, 216

Romanticism 35, 157-170

Rosa, Salvator 11, 21

Rousseau Henri, see : Douanier

Rousseau, Théodore 155

Royal Academy 8-12, 27, 55, 56, 64, 73, 80, 81, 88, 95, 98, 99, 104, 108, 118, *120*, 131, 137, 138, 148-150, 152, 155, 166, 171, 172, 180, 185, 190, 211, 214

Rubens, Pierre-Paul 17, 18, 57, 81, 144, 214

Ruisdael, Jacob Van 56, 144

Ruskin, John 131, 177, 183, 213, 217

Salon des refusés 188

Sandby, Paul *4*, 25, 27, *28*, 216

Sandby,Thomas 27

Scott, Samuel 21, 22, *23*, 216

Seurat, Georges Pierre 216

Seven and Five Society 195, 202

Severini, Gino 198

Shakespeare, William 15

Siberechts, Jan 18, *19*, 40, 216

Sickert, Walter 188, *189*, 190, 216

Sidney, Sir Philip 15

Signac, Paul 216

Skelton, Jonathan 29, 123, 216

Slade School 190, 212, 214, 215, 216

Smart, Borlase 201

Smith, J. T. 212

Smith, John Rapahel (ed.) 214

Smith, Sir Matthew 196, *197*, 216

Smith, John "Warwick" 123

Society of Norwich Artists 135, 213

Sotheby's 9

Spencer, Stanley 201, 216

Stanfield, Clarkson *162*, 166, 216

Steer, Philip Wilson 188, 190, 216

Stothard, Thomas 98

Stubbs, George 4, 39, 40-49, 211, 216

St Ives School 201

Sublime, the 6, 10, 12, 98, 110

Surrealism 195, 198

Sutherland, Graham 13, 206, 208, *211*, 216

Tonks, Henry 190, 216

Topographers 25, 27, 40, 108

Topography 18, 22, *26*, 27, 29, 32, 57, 73, 81, 88, 93, 95, 98, 125, 163

Towne, Francis 77-80, *81*, 86, 123, 128

Turner, Dawson 93, 213, 216

Turner, Joseph Mallord William *6*, 8, 9, 10, 12, 21, 27, 36, 77, 80, 81, 86, 95-121, 123, 125, 131, 148, 152, 157, 166, 168, 211, 217

Turner, William, called Turner of Oxford 217

Unit One 195, 208

Van de Velde, William the Younger 18, 21, 22, 33, 114, 217

Van de Velde, William the Elder 18, 21, 22, 33, 114, 217

Vand Dick, Sir Antoon, *4*, 17, 18, 217

Van Gogh, Vincent 13, 193, 196

Varley, John 158, 159

Vernet, Claude Joseph 55, *56*

Vorticism 13, 195, 196, 198, 201

Wadsworth, Edward 201, 217

Wallis, Alfred *200*, 201, 202, 217

Ward, James 168, 217

Watercolour 9, 11, 12, 18, 27, 73-93, 104, 125, 128, 157, 159, 166

Watercolour drawing 29

Watercolour Society, the 9, 93, 213

Watteau, Antoine 57

Webber, John 125, 217

West, Benjamin 152

Whistler, James McNeill 8, 12, 180, 183-188, 190, 211, 217

Wilson, Richard 11, 21, 26, 27, 40, 51-56, 73, 99, 125, 135, 211, 215, 217

Wood, Christopher 201, 202, 203, 217

Wootton, John 40, *41*, 215, 217

Wordsworth, William 60, 138, 211

Wright, Joseph, called Wright of Derby 67-71, 217

Wyck, Jan 40

Zucarelli, Francisco 11, 21, 55

Selected bibliography

General Works

Gaunt, William, *English Painting*, London, 1983.

Piper, David, *Painting in England 1500-1830*, London, 1965.

Redgrave R. and S., *A Century of Painters of the English School*, New Edition, 1947.

Rothenstein, John, *Modern English Painters*, 3 volumes, London, 1976.

Spalding, Frances, *British Art Since 1900*, London, 1986.

Waterhouse, Ellis, *Painting in Britain 1530-1790*, London, 1986, The Pelican History of Art.

Concerning watercolours

Hardie, Martin, *Watercolour Painting in Britain*, 3 volumes, London, 1966-1968.

Lemaitre, Henri, *Le paysage anglais à l'aquarelle*, Paris, 1954.

Stainton, Lindsay, *Nature into Art. English Landscape Watercolours*, British Museum Press, London, 1991.

Williams, Iolo, *Early English Watercolours*, London, 1952.

Wilton, Andrew, *British Watercolours 1750-1850*, Oxford, 1977.

Monographs and Exhibition catalogues

Most painters are the subject of one or more monographs. We list here only those concerning the most important artists.

Richard Parkes Bonington

Catalogue of the Bonington exhibition at the Petit Palais, Paris, 1992.

John Constable

Catalogue of the Constable exhibition at the Tate Gallery, London, 1991.

Reynolds, Graham, *Constable, The Natural Painter*, 1965.

Rosenthal, Michael, Constable, London, 1987.

John Sell Cotman

Catalogue of the Cotman exhibition, London, Manchester, Bristol, 1982-1983.

Alexander and John Robert Cozens

Sloan, Kim, *Alexander and John Robert Cozens: The Poetry of Landscape*, London, 1986.

Thomas Gainsborough

Hayes, John, *Gainsborough*, London, 1975.

Catalogue of the Gainsborough exhibition, Paris, Grand Palais, 1981.

Nicholas Hilliard

Reynolds, Graham, *Nicholas Hilliard and Isaac Oliver*, London, 1971.

Oskar Kokoschka

Catalogue of the exhibition at the Tate Gallery, London, 1986.

Paul Nash

Eates, Margot, ed., *Paul Nash, A Memorial Volume*, London, 1948.

Ben Nicholson

Read, Sir Herbert, *Ben Nicholson*, 2 volumes, 1948-1956.

Isaac Oliver

See Hilliard.

Samuel Palmer

Melville, Robert, *Samuel Palmer*, London.

Preraphaelites

Catalogue of the exhibition, *The Pre-Raphaelites*, Tate Gallery, London, 1984.

Paul Sandby

Hermann, Luke, *Paul and Thomas Sandby*, London, 1986.

Matthew Smith

Halliday, Francis, and Russell, John, *Matthew Smith*, London, 1962.

Stanley Spencer

Robinson, Duncan, *Stanley Spencer*, Oxford, 1990.

St Ives

Catalogue of the exhibition, *St Ives, 1939-1964*, Tate Gallery, London, 1985.

George Stubbs

Catalogue of the Stubbs exhibition, Tate Gallery, London, 1984.

Graham Sutherland

Cooper, Douglas, *Graham Sutherland*, 1961.

Francis Towne

Bury, Adrian, *Francis Towne, Lone Star of Watercolour Painting*, London, 1962.

Joseph Mallord William Turner

Finberg, A.J., *Life of J.M.W. Turner*, 2nd edition, 1961.

Wilton, Andrew, *The Life and Work of J.M.W. Turner*, London, 1979.

Catalogue of the exhibition, *Turner in France*, Centre culturel du Marais, 1981.

Catalogue of the Turner exhibition, Grand Palais, Paris, 1983.

James McNeill Whistler

Holden, David, *Whistler, Landscapes and Seascapes*, New York, Oxford, 1976.

Richard Wilson

Catalogue of the Wilson exhibition, Tate Gallery, London, 1982.

Joseph Wright of Derby

Catalogue of the Wright of Derby exhibition, Tate Gallery, London, 1990.

Photo credits

ARTEPHOT / Bridgeman: 186, 187; / Nimatallah: 182, 183. BIBLIOTHEQUE NATIONALE, Paris: 188. BRITISH MUSEUM, London: 11, 34, 35, 37, 72, 73, 76, 81, 87, 89, 90, 91, 117, 132, 133, 150 a., 163, 166, 212; / John Williams: 18, 29, 30, 75, 122, 123, 124, 156, 157; / Kevin Lowelock: 82-83. CITY MUSEUM AND ART GALLERY, Birmingham: 105, 178-179. EDIMEDIA: 38, 39, 185, 205. FITZWILLIAM MUSEUM, University of Cambridge: 168. GIRAUDON: 24, 25, 61; / Bridgeman: 99, 199, 204. INDIANAPOLIS MUSEUM OF ART, anonymous gift in memory of Evan F. Lilly: 6. NATIONAL GALLERY OF ART, Washington, Andrew W. Mellon collection: 62. NATIONAL GALLERY OF CANADA, Ottawa: 140. NATIONAL GALLERY OF VICTORIA, Melbourne: 31, 116. NATIONAL MARITIME MUSEUM GREENWICH, London: 20, 127. NATIONAL MUSEUM OF WALES, Cardiff: 56. REUNION DES MUSEES NATIONAUX, Paris: 68-69, 167. RIGHTS RESERVED: 15, 22, 26, 65, 71, 198, 206, 209. TATE GALLERY, London: 2, 19, 41, 48, 50, 51, 53, 54, 66, 67, 94, 95, 97, 103, 106-107, 109, 110, 111, 119, 121, 126, 131, 136, 142, 143, 169, 170, 171, 173, 174-175, 176, 177, 181, 191, 192, 193, 194, 195, 200, 201, 205, 211. THE ART INSTITUTE OF CHICAGO, Stickney Fund: 184; Gift of Clara Margaret Lynch in memory of John A. Lynch: 187. THE BRIDGEMAN ART LIBRARY, London: 23, 28, 57. THE BURRELL COLLECTION, Glasgow: 203. THE CLEVELAND MUSEUM OF ART, Bequest of John L. Deverance: 112-113; Leonard C. Hanna Jr Fund: 139. THE GOODWOOD ESTATE COMPANY LIMITED, cover, 16, 17, 44, 45. THE MUSEUM OF FINE ARTS, Boston, Warren collection: 134, 135; M. Theresa B. Hopkins Fund: 186. THE NATIONAL GALLERY, London: 58, 137. THE ROYAL ACADEMY OF ART, London: 42, 60, 63, 98, 151, 153, 189. THE WHITWORTH ART GALLERY, University of Manchester: 162. VICTORIA AND ALBERT MUSEUM, London: 9, 14, 77, 78, 79, 88, 92, 130, 144, 145, 146-147, 148, 150 b., 154, 155, 159. YALE CENTER FOR BRITISH ART, New Haven, Paul Mellon collection: 33, 46, 47, 52, 74, 85, 93, 115, 129, 158, 160, 161, 164, 165. All rights reserved for the other artists whose work is reproduced in this book.

Acknowledgments

At the conclusion of this work I would like to thank all those who have helped me with advice, most especially Mme Therese Tessier, Professor Emeritus at the University of Paris XII and Mrs Maria K. Greenwood, Master of conferences at the University of Paris VII, M.A. (Oxon), who greatly benefitted me with their wise advice and suggestions.

For the illustrations I would particularly like to thank His Grace the Duke of Richmond, Lennox and d'Aubigny, who allowed us to reproduce some pictures from his celebrated collection. I would also like to express my gratitude to the many museum directors and staff who have generously responded to our requests for photographs.

Laure Meyer

Printed in Italy
La Zincografica Fiorentina